BILL AND WESLEY FORTNEY

AMERICA
From 500 Feet!

Photography by Bill Fortney and Wesley Fortney
Edited by Barbara K. Harold
Designed by Russell S. Kuepper

Front cover photograph: Boundary Waters Canoe Area Wilderness, Minnesota.
Back cover photographs: Stonington, Maine (upper left); Bradley, California (middle and upper right)

NorthWord Press
5900 Green Oak Drive
Minnetonka, MN 55343
1-800-328-3895

Library of Congress Cataloging-in-Publication Data
Fortney, Bill
 America from 500 feet! / Bill Fortney.
 p. cm.
 ISBN 1-55971-785-8
 1. Aerial photography--United States. 2. Landscape photography--United States. 3.
 Nature photography--United States. 4. United States--Aerial photographs. I. Title

 TR810 .F65 2001
 779'.3673--dc21 2001022216

Printed in Singapore

10 9 8 7 6 5 4 3 2 1

 Kodak Professional

Kemmeries Ultralight Flight Center - Kenyon Labs - Bearcat Trailers - Grand Rapids Technology - AirCreation

BILL AND WESLEY FORTNEY

AMERICA
From 500 Feet!

NORTHWORD PRESS
Minnetonka, Minnesota

Table of Contents

In Loving Memory of
Douglas Blair — 1917 to 1999
Marc Anthony Dudley — 1974 to 1995
John Netherton — 1948 to 2001

First light on sand dunes, Death Valley National Park, California.
Bill Fortney

Dedication

For
My Lord and Savior, Jesus Christ,
for this wonderful life and the life to come.

Sherelene, the love of my life, and the family she has given me,
Scott, Diane, Benjamin and Hannah,
Wesley, Catherine, Clint and Cassidy.

Wesley, my partner, strength, companion, son, co-pilot, and friend.
My father, William Pelle Fortney, and my brother, Homer Richard Fortney,
who taught me how to be a man, by example.

John Shaw, Cliff Zenor, Bill Campbell, Chuck Summers,
and David Middleton, who have been my photographic inspirations and dear friends.

Don Nelson and Jim Brandenburg, who have
opened so many doors that led to this moment.

Paul Huber, a true friend and enabler.

Charles Stanley, whose prayers and friendship
carried us through this awesome project.

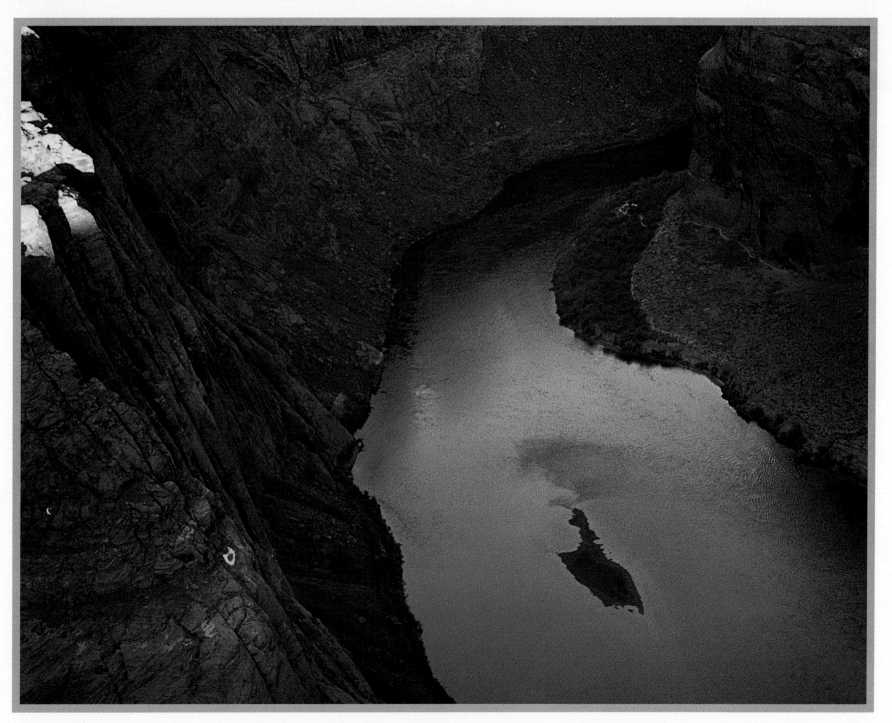

Warm light reflecting from the canyon walls onto the Colorado River, near Page, Arizona.
Bill Fortney

7

Preface *by Ned Beatty*

My first cousin is one of the guys in the ultralight plane shooting pictures from five hundred feet or thereabouts. My first cousin, Bill Fortney.

Now don't ask me the difference between a first cousin and a second or third or fourth cousin. I know not. Bill Fortney is my first cousin. His father and my mother were brother and sister, and I am proud enough to bust. Because of this relationship, I have been privileged to preview some of this material and it is good. Anyone who doesn't agree with that can just get ready to deal with me. I am Bill Fortney's cousin, remember.

A bunch of us cousins got together this last year, and I was amazed how the stories and tales came tumbling forth from all sides. What fun. I am also pleased that Bill (it is so hard not to call him Bill Glenn, which is his growing-up name) is gaining more and more fame.

For a long time, I was the most infamous of the cousins. Thanks, Bill, for taking on your share of the burden—but did you have to go so high in the motorized kite to do it?

> With great pride,
> I am Ned Beatty
> (Bill Fortney's cousin)

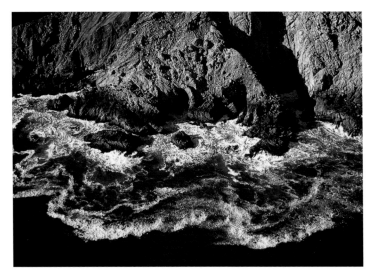

Rocky coastline at Big Sur coast, California.
Bill Fortney

Foreword *by Dr. Charles Stanley*

When a man has a dream backed by a passion to fulfill it, faith to believe that he can, and the persistence to press on with the help of God, no matter what, he will reach his goal. Bill Fortney is such a man.

In October of 1999 I stood in a circle of photography friends and we held hands and I led a prayer for Bill and Wesley as they started the project that resulted in this book. As a friend, I have to admit to being concerned for Bill's safety, but as his brother I knew he had committed his life and the project to the Lord. Bill and I have shared many great experiences and meaningful discussions about our faith. I know that Bill has dedicated this project and his life to the glory of God. I know what happens when a man or woman gives God first place in their lives; it opens the door for God to allow us to do our best and be our best, and if we are under His mantle of protection, we can believe in and count on His presence in everything we face.

Bill and Wesley drove over 73,000 miles and flew countless hours over some of the most hostile terrain in America, and they have survived to share their story. When God helps us to be the best we can be, the results can be awesome. As you turn these pages and share in the beauty of what God has made and in the experiences of Bill and Wesley, you will not doubt what God can do with our lives if we are willing to give ourselves to Him.

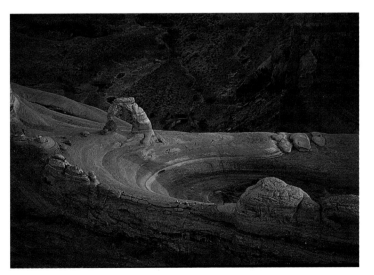

Delicate Arch at sunset at Arches National Park.
Bill Fortney

The Firestar was a dream in the air—it went exactly where you pointed it and its climb rate was astounding. After my heart settled down I made lots of easy turns around the pattern. After about a half hour of flying it was time to land. This was the hardest part—not that landing a Firestar is hard, it was just something I'd never done without a trainer sitting next to me. I flew my downwind leg and turned on a base leg, then made another turn onto a final approach. The runway was starting to roll by under me and I realized I was too high. So I gave it some throttle, climbed up and went around again.

I talked to myself as I made another downwind and base leg. For this approach I flew about a quarter-mile farther out on my downwind leg so I would have lots of time to line up on the runway and adjust my altitude on my final approach. This approach was almost perfect. The runway was right in front of me and my descent was nice and easy. I reduced my power and started to settle down onto the runway. Just above deck I held off for a few more seconds and then set down with a nice firm plant.

My exhilaration was short lived as I immediately lost control of the plane on the ground and skidded off the runway into a dirt field. Thankfully, nothing was hurt but my pride. I was determined to take it up again and get it right.

Unfortunately, the wind picked up and my courage started to fall, so I put the plane away in favor of waiting for a better day. The rest of our stay in Wall never gave us another calm day, so soon we were on our way back to Kentucky. I did a lot of thinking about that flight and tried to figure out how to solve the ground-handling problems. I have to admit, it started to become an obsession.

When we got home, a calm afternoon, I took the plane to the local airport and did my second solo flight in the Kolb. The flight went great. The landing was still nothing to write home about, but it didn't end in an out-of-control ground situation. I was starting to feel better but knew that every flight has to end in a good landing, so I vowed to be back at the airport the next morning to get it right.

THE CRASH

Early the next morning I took the Firestar out to the runway and smoothly rolled on the throttle and made a nice takeoff. Unfortunately, within seconds of rotation, the engine lost power.

A principle you learn in training is that if you lose an engine you will come back to the ground at the same angle you left it. I was climbing out very steeply, so I came back the same way! It only took a few seconds until I had slammed nose-first from 60 feet high into the grass just off the runway. The plane cartwheeled and the steel cage I was in collapsed.

It was just a few moments until I realized that I had survived the crash. In fact, the heavy-duty shoulder harnesses and seatbelt had held me firmly in the seat. I didn't have a scratch!

Though my body was unblemished, my psyche was not. I went through several emotional states. I immediately swore I would never get back in an airplane again. Later that day I vowed to get more training and think about it.

Though I regained my enthusiasm to keep trying, my courage was another matter. The plane was going to be months in repair and I had too much time to relive those horrible eight seconds heading directly at the ground. More than a few nights' sleep were interrupted as I woke in a cold sweat from reliving the crash.

While I obsessed about the crash I had time to re-evaluate the situation. I knew I was committed to doing the book. I also knew that the problem with flying the Firestar was that I could not get the right kind of training in the actual plane I was flying. After a lot of soul searching I decided to sell the Firestar and look for a third plane.

Bill in the Air Creation Fun Racer flying over some oak trees in the Hombre Hills near Bradley, California.
Bill Fortney

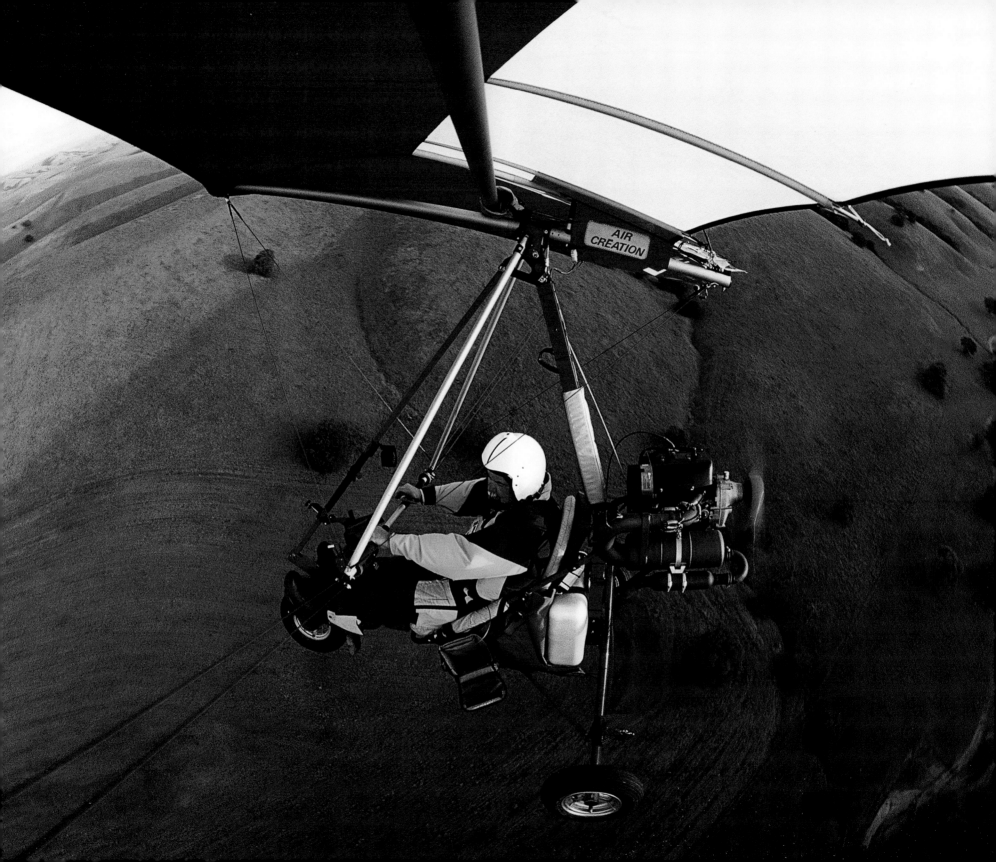

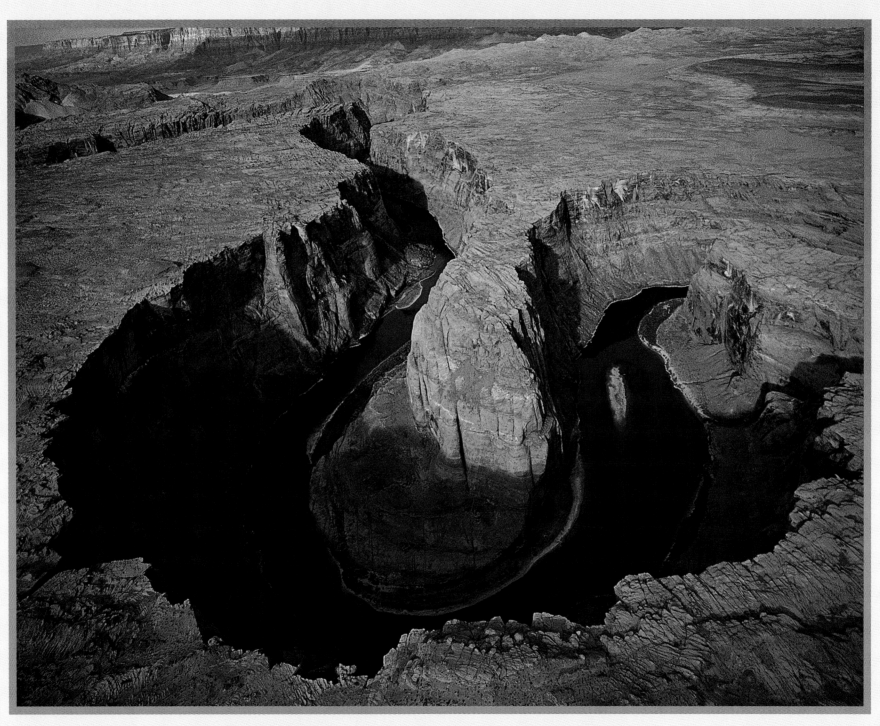

Horseshoe Bend's deep canyons and the Colorado River in early-morning light near Page, Arizona.
Wesley Fortney

THE "LAST" PLANE

I called my dear friend in Arizona, John Kemmeries. After the twenty hours I had trained with John and his folks when I had the Pegasus, I trusted his opinion. I really liked trikes and I knew that no one would be more knowledgeable than John. I also knew he would be honest with me about what I should be flying.

John recommended the Air Creation Fun Racer 447, a fully legal Part 103 ultralight trike that was easy to fly. It had a remarkable quality I needed—a stall speed of only 22 miles per hour. I had barely started the search when my friend Paul Huber found a Fun Racer for sale at a good price in Florida. Wesley and I drove down to Florida and purchased the plane. We then went straight out to Peoria, where we both finished our training and soloed in the Fun Racer.

It wasn't easy to climb back in an airplane and fly after months of thinking about what had happened. But with encouragement from Wesley, and a lot of prayers, we got the job done. While I was laid up, we hired pilots and planes for the shooting, but now we could start doing more of the flying ourselves and, in the right locations, the trike was a treat to shoot from.

A WORD ABOUT SAFETY

I made a promise to my wife, Sherelene, that if she would go along with this idea I would commit to being very careful and flying only when we felt the conditions were right to be in the air.

I've shared some of the behind-the-scenes mistakes in hopes that anyone who gets turned on about flying after reading this book will know the dangers and pitfalls of sport flying. I truly believe that this is a sport that can be fun and safe—if you get good training and use good judgement about when and how to fly. I wouldn't trade anything for the experience, but I know how badly things can go and why pre-flights and weather evaluations are so important.

Whatever kind of plane you choose, make sure your dealer can either provide you with good training or steer you to a person who can get you well prepared to fly. Most ultralights are very easy to fly, but that doesn't mean you shouldn't get lots of training. Talk to other ultralighters, get a private license if you can, and at least read and study all the FAA material for the written private pilot's test. It is valuable information that will come in handy once you start flying!

ABOUT THIS COUNTRY

These fourteen months of flying over America have deepened my love and respect for its wild lands and its people. On countless occasions, Wesley and I have been befriended by people who have helped us keep the project going. In large part, this book is dedicated to them.

In natural history terms, this is one of the most diverse countries on the face of the earth, and the boundless beauty is everywhere to enjoy. I hope that as you view these images they will lead you to a re-commitment to preserving the truly remarkable natural beauty we have as a nation. If this book does that and nothing else it will have all been worthwhile.

Now turn the pages and soar with Wesley and me, across every imaginable landform, and may you feel the wind in your face and the sun on your shoulder!

Wesley flying low over the shallow banks of Lake Superior and the Pictured Rocks National Lakeshore, Michigan.
Bill Fortney

The West

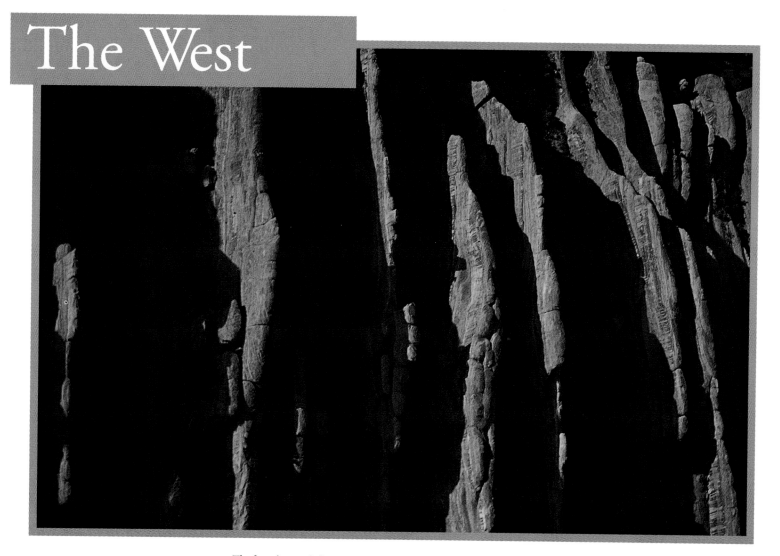

The fins, sheer rock formations, in Arches National Park, near Moab, Utah.
Wesley Fortney

One of the countless fort-like ridge lines in
Canyonlands National Park, near Moab, Utah.
Bill Fortney

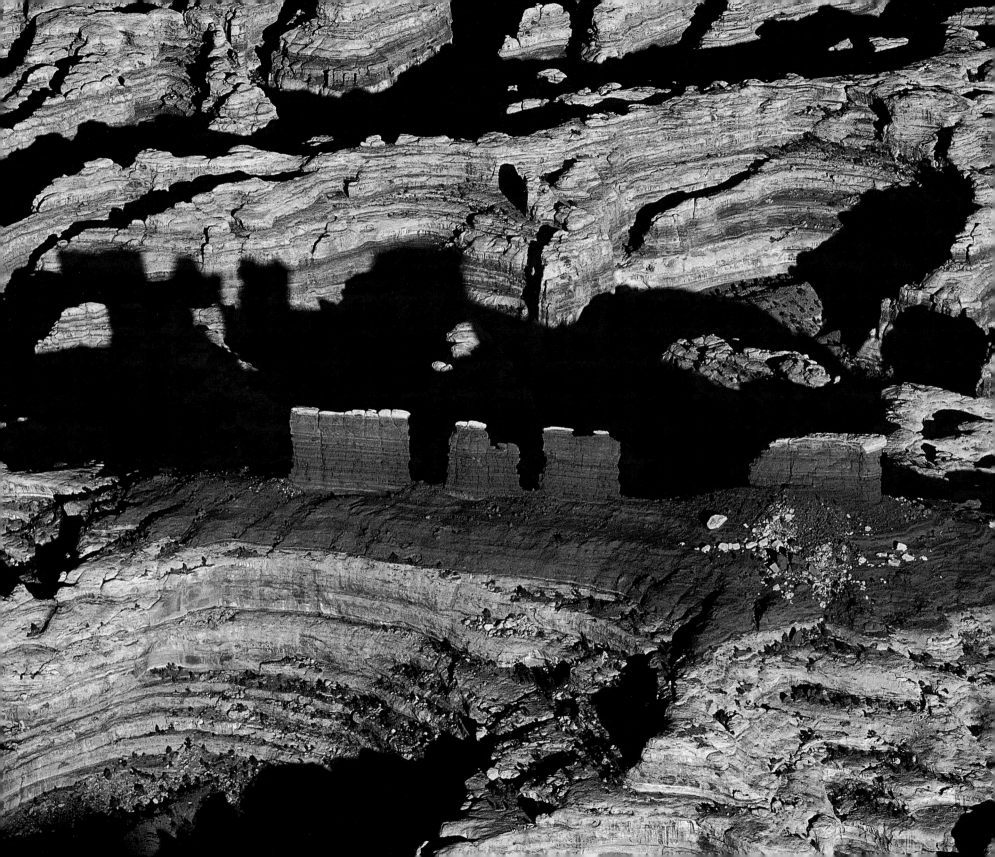

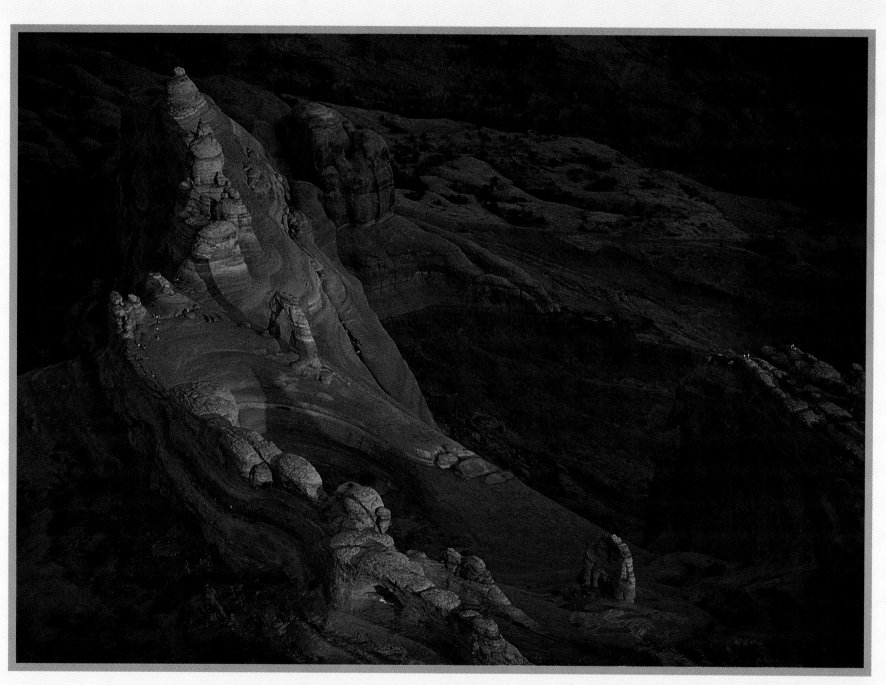

Sunset light on Delicate Arch, complete with park guests enjoying the view along the rock ledges, Arches National Park.
Bill Fortney

PILOT'S LOG

Date: March 4
Location: Arches & Canyonlands, Utah
Flight time: 4:45 p.m. MST
Visibility: Clear
Conditions: Light wind, 68°F
Base of operation: Moab Canyonlands Airport
Field elevation: 4,553 feet MSL
Altitude: 4,553 to 11,500 feet MSL

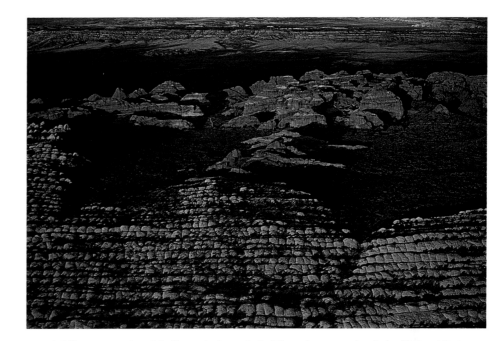

A different perspective of the fins and other geological formations at sunrise, Arches National Park.
Wesley Fortney

It's hard to believe that what I'm photographing is the result of over a hundred million years of water and wind. Arches National Park, with over 2,000 cataloged arches, and Canyonlands National Park, with hundreds of colorful canyons, mesas, buttes, fins, arches, and spires, make up some of the most fascinating parts of the territory known broadly as the Colorado Plateau. Flying over this region is a little like trying to find something colorful to photograph at Disney World—it's sensory overload!

Arches and Canyonlands lie atop an underground salt bed, which is basically responsible for the arches, spires, balanced rocks, sandstone fins, and eroded monoliths that make the area a sightseer's Mecca. Thousands of feet thick in places, this salt bed was deposited across the Colorado Plateau some 300 million years ago when a sea flowed into the region and eventually evaporated. Much of this debris was compressed into rock. At one time this overlying rock may have been more than a mile thick.

Over millions of years the salt bed was covered with residue from floods and winds and the oceans that came and went at intervals.

Over time and under pressure, the salt bed shifted, buckled, liquefied, and repositioned itself, thrusting the rock layers upward into domes. Whole sections dropped into the cavities. Wind and water later cleaned out the loose particles finishing the job. Actually, the job is far from finished—if you don't believe me come back in a few million years and see what has developed!

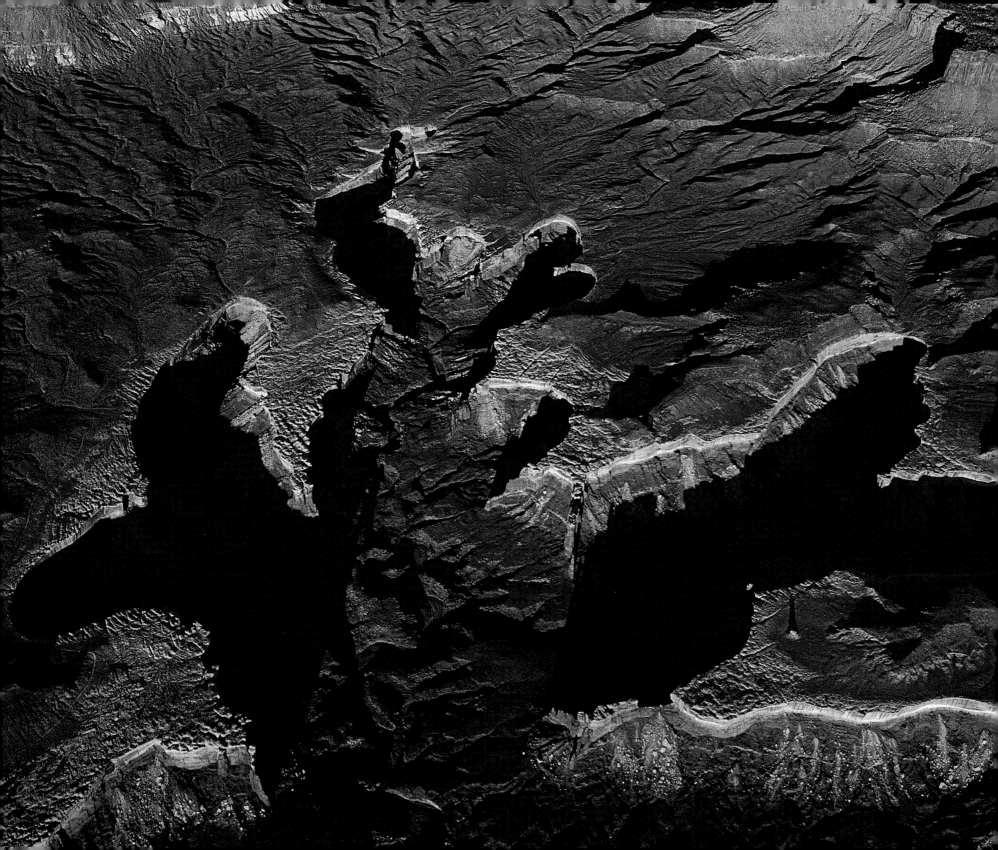

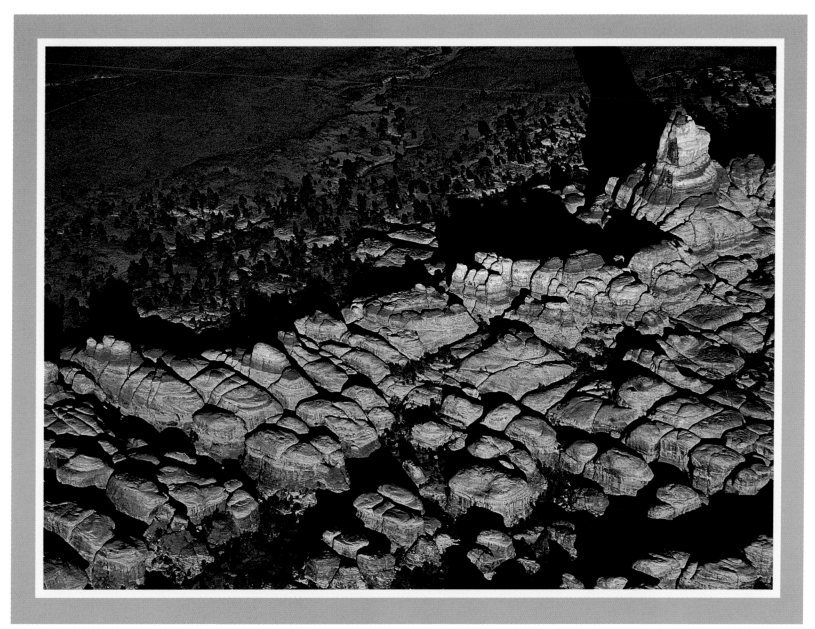

These unique formations are the namesake of a part of Canyonlands National Park, known as The Needles.
Bill Fortney

Canyon patterns from six thousand feet above the canyon walls, Canyonlands National Park.
Bill Fortney

PILOT'S LOG

Date: January 26
Location: Vulture Mountains, Arizona
Flight time: 7:20 a.m. MST
Visibility: Clear
Conditions: Light wind
Base of operation: Lake Pleasant Airport
Field elevation: 1,600 feet MSL
Altitude: 1,600 to 2,600 feet MSL

This is the end of a ten-day stay for Wesley and me at Kemmeries Ultralight Flight Center in Peoria, Arizona, about 15 miles north of Phoenix. Wesley completed his pilot's training and soloed. I was checked out in the new plane and we both had time to do some flying just for pleasure.

Before returning to Kentucky, I decided to go up this morning to watch the sun rise over the Vulture Mountains, just to the south of the airport. I was glad I took a camera along when the rim of early light lit these small but beautiful mountains. I couldn't help but think of John Shaw's words, "Every place is magical if you are there at the right time."

He surely was right on this morning as a non-descript little range of 500-foot-high mountains loomed in the glory of early-morning light and haze.

Lovely first light on the Snake Mountains, South of Peoria, Arizona, and Kemmeries Ultralight Flight Center.
Bill Fortney

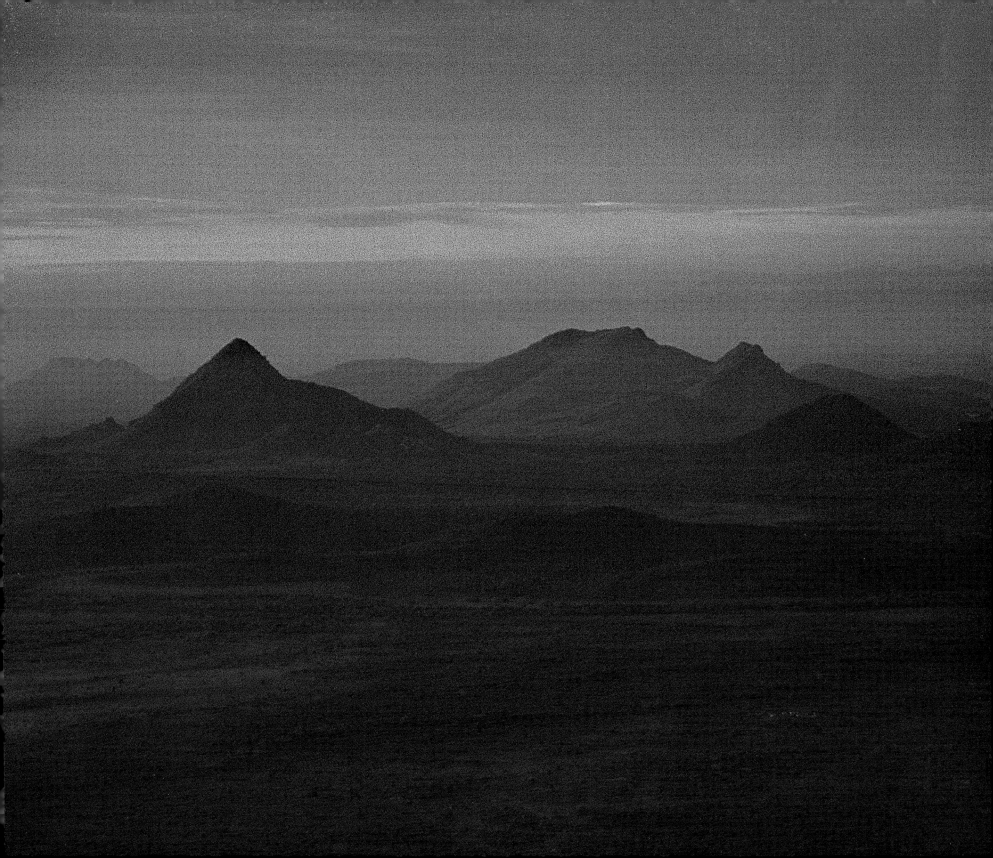

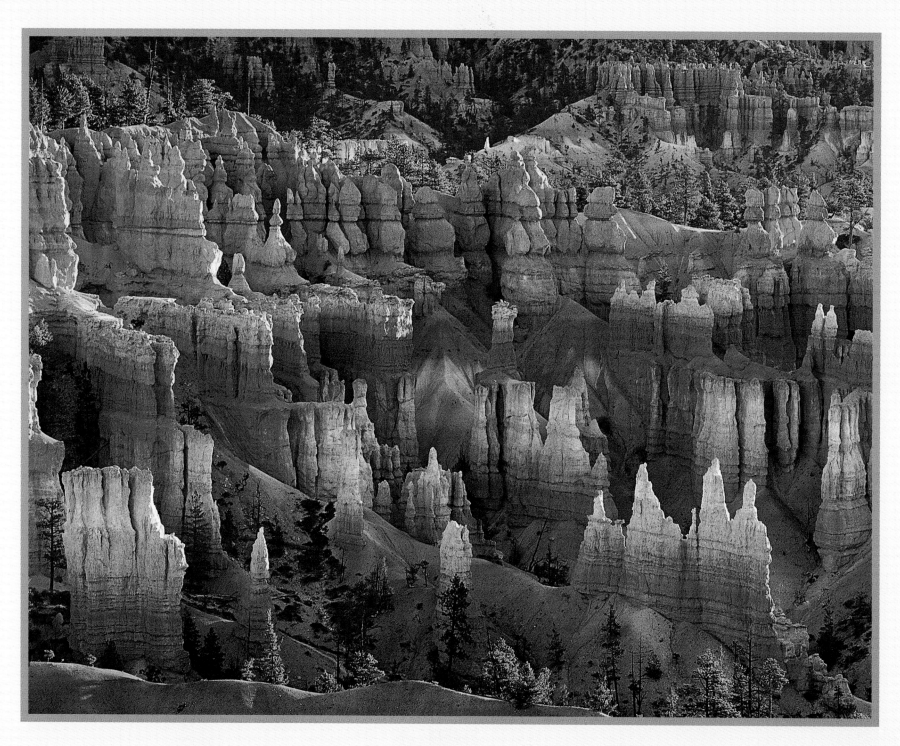

The fins at sunrise, Arches National Park.
Wesley Fortney

*View from the rim, at first light, of Bryce Canyon
National Park, Utah.*
Wesley Fortney

"Whatever you can do or dream
you can, begin it. Boldness has genius,
power and magic in it."

Johann Wolfgang von Goethe

Erosion patterns in rock strata, Arches National Park.
Wesley Fortney

25

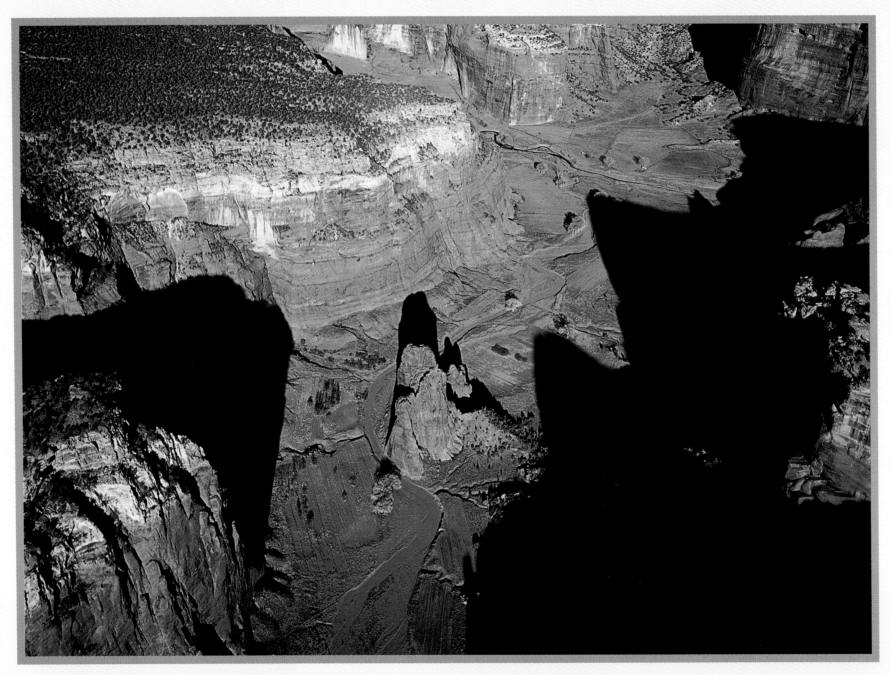

Canyon de Chelly, ancient home of the Anasazi, and of endless shadows.
Bill Fortney

PILOT'S LOG

Date: March 19
Location: Canyon de Chelly National Monument, Arizona
Flight time: 6:30 a.m. to 9:30 a.m. MST
Visibility: Clear
Conditions: Serious updrafts; very windy and rough
Base of operation: Page Airport
Field elevation: 4,310 feet MSL
Altitude: 4,310 to 8,500 feet MSL

This is the trip we unaffectionately call the "flight from hell."

The winds were very strong this morning, but I really wanted to shoot these locations. At first we thought, What a mistake! But then, even though the flight was a real, live "rock n' roll" show in the air, it worked out very well. We had nice light conditions and we found a number of very interesting subjects, so all is well that ends well. Translation: You get back to the home field alive!

Canyon de Chelly is one of the most beautiful of the Colorado Plateau's canyons. The area is still inhabited and farmed by the Navajos, in many ways much as it was for hundreds of years. These awesome canyons sheltered prehistoric Pueblo Indians for a thousand years and also served as an ancestral stronghold of the Navajo.

Just north, between the towns of Mexican Hat and Bluff, Utah, on the San Juan River, the striking chevron formations of Comb Wash gave us great delight. Finally, on our return loop, we saw some completely new views of Lake Powell.

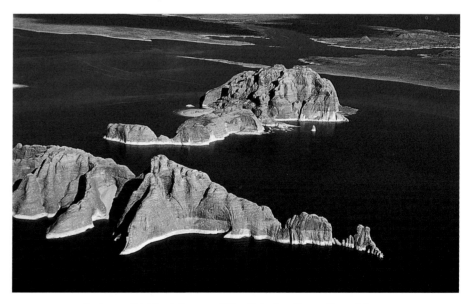

Rock monolith islands in a sea of blue, Lake Powell, near Page, Arizona.
Bill Fortney

PILOT'S LOG

Date: March 14
Location: Colorado Plateau, Arizona
Flight time: 2:30 p.m. MST
Visibility: Scattered clouds
Conditions: Thermal bumps, 65°F
Base of operation: Page Airport
Field elevation: 4,310 feet MSL
Altitude: 4,310 to 10,500 feet MSL

We got a break in the weather today and decided to try a whirlwind tour of the Colorado Plateau northwest of Page. In this land of endless canyons it is often necessary to fly in the middle of the day when the light finally reaches the canyon floor. Otherwise, early and late light produce photographs in which the canyons can seem to be a simple crack in the earth!

The light was amazing for our flight with Cris Widener and her Cessna 182. Our first stop on this 2½-hour flight was the stunning Zion National Park. I've photographed this park many times from the ground and found it spectacular, but frustrating to shoot.

Zion is so vertical that finding the right light is very difficult. From above it is wonderful!

From Zion we flew up to Bryce Canyon National Park with a short detour to Red Rock Canyon State Park. The snow covered the ground and the red rocks were even more dazzling than usual. Finally, on our return to Page we flew over the Paria Wilderness Area and had perfect light for photographing the Chinle formation shale. This was a bumpy flight due to the thermal activity off the earth's surface. The changing terrain added to the roller-coaster ride, but it was worth it.

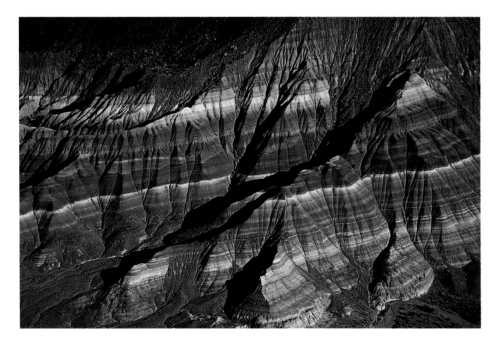

Chinle shale formations create a rainbow of color in the Paria Canyon Wilderness Area, southern Utah.
Bill Fortney

The majestic canyons of Zion National Park, Utah.
Bill Fortney

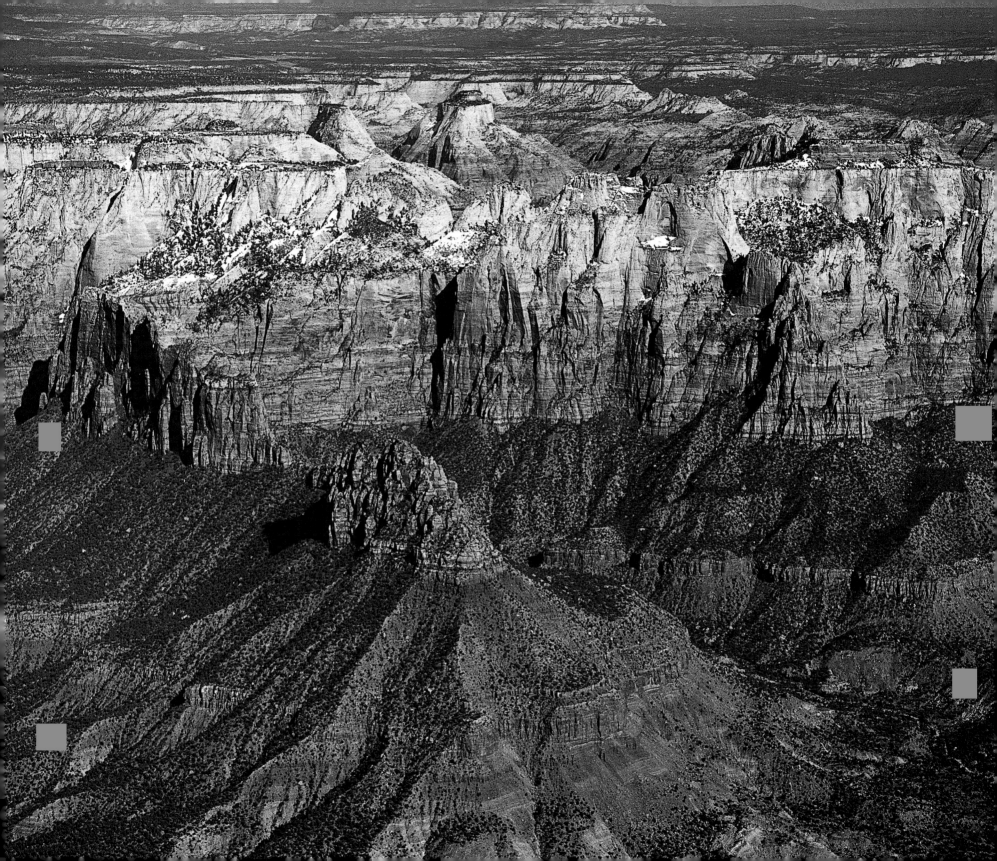

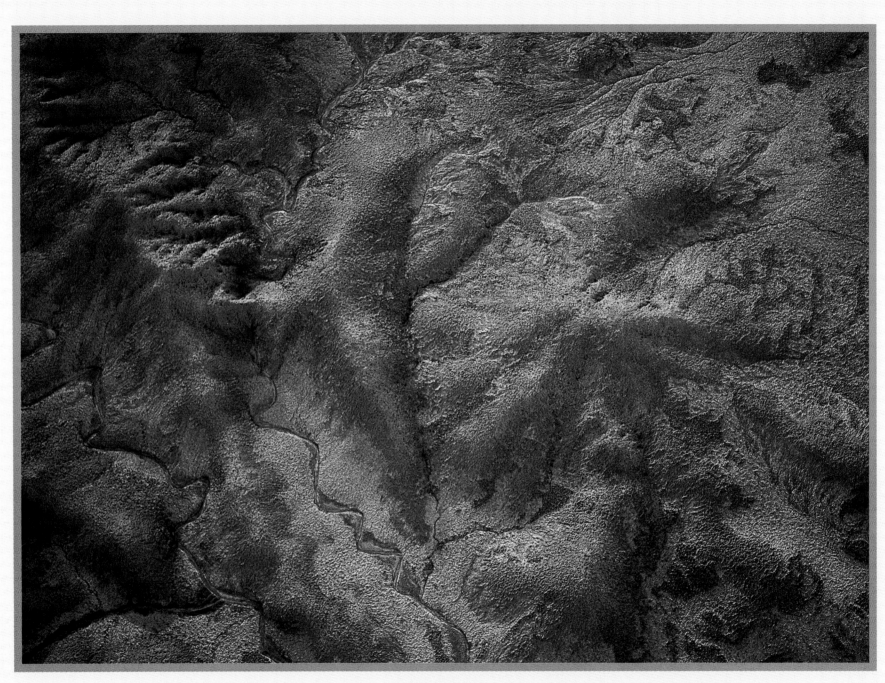

Mustard Canyon of Death Valley National Monument inherits its intense color from iron-based minerals and generous salt deposits.
Wesley Fortney

PILOT'S LOG

Date: March 23
Location: Death Valley National Park, California
Flight time: 5:50 a.m. PST
Visibility: Clear
Conditions: Calm winds, 51°F
Base of operation: Stove Pipe Wells Airstrip
Field elevation: 25 feet MSL
Altitude: 25 to 800 feet MSL

Sand dune patterns, near Stove Pipe Wells, California, in Death Valley National Park.
Bill Fortney

One of the best things about this project has been the people we've met across America. When we arrived at Death Valley the wind was blowing too hard for us to fly, so we decided to camp at Stove Pipe Wells and see what the morning would bring.

As often happens, a number of people asked about the sign on the trailer and what was in the trailer. Wesley and I never tire of telling people about the project but this evening held a real bonus. Four men who came over were all experienced pilots with a lot of knowledge about the area. As we talked they invited us to dinner and to visit around their campfire. They assured us the early-morning air would be calm and the skies clear.

They were right; it turned out to be a perfect morning to fly. I took off at 5:50 and the sun peaked over Funeral Mountains at 5:51! The light on the dunes was absolutely astounding and the conditions perfect. I shot a roll and a half while Wesley burned a few rolls just below me on the southeastern side of the dunes.

Death Valley. The name is so foreboding and gloomy.

Yet here in this valley, much of it below sea level, you can see spectacular wildflower displays, snow-covered peaks, beautiful sand dunes, abandoned mines, and the hottest spots in North America.

33

PILOT'S LOG

Date: April 11-12
Location: Death Valley National Park, California
Flight time: 6:00 p.m. and 5:45 a.m. PST
Visibility: Clear
Conditions: Hot and calm winds
Base of operation: Furnace Creek Airstrip
Field elevation: -211 feet MSL
Altitude: -211 to 800 feet MSL

Wesley and I have just returned from ten days off, me to go home and make sure I was still married—gratefully I was. And Wesley to hike and camp in the Grand Canyon with friends. On our way to the green hills of California we decided to visit one more location in the area. We stayed at Furnace Creek Lodge. Unlike our visit of only a couple weeks ago the days were now turning hot, with high 90s during the afternoon, and even the nights have not cooled down. The air was calm and the flying was the best yet!

We discovered more of the magic of Death Valley as we flew over eroded hills, salt flats, and textures of every kind.

In spite of the heat we were treated to a natural history display unlike any other we've seen in America. If you decide to visit, try March or November for the most comfortable daytime temperatures. Whenever you visit, you will find it an adventure to remember for a lifetime. ⟩

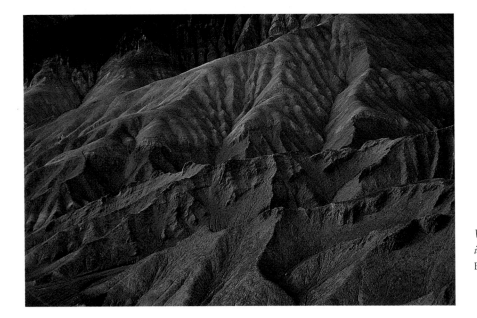

Volcanic ash and lake sediments create the bands of color in the hills above Artists Point in Death Valley.
Bill Fortney

Countless hills and valleys in the sand dunes of Death Valley National Park.
Bill Fortney

34

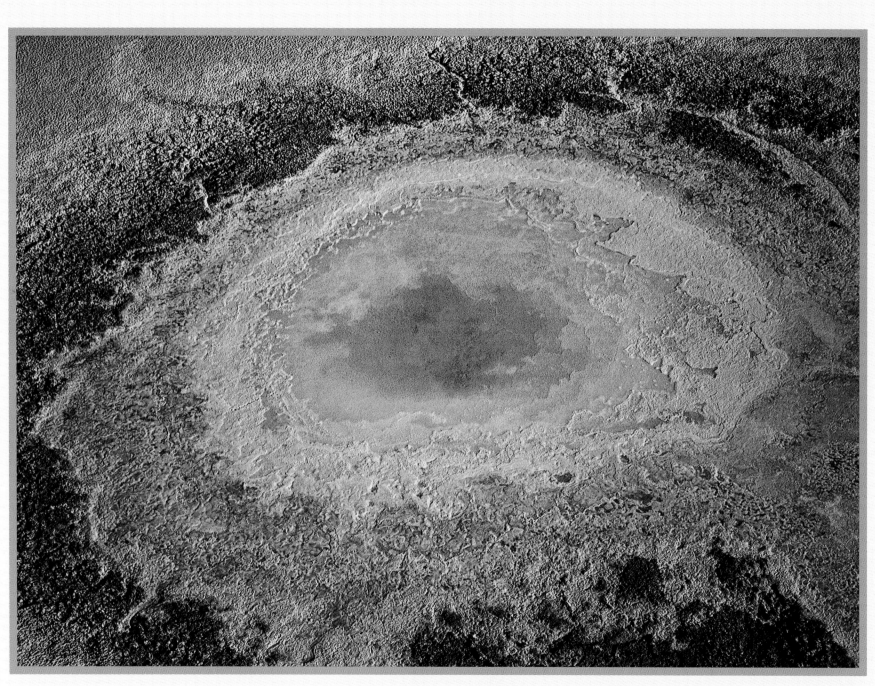

Bacteria in a thermal pool with salt sediments, Furnace Creek, Death Valley National Park.
Bill Fortney

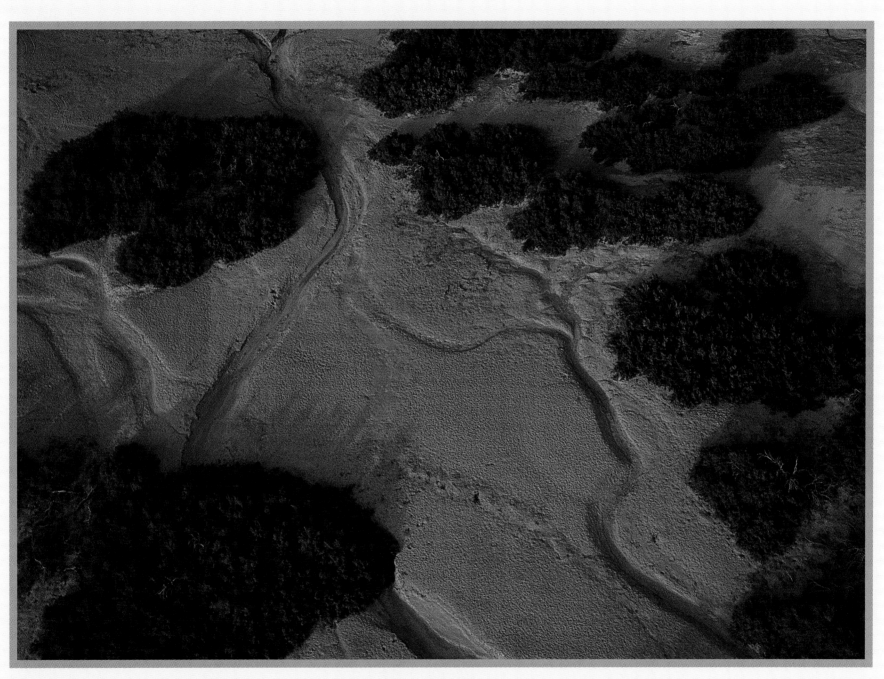

Very little grows on the floor of Death Valley, but when the rains come the honey mesquite hold on and flourish.
Bill Fortney

PILOT'S LOG

Date: October 24
Location: The Grand Staircase—
Escalante National Monument, Utah
Flight time: 6:30 a.m. MDT
Visibility: Clear
Conditions: Smooth air
Base of operation: Page Airport
Field elevation: 4,310 feet MSL
Altitude: 4,310 to 5,600 feet MSL

A perfect morning to fly in a perfect place to do it!

Wesley and I climbed aboard a Hughes 500E helicopter with Jim Wurth to explore the Escalante Staircase region, especially around the area of Coyote Buttes Wilderness Area and the town of Big Water. Flying at barely over 500 feet we saw one intricate pattern after another. The canyons were deep in shadows but the crests of cliff sides glowed deep orange and amber in the early light. Millions of years of water and wind erosion have carved this region into a dizzying array of swirling sandstone lines.

The Grand Staircase—Escalante National Monument is 1.7 million acres of multicolored cliffs, plateaus, mesas, buttes, pinnacles, and canyons. This glorious geological formation runs through the Colorado Plateau. Named a national monument in the late 1990s, it will now be preserved for posterity. ⟩

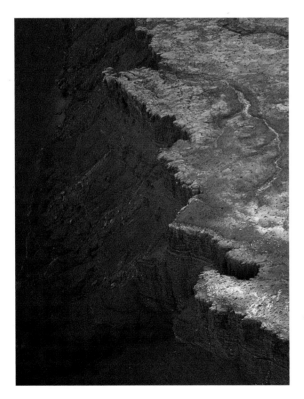

Dappled light on the canyon wall edges at
Vermilion Cliffs, along the Colorado River in Arizona.
Bill Fortney

Wesley photographing from atop one of the conical formations in
Coyote Buttes, Escalante Grand Staircase, Utah.
Bill Fortney

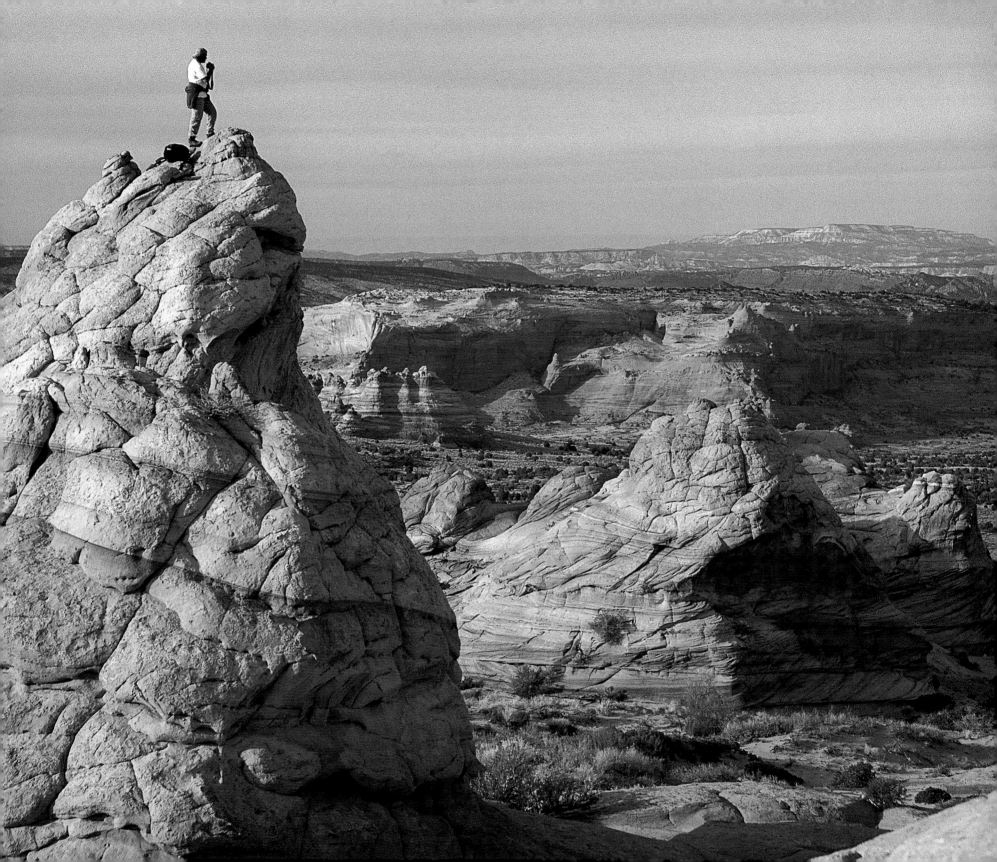

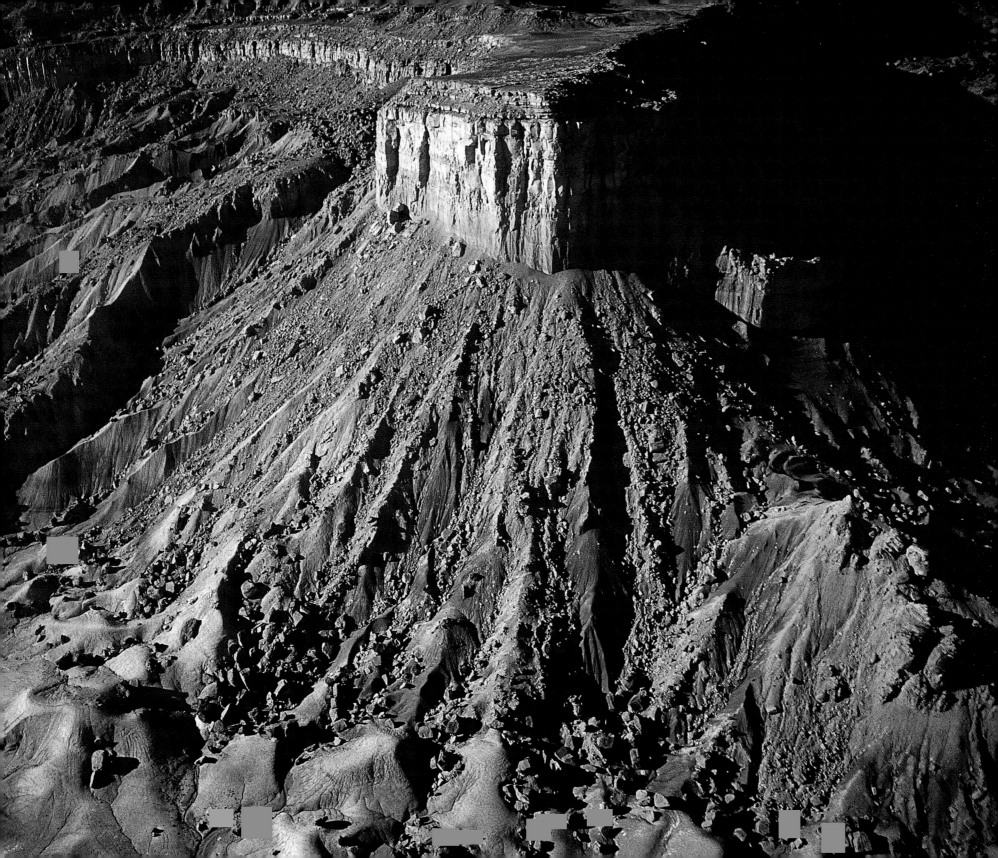

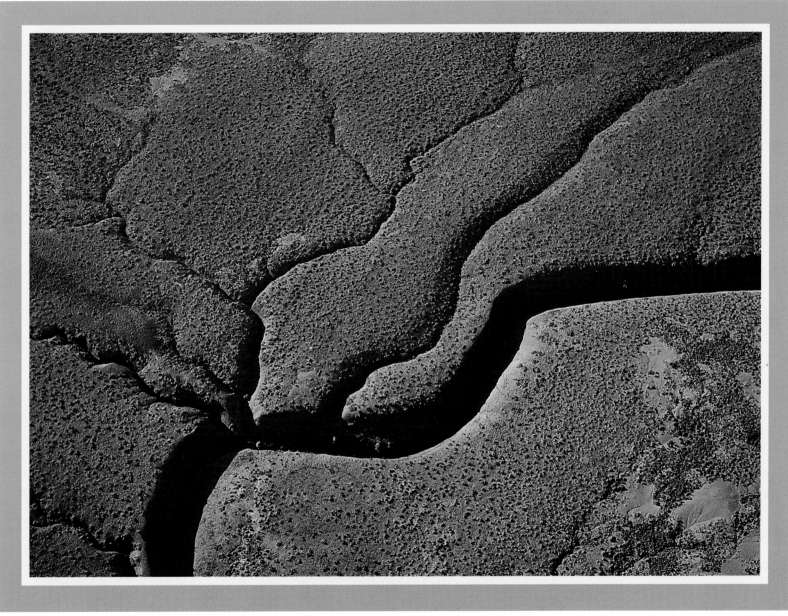

Erosion lines in the valley floor at Escalante Grand Staircase, Utah.
Bill Fortney

From any angle, the bluffs in Glen Canyon National
Recreational Area are awe inspiring. Near Page, Arizona.
Bill Fortney

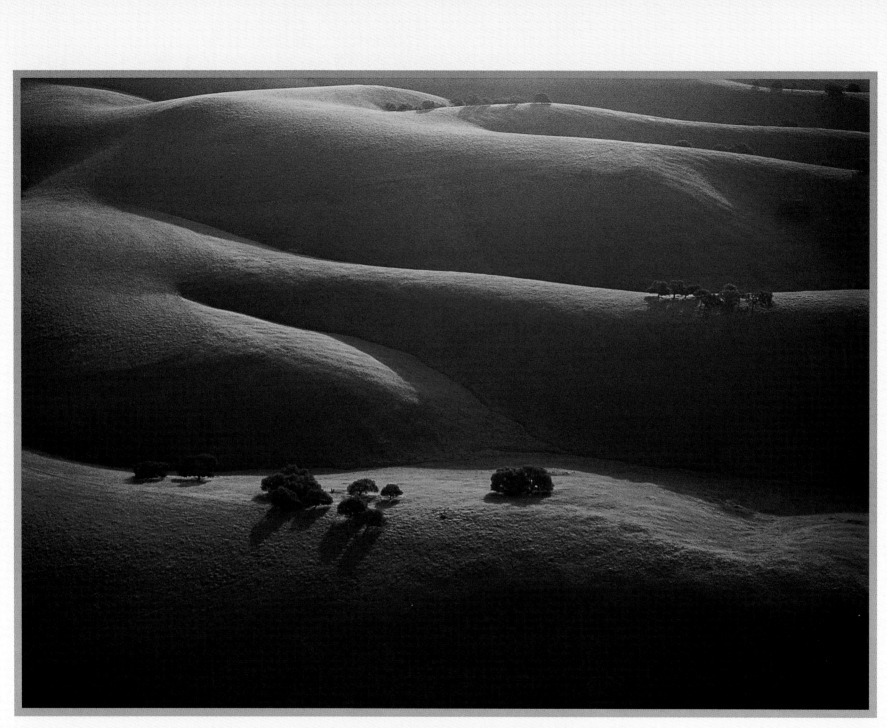

Soft, rolling Hombre Hills and some oak trees near Bradley, California.
Bill Fortney

PILOT'S LOG

Date: April 22
Location: Hombre Hills near Bradley, California
Flight time: 6:15 a.m. PDT
Visibility: Low broken clouds
Conditions: Moderate wind, mild temperatures
Base of operation: Old Highway 101
Field elevation: 922 feet MSL
Altitude: 922 to 2,500 feet MSL

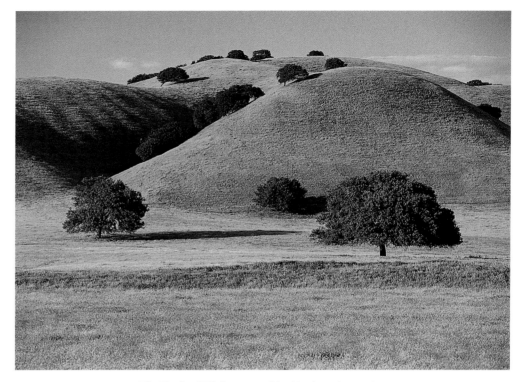

The Hombre Hills from ground level in the early morning.
Wesley Fortney

The closest airport to our intended shoot location was very near a military base, not a good choice for a low, slow-flying ultralight. Instead, we found a stretch of old Highway 101 that was, for all practical purposes, deserted. After we sat on the side of the road and counted thirty-five minutes between two cars that came along, we decided the traffic wouldn't keep us from safely taking off. So we jumped into the air for a great flight around the wonderful Hombre Hills.

It has been our routine that Wesley shoots the first light on the ground while I fly. Then, immediately on my landing, he heads up to a higher altitude than I flew to see what the light is doing over the terrain from a different perspective.

This method has allowed us to get lots of varied shots within the best 1½ hours of first light.

Our work is often very different and that makes for a great comparison between our two "feels" of a landscape.

PILOT'S LOG

Date: October 20
Location: Page, Arizona
Flight time: 8:00 a.m. MDT
Visibility: Clear
Conditions: No wind, 55°F
Base of operation: Stan Burman's house in Green Haven
Field elevation: 4,310 feet MSL
Altitude: 4,310 to 5,000 feet MSL

If you're going to fly over the clear blue waters of Lake Powell in the Glen Canyon National Recreation Area you couldn't do better for a pilot and a craft than Jim Wurth and his Hughes 500E helicopter.

Jim is a retired Eastern Airlines front-line captain with many years of experience. When Jim retired he decided to try his hand—actually both hands and both feet—at flying helicopters. If you don't already know, learning to fly a helicopter is very different from flying airplanes. Jim says, "I thought I would breeze through the training. But after my first 25 minutes I was wringing wet with sweat. In many ways it was like starting all over again!" After a couple hundred hours, Jim mastered his new craft, and he showed his stuff for us this morning.

Glen Canyon National Recreation Area was developed by the Bureau of Reclamation in 1972. Lake Powell and the surrounding desert and canyon areas cover more than a million acres. At the lowest point, the main channel is over 580 feet deep.

The blue water and contrasting Navajo sandstone make for unusual graphic color contrasts, lines, and forms.

Moonrise over Lake Powell.
Bill Fortney

Geology and erosion weave a complex pattern along the shores of Lake Powell.
Bill Fortney

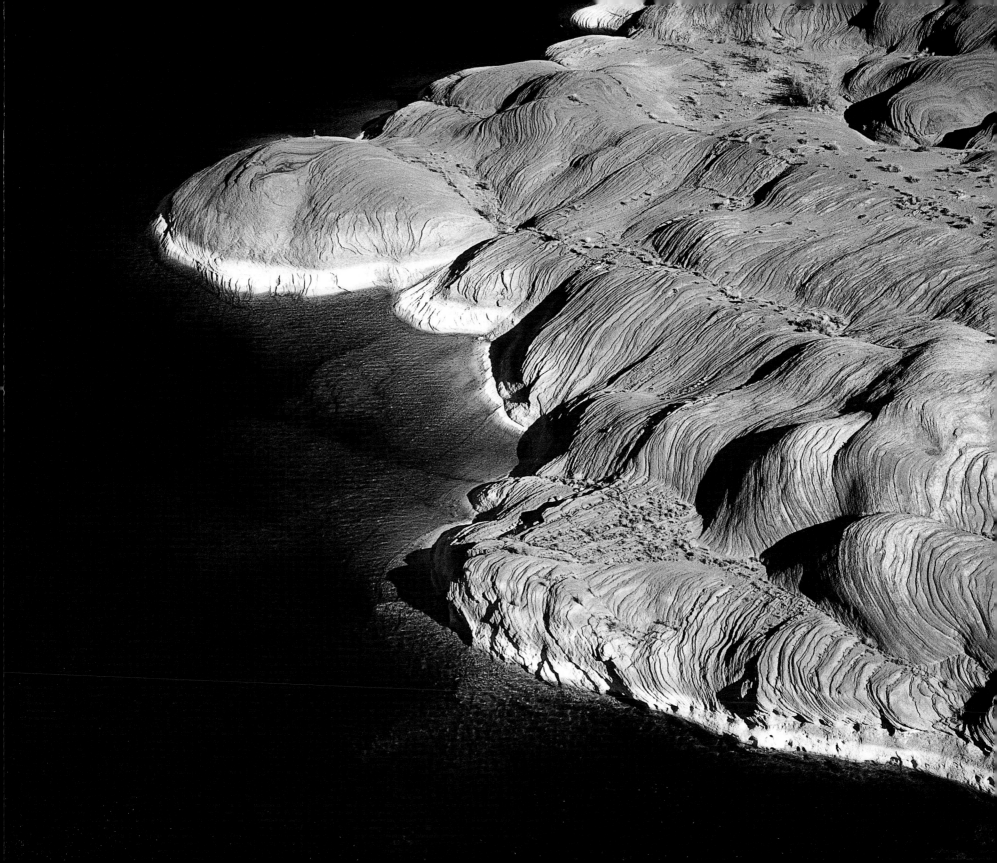

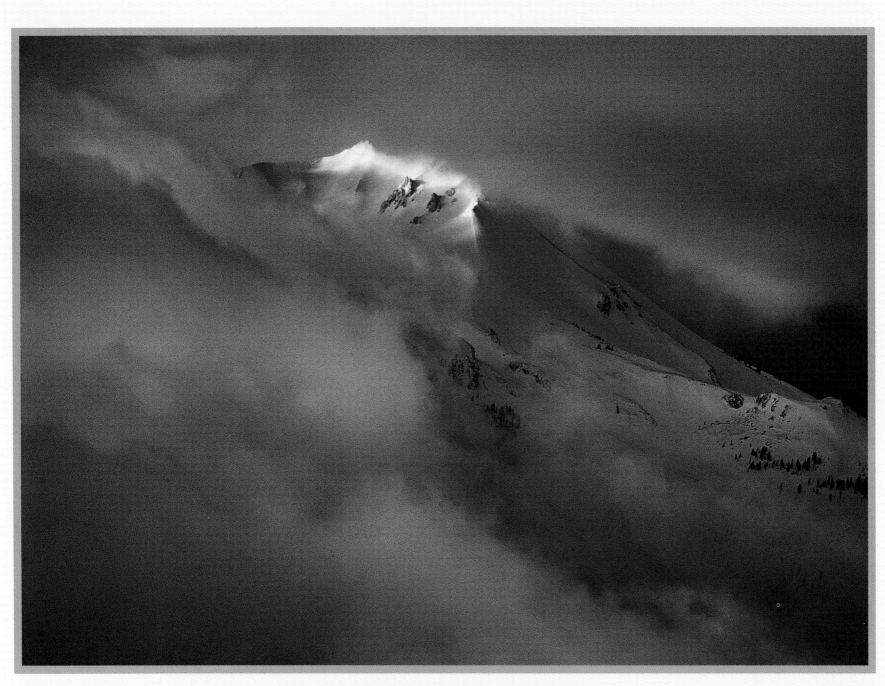

Lassen Peak in clouds and snow, Lassen Volcanic National Park, California.
Bill Fortney

PILOT'S LOG

Date: April 14
Location: Lassen Volcanic National Park, California
Flight time: 6:00 a.m. PDT
Visibility: Clouds and intermittent light rain and snow
Conditions: Light winds, mild turbulence
Base of operation: Rogers Field, Chester Airport
Field elevation: 4,525 feet MSL
Altitude: 4,525 to 10,000 feet MSL

Dense forest area in Lassen Volcanic National Park.
Bill Fortney

In May of 1914 Lassen Peak erupted, beginning a seven-year period of sporadic volcanic outbursts. The climax of this episode took place in 1915, when the peak blew an enormous mushroom cloud some seven miles into the stratosphere. The reawakening of this volcano, which began as a vent on a larger extinct volcano known as Tehama, profoundly altered the surrounding landscape. The area was made a national park in 1916 because of its significance as an active volcanic landscape.

*The park is a compact laboratory of volcanic phenomena
and associated thermal features.*

As we flew over Lassen Peak all was quiet and covered in fresh snow, which Wesley had photographed the evening before. The majestic peaks, forcing their way through the remnant storm clouds, gave a feeling of the lasting solidity of this range. We were told that when Mount Saint Helens erupted, the lessons previously learned about reforestation and recovery at Lassen were extremely valuable.

The value to us of this early-morning flight was the simple yet extraordinary majesty of this park. Lassen is probably one of the least visited national parks. It's a shame that so many are missing so much. ✐

Date: March 24
Location: Lone Pine, California
Flight time: 5:55 a.m. PST
Visibility: Broken clouds
Conditions: Light wind, 3 knots
Base of operation: Lone Pine Airport
Field elevation: 3,680 feet MSL
Altitude: 3,680 to 4,900 feet MSL

Lone Pine is the small hamlet just east of the Sierra Nevadas' highest peak, Mount Whitney, and the famous Alabama Hills that lie at the base of the rugged Sierra Nevada range. The Alabama Hills have been the site of many western films with stars from Roy Rogers and Gene Autry to Clint Eastwood. On this morning there was a thin veil of clouds subduing the early-morning light, but we still had a magnificent view of the rocky hills at the base of the stately group of peaks.

Once you leave the deserts of Nevada these mountain ranges come one after another, each reaching farther into an azure-blue sky.

This part of California is as rugged and beautiful as any country I've ever seen. The Sierra Nevada Mountains are among the most rugged and beautiful of all our peaks.

Rock formations in the Alabama Hills, near Lone Pine, California.
Wesley Fortney

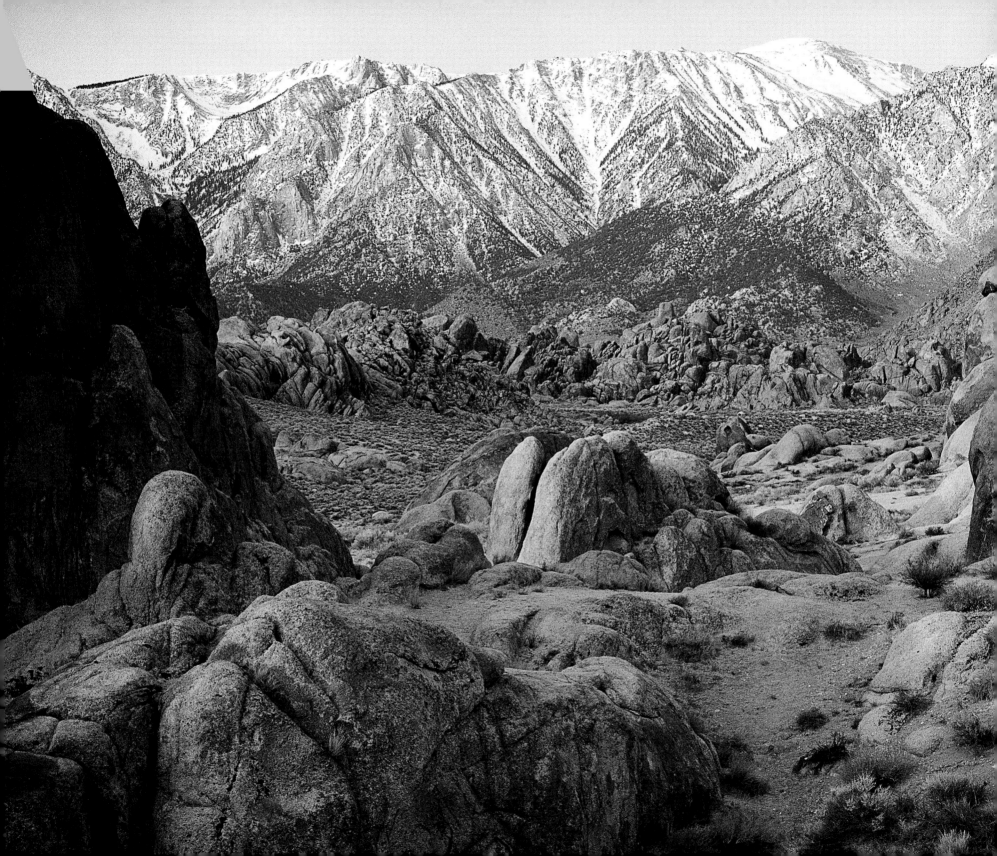

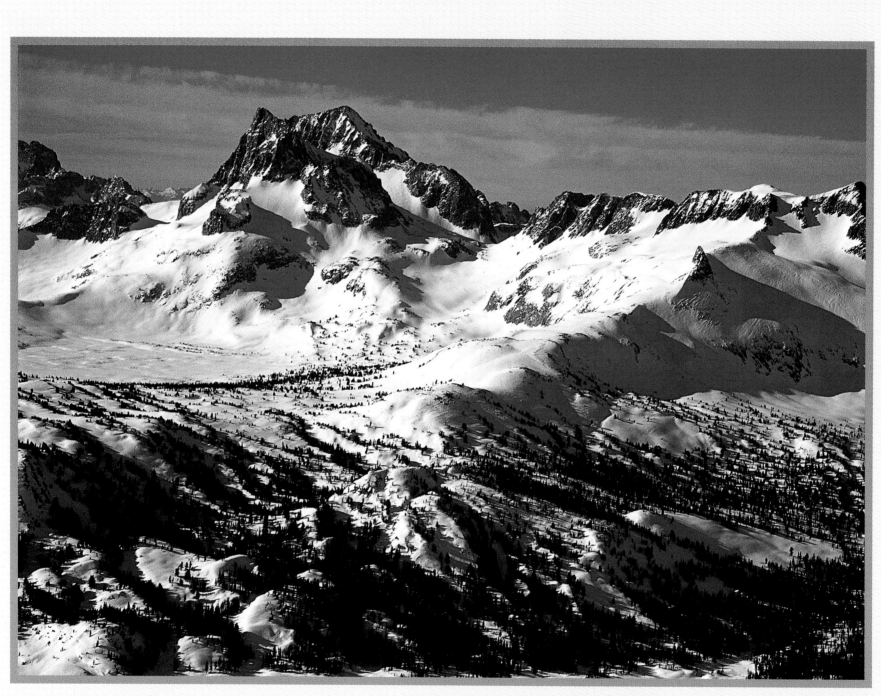

Snow-covered High Sierra Range in northern California.
Bill Fortney

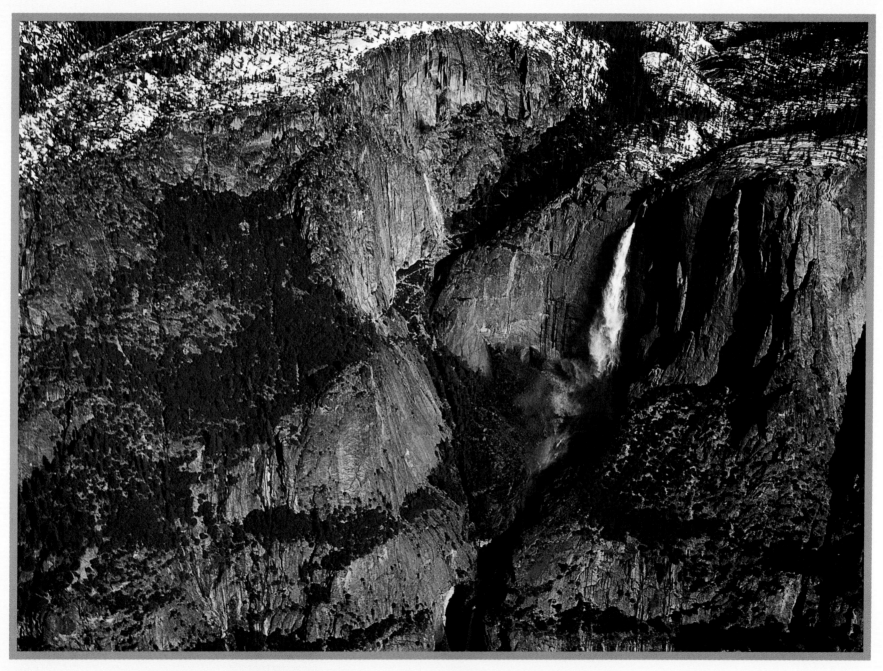

Yosemite Falls with the prismatic effect of early light, Yosemite National Park, California.
Bill Fortney

Date: March 25
Location: Mono Lake Tufa State Reserve, California
Flight time: 6:10 a.m. PST
Visibility: Clear, with very light winds
Conditions: 21°F
Base of operation: Lee Vining Airport
Field elevation: 6,802 feet MSL
Altitude: 6,802 to 8,000 feet MSL

What a thrill to fly out of an airstrip with a field elevation of almost 7,000 feet! Add to that the beauty of Mono Lake and the exhilaration of a -20°F windchill, and you have a lasting memory or two.

Mono Lake's tufa towers are spectacular examples of what nature can do with a few basic elements. These unusual spires and knobs are formed when calcium-bearing freshwater springs happen to well up through alkaline lake water, which is rich in carbonates. The calcium and carbonates combine, precipitating as limestone. Over many years, a tower forms around the mouth of the spring. This tufa-forming reaction happens only in the lake itself. As the lake level drops and exposes the tufa towers, they cease to grow.

This is a great way to spend a morning, even if your fingers feel frozen solid!

As I flew over the tufa towers in the early-morning light, with the Sierra Nevadas as a backdrop, I found myself filled with the feeling of awe that so often has overtaken me as I've seen such wonders of nature.

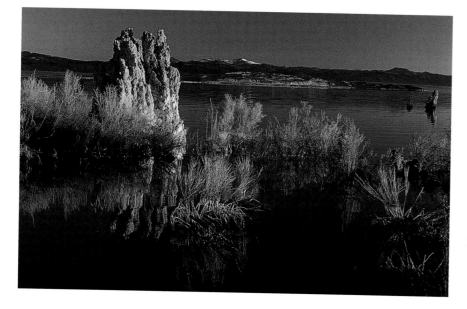

Tufas at sunrise in Mono Lake, near Lee Vining, California.
Bill Fortney

First light on the Sierra Range at Mono Lake.
Bill Fortney

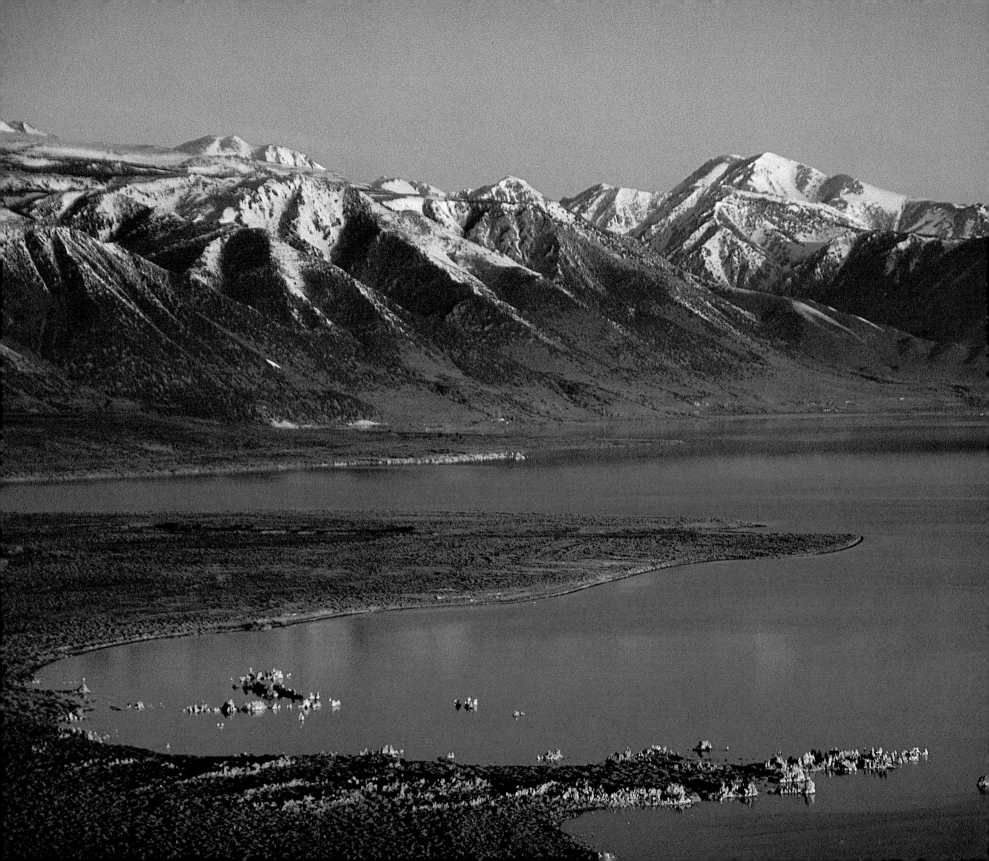

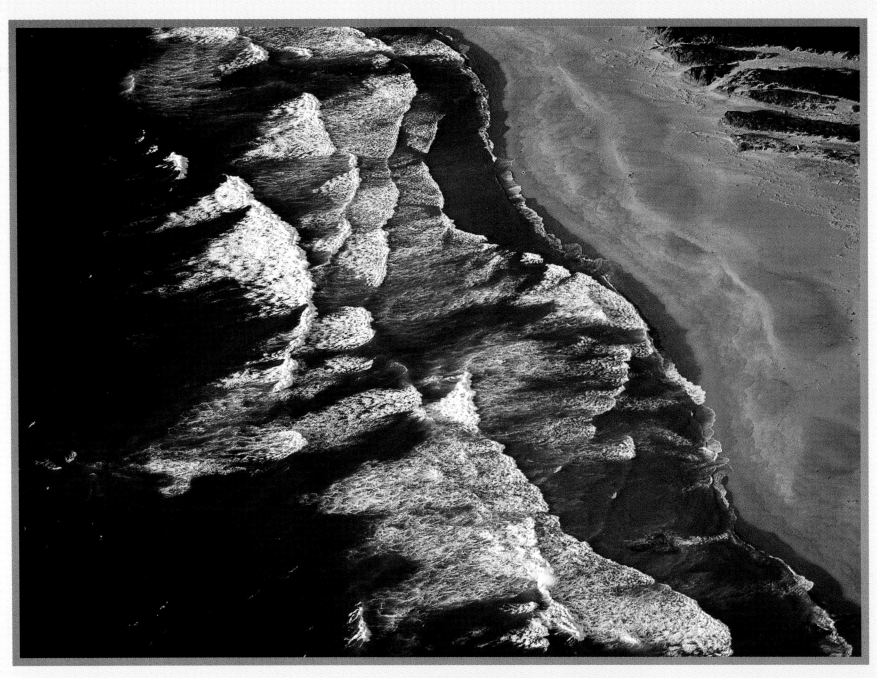

The pounding surf of the Big Sur coast near Monterey.
Bill Fortney

PILOT'S LOG

Date: April 21
Location: Big Sur coast, California
Flight time: 6:18 p.m. PST
Visibility: Clear
Conditions: Very gusty winds
Base of operation: Monterey Peninsula Airport
Field elevation: 254 feet MSL
Altitude: 254 to 2,000 feet MSL

Slipping along the Big Sur coast I wondered if any place on Earth is more beautiful than where the sea meets the land. The coastal mountains with their lush grasses dive into steep ridges ending in rocky coastline. The wind was strong and we often had to fly off course to get out of a strong north wind along the coast. In spite of the rough nature of the flight, what took my breath away most was the scenery!

What we affectionately call the Big Sur coast is 200,000 acres—along 90 miles—of premium California landscape. It is such raw, bold beauty. Thankfully it has been protected. It's one of this country's most honored treasures.

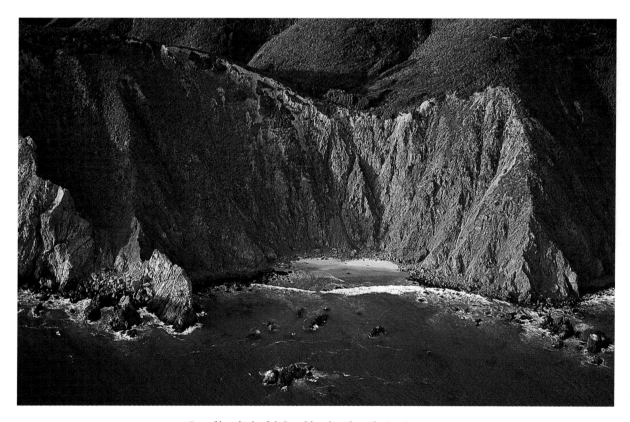

One of hundreds of sheltered beaches along the Big Sur coast.
Bill Fortney

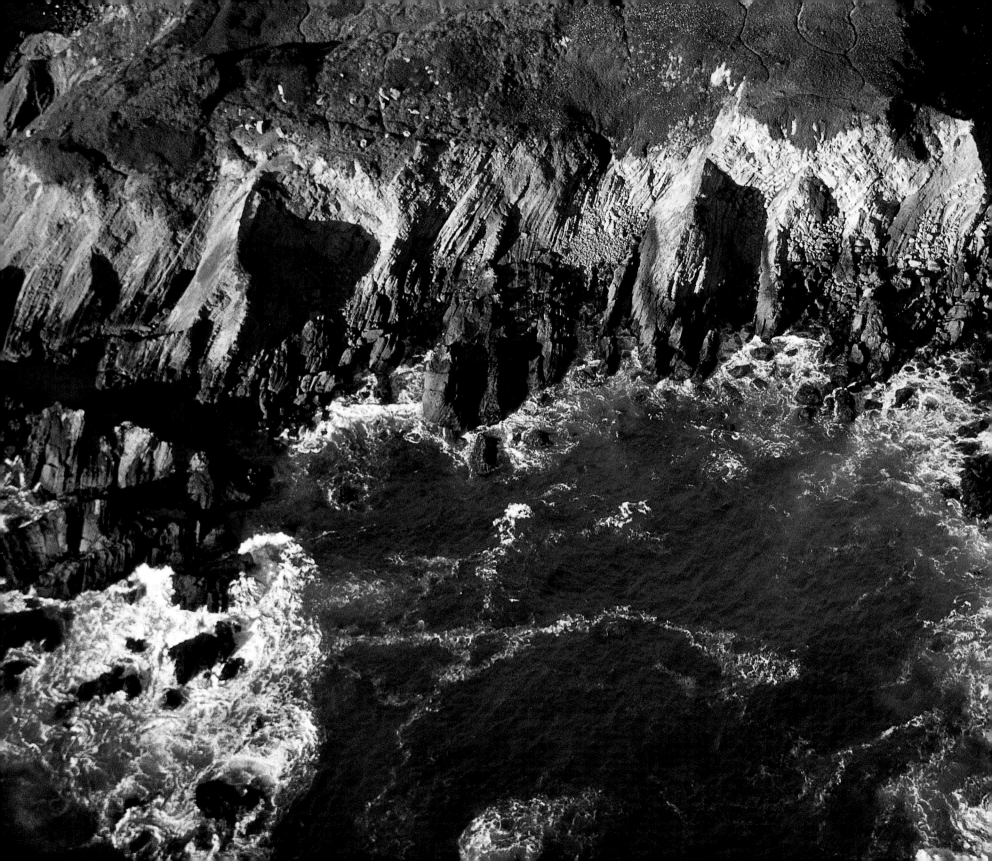

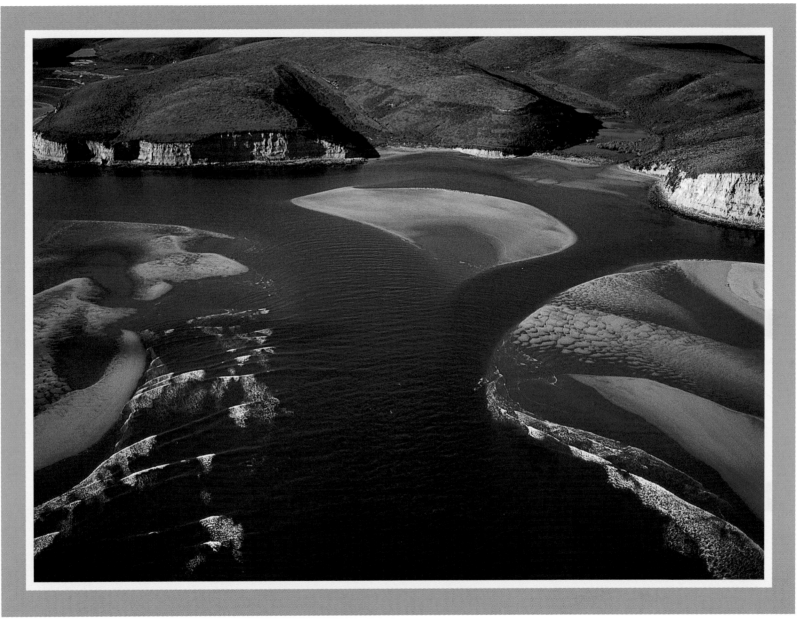

Sand bars and inlet in evening light, Point Reyes National Seashore, California.
Bill Fortney

Typical rugged coastline in the Monterey area of the Big Sur coast.
Bill Fortney

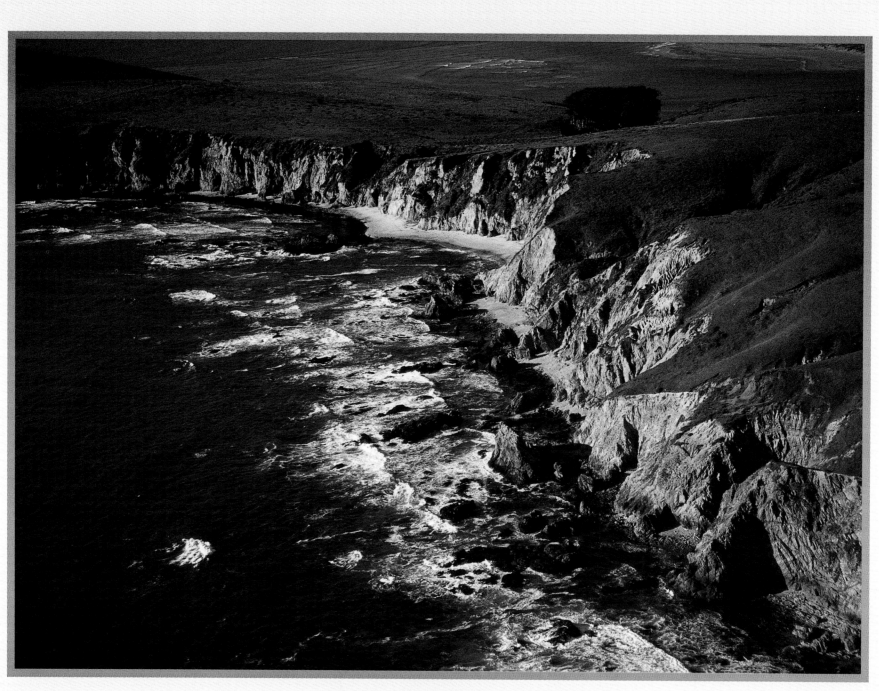

Point Reyes National Seashore's rugged coastline.
Bill Fortney

"Once again I am roaring
drunk with the lust of life
and adventure and unbearable beauty . . .
Adventure seems to beset me on all quarters
without my even searching for it . . .
Though not all my days are as wild as this,
each one holds its surprises and I have seen
almost more beauty than I can bear . . ."

Everett Ruess, *Wilderness Journals*

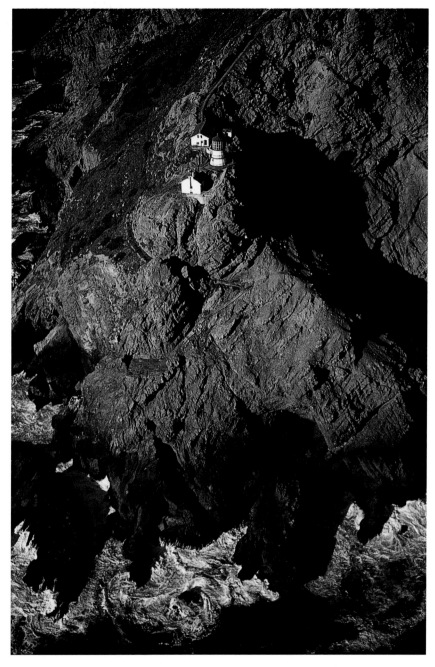

Point Reyes Lighthouse, Point Reyes National Seashore, California.
Bill Fortney

Farming pattern in the fertile valley inland from the Big Sur coast at Monterey, California.
Wesley Fortney

The unique and very deep hillside ravines along the Big Sur coast.
Bill Fortney

PILOT'S LOG

Date: October 23
Location: Monument Valley Tribal Park, Arizona
Flight time: 4:30 p.m. PDT
Visibility: Partly cloudy, slight haze
Conditions: 10 knot wind
Base of operation: Page Airport
Field elevation: 4,310 feet MSL
Altitude: 4,310 to 9,500 feet MSL

When I first decided to do this book a pilot friend and one of my first instructors, John Kemmeries, told me about a special he had seen on Arizona public television. The program featured a pilot who had taken up aerial photography and was already doing what I was planning to do. A few weeks later a videotape arrived in the mail containing the TV special that featured Adrial Heisey. It was a turning point in the project for me. I just knew that the photographic opportunities from the air would be wonderful. Adrial's work proved it to me.

This ancient land, rich with Indian heritage, is a blessing to experience, especially from the air.

All of Adrial's work was stunning, but one shot of Monument Valley was my favorite. As Cris Widener (in her Cessna 172) flew me from Page to the Tribal Park I was haunted by that image. I worried that the light would not be right or that we would not be able to get the angles that worked. I didn't want to copy Adrial's shot, though it was so impressive I would love to have a similar shot as my own.

Once we got on location and started to make turns around the formations, I started to see lots of great shots. In only twenty minutes over the park I shot nine rolls! The image with the deep, long shadows and the expanse of the valley was my favorite.

Monument Valley Tribal Park bathed in the last light of the day.
Bill Fortney

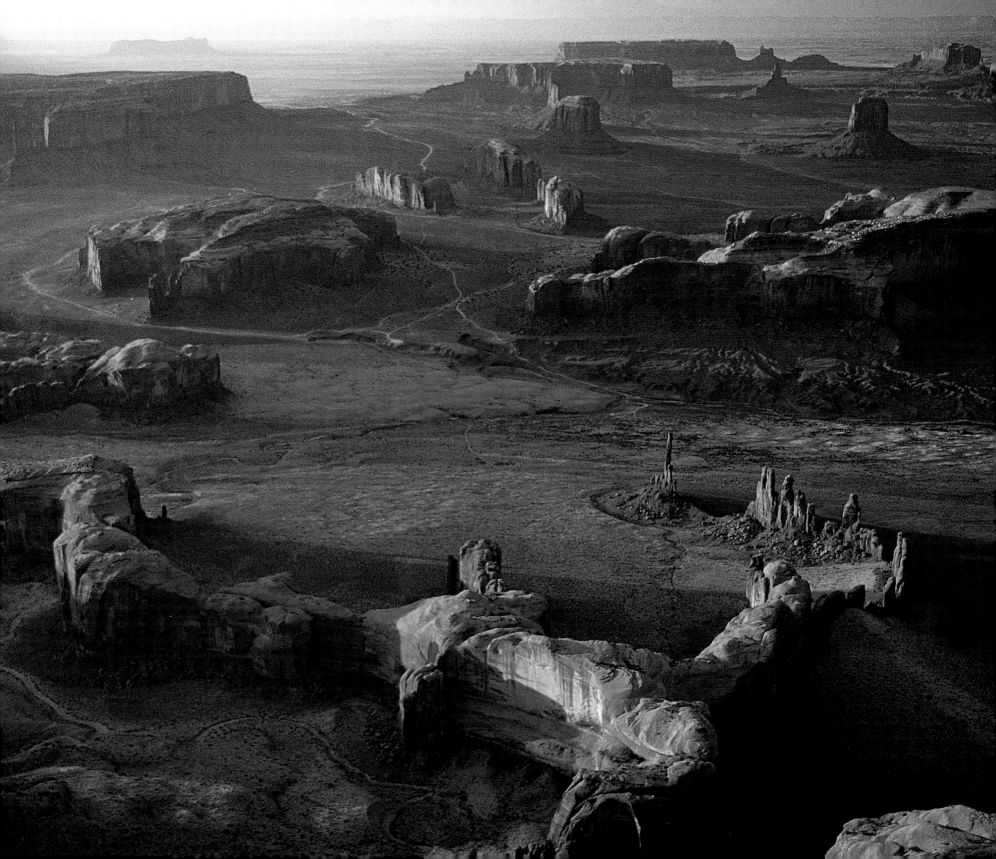

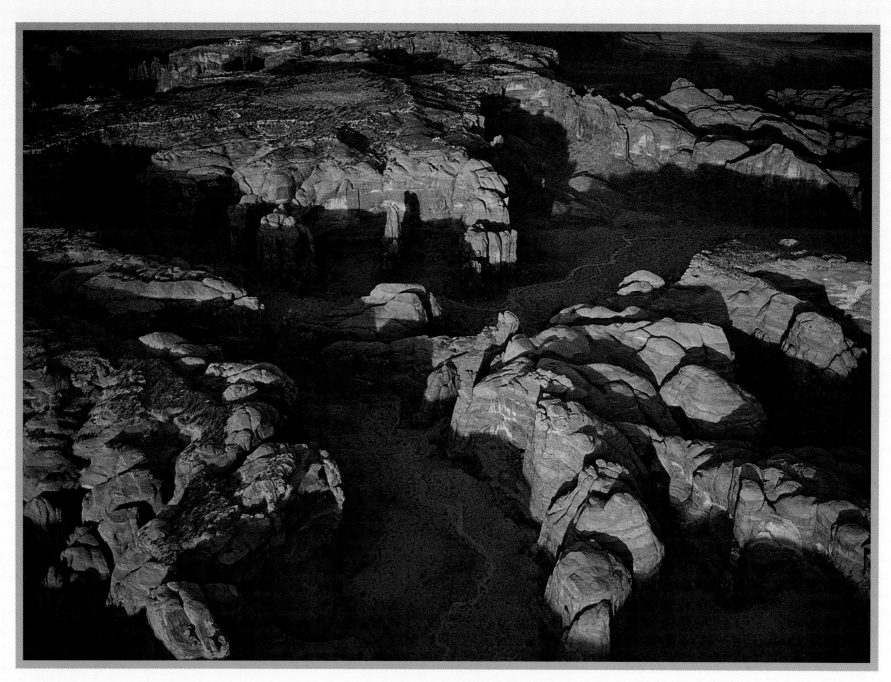

Canyons in Monument Valley Tribal Park at sunset.
Bill Fortney

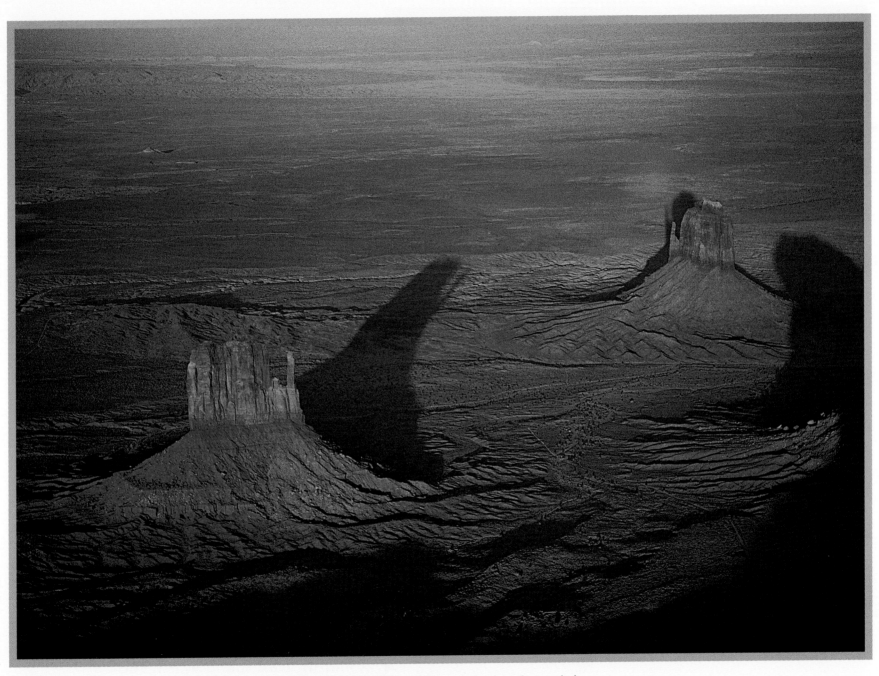

The "mittens" of Monument Valley, with their long afternoon shadows.
Bill Fortney

PILOT'S LOG

Date: June 26
Location: Rialto Beach, Olympic National Park, Washington
Flight time: 8:10 p.m. PDT
Visibility: Clear
Conditions: Moderate, gusty winds up to 12 knots
Base of operation: Quillayute State Airport
Field elevation: 194 feet MSL
Altitude: 194 to 2,600 feet MSL

Over sixty miles of Pacific Ocean coastline grace the western border of Olympic National Park.

This rugged coast has remained virtually unchanged since the first European explorers arrived, except for the constant impact of the pounding surf and storms.

The closest airport to this great coastline was a World War II air base. Now only used by the occasional pilot passing through, the buildings were all falling down, except for an NOAA weather station.

The runways were very large; they must have trained bomber crews here in years past. The tarmac area was plenty large to serve as a main runway for us. This airport reminded me of an old ultralight joke: An ultralighter was once asked what he thought of the massive runway at an international airport where he had just landed with permission. His response? "Well, to be honest I thought the runway was just a tad short, but unbelievably wide!"

This was a great flight and the scenery was nothing short of spectacular.

Once in the air I flew for almost twenty minutes over very thick forest until the coastline appeared below. I've photographed this coastline a number of times from the shore, but this was a new and gratifying experience seeing it from about 800 feet MSL.

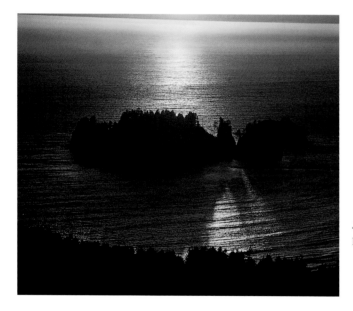

Sea stacks along the coast at Olympic National Park, Washington.
Bill Fortney

Last light on the tips of trees in a forested area near Rialto Beach, Olympic National Park.
Bill Fortney

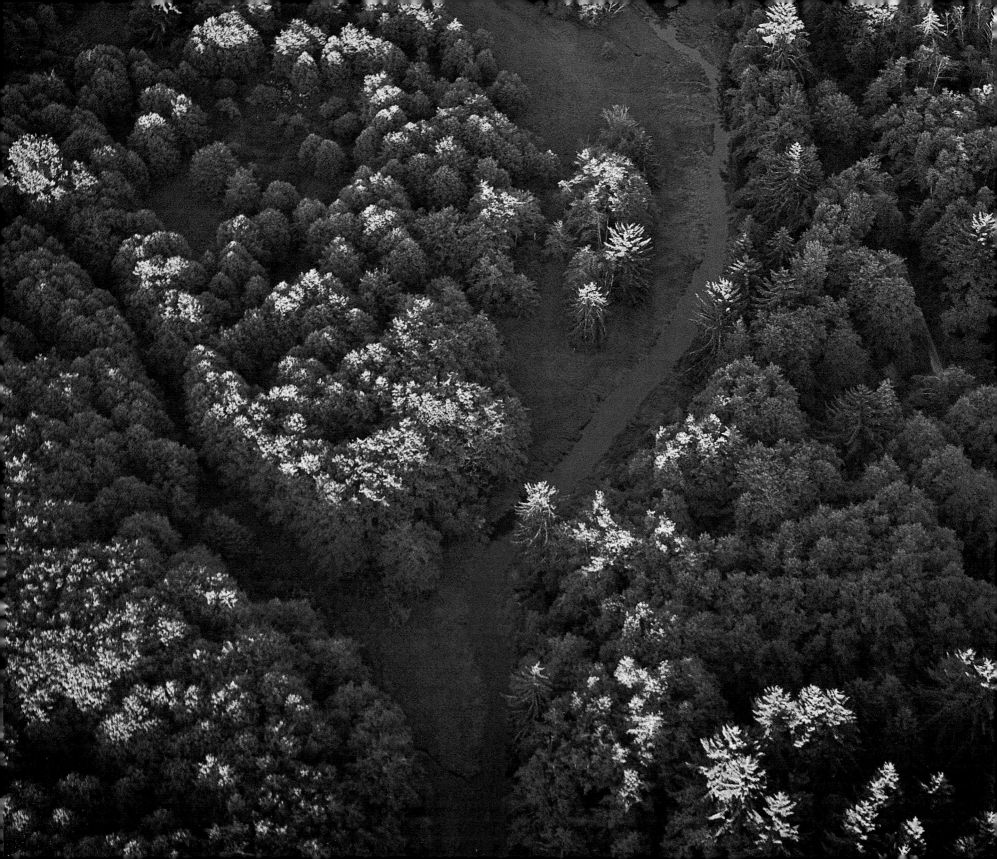

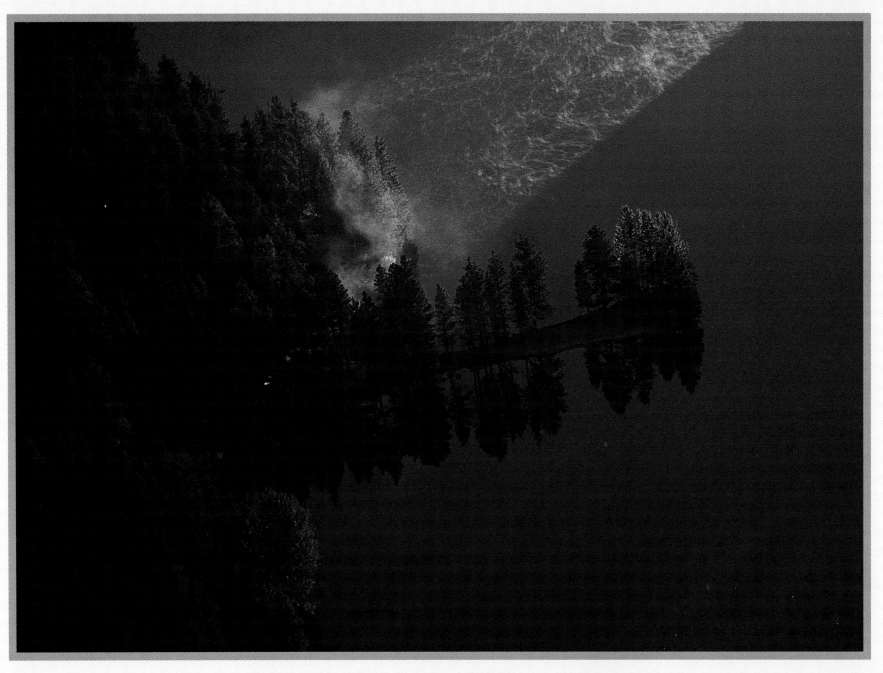

Rays of the first light of the day strike a tree line at Rimrock Lake State Park, Washington.
Bill Fortney

PILOT'S LOG

Date: June 24
Location: Rimrock Lake near Mount Rainier, Washington
Flight time: 5:30 a.m. and 8:30 p.m. PDT
Visibility: Clear
Conditions: Calm
Base of operation: Tieton Airstrip
Field elevation: 2,961 feet MSL
Altitude: 2,961 to 6,300 feet MSL

When Wesley and I started this project I have to admit that one fantasy I had about our flying was taking off from a runway in a wooded area with a lake at the end of the runway. This was it! This beautiful airport, maintained by the state of Washington, is a dream of an experience. And even better, we discovered a group from the Northwest Antique Aircraft Flyers club had flown in for an overnight camping trip.

It was wonderful to sit around the campfire and trade flying stories with some real great folks.

When the morning came Wesley was first up for a high-flying trip to capture the first light to fall on Mount Rainier, which was only about fifteen miles away. Wesley was fortunate on a number of fronts—it was clear, the light was great, the winds calm, and his hand steady! His images and my later ones attest to what a wonderful time we had this morning. ➤

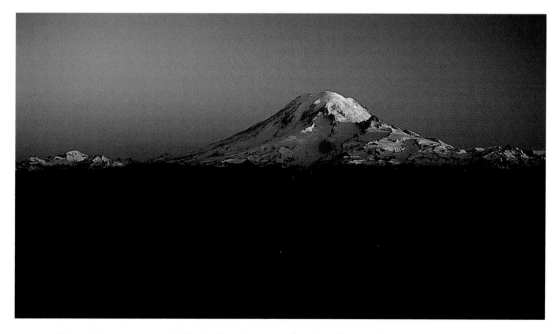

Majestic Mount Rainier at daybreak. Shot from 5,000 feet above the ground at Rimrock Lake State Park.
Wesley Fortney

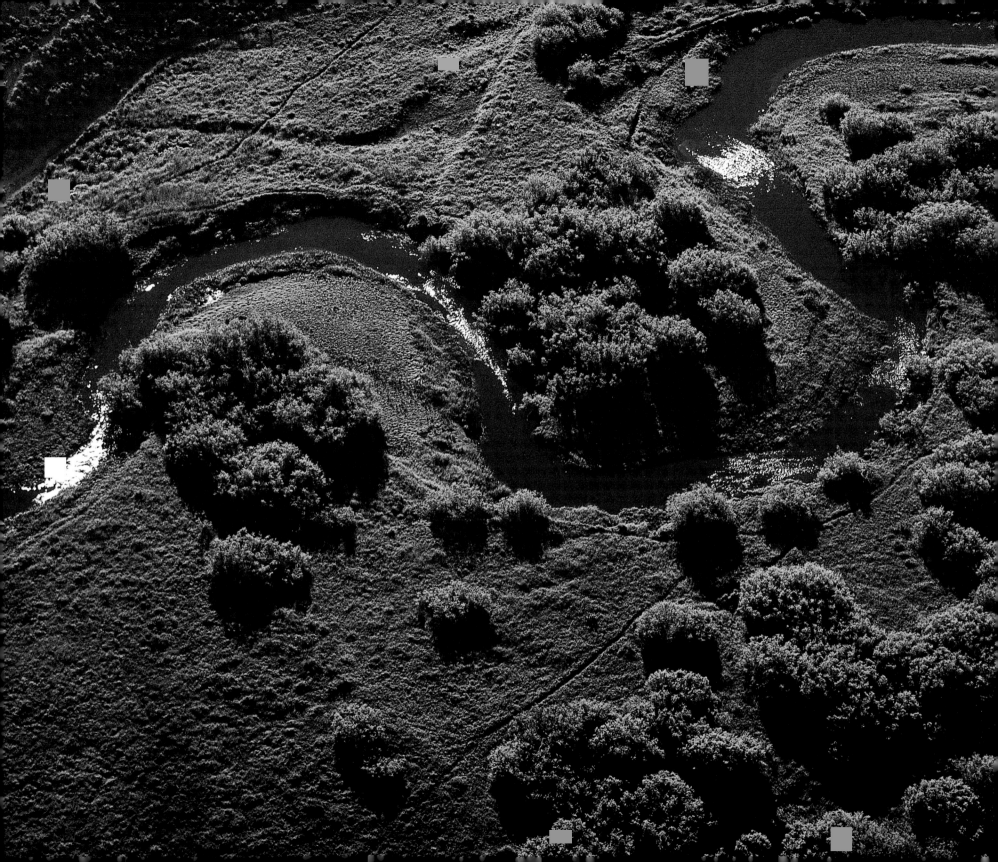

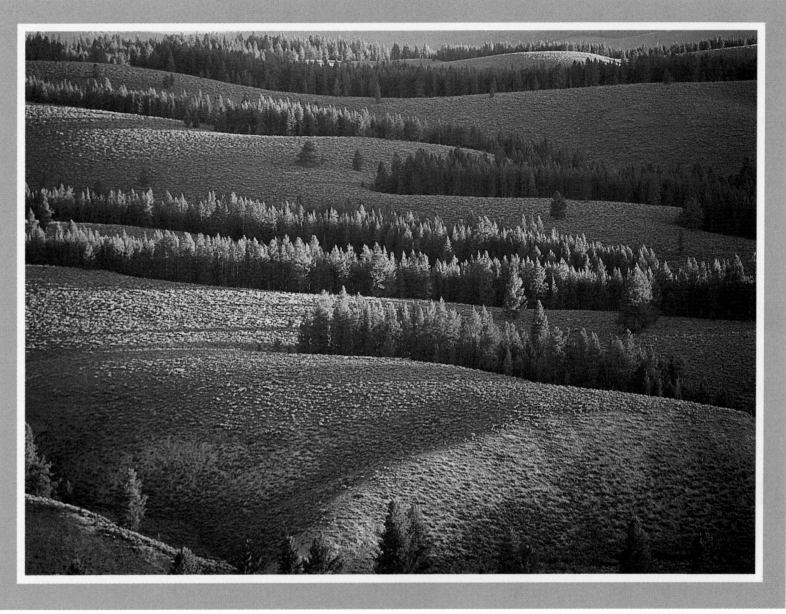

Rows of pine trees on a bare ridge in the foothills of the Sawtooth Range, Idaho.
Bill Fortney

Light reflections off a stream in the Sawtooth Region
of the Rockies in Idaho.
Bill Fortney

PILOT'S LOG

Date: June 22
Location: Sawtooth National Recreation Area, Idaho
Flight time: 6:00 a.m. MDT
Visibility: Clear with clouds
Conditions: Calm
Base of operation: Stanley Airport
Field elevation: 6,370 feet MSL
Altitude: 6,370 to 9,500 feet MSL

As we took off from a grass field right above Stanley, Idaho, the immediate view of the expansive woods leading to the majestic Sawtooth Range was awe inspiring! Wesley and I had decided at the last minute to drive this route to check out the legendary little airport. It was well worth the trip. Not only was this a great field for our purposes, the people were very helpful and the scenery spectacular.

For years, when asked which part of the Rocky Mountains in the lower 48 I thought were the most beautiful, I immediately answered the Grand Tetons. But after a few flights in the Sawtooth this is no longer a foregone conclusion!

The mist rising over the valley and the Salmon River made wonderful subjects at first light. Later, when the sun had been up for a little while, the winding streams through the lush meadows gave another opportunity to play with lines of design. ❧

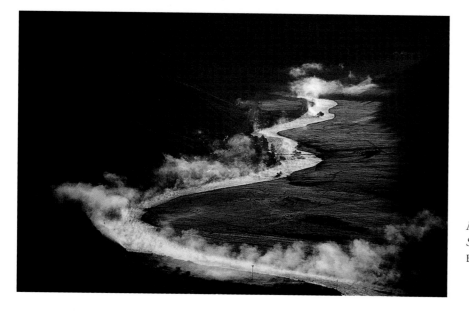

Mist at dawn on the Salmon River in the Sawtooth National Recreation Area.
Bill Fortney

Meandering creek in farm field near Stanley, Idaho.
Bill Fortney

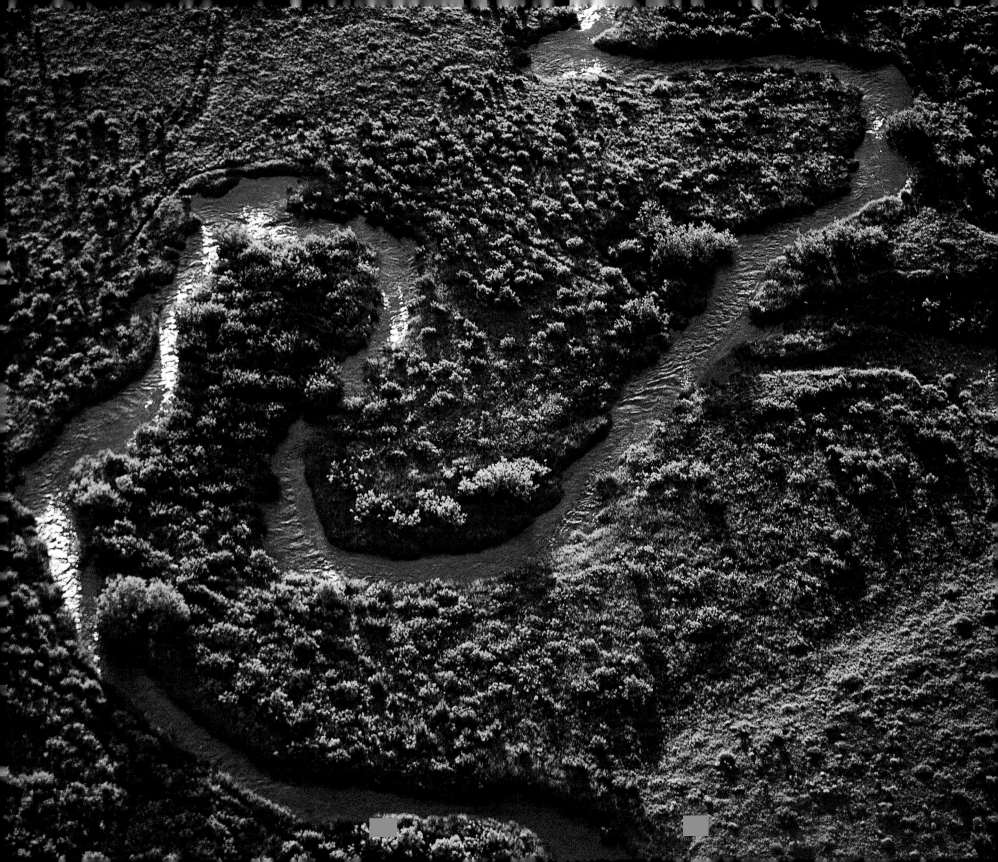

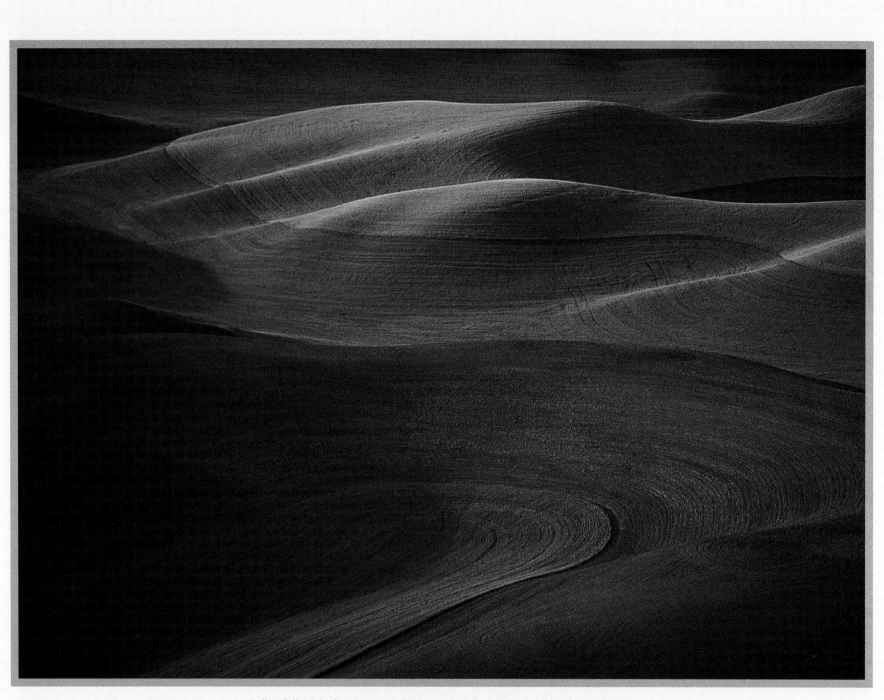

Rolling hills in the farming country known as the Palouse Region, near Colfax, Washington.
Bill Fortney

PILOT'S LOG

Date: June 23
Location: Palouse Region near Colfax, Washington
Flight time: 7:30 p.m. PDT
Visibility: Clear
Conditions: Calm
Base of operation: Whitman County Memorial Airport
Field elevation: 2,171 feet MSL
Altitude: 2,171 to 3,171 feet MSL

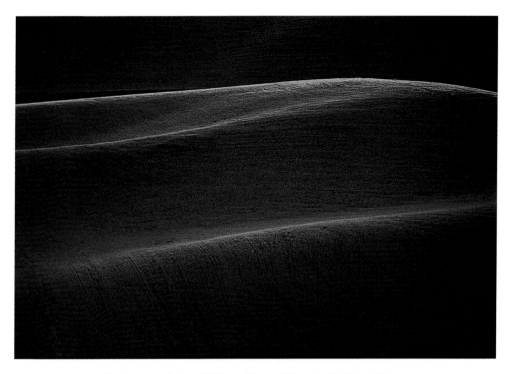

Very last rays of the day's light settling on hilltops in the Palouse Region.
Bill Fortney

The beauty of the Palouse Region is something you have to see to believe. I only hope that what we shot will convey the peace that comes over you when you see the miles of outstretched rolling hills and the lush, green crops. This is a very special place for me. I've come here several times before to shoot and teach photographic workshops, and have always felt embraced by the land and its people. This is farm country, and the Washingtonians who live in these rolling hills are as gentle and striking as the land itself.

Wesley and I arrived at the airport just in time to set up the plane (it takes about twenty-five minutes), and get into the air for about an hour of flying. I'm sure that when the project is finished this will stand out as one of the best flights. The air was dead calm and the light on this evening was perfect.

This is what you pray for. And tonight our prayers were answered! ➴

77

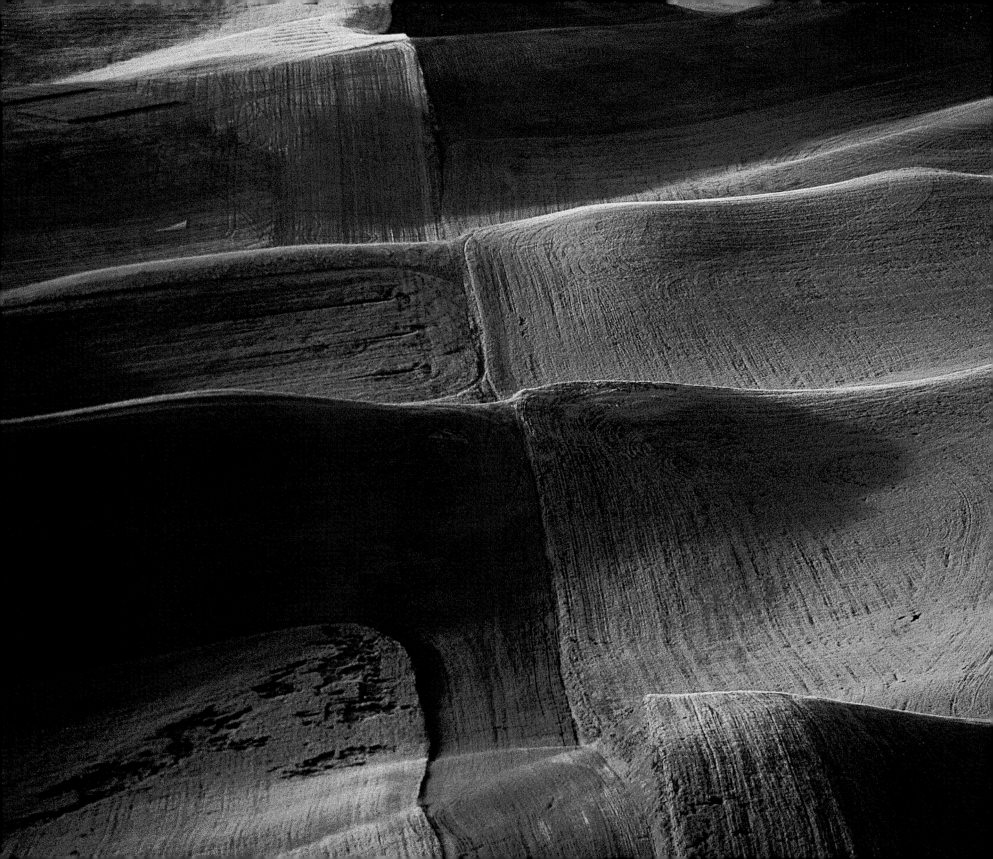

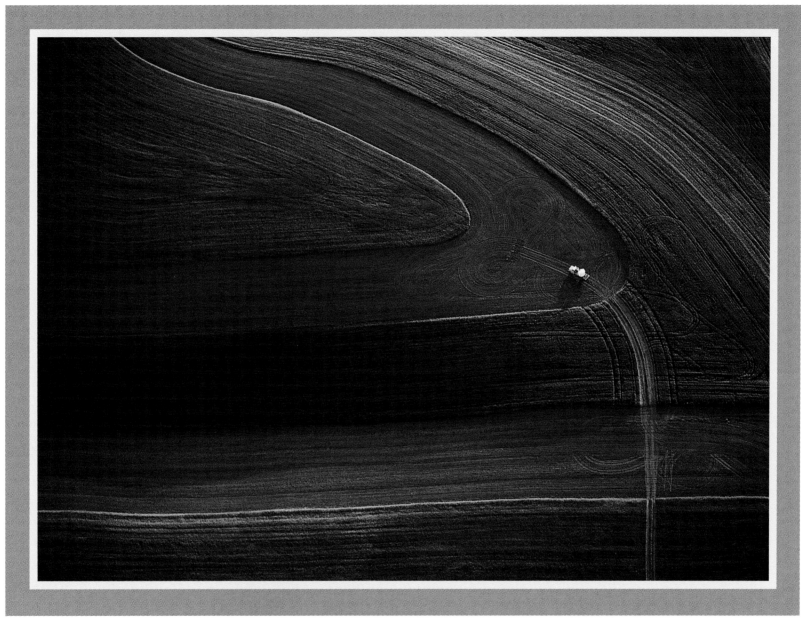

As it leaves its trail, farming equipment disrupts the orderly pattern of the fields in the Palouse.
Wesley Fortney

Rolling hills seem to undulate into the distance in the Palouse.
Bill Fortney

Central

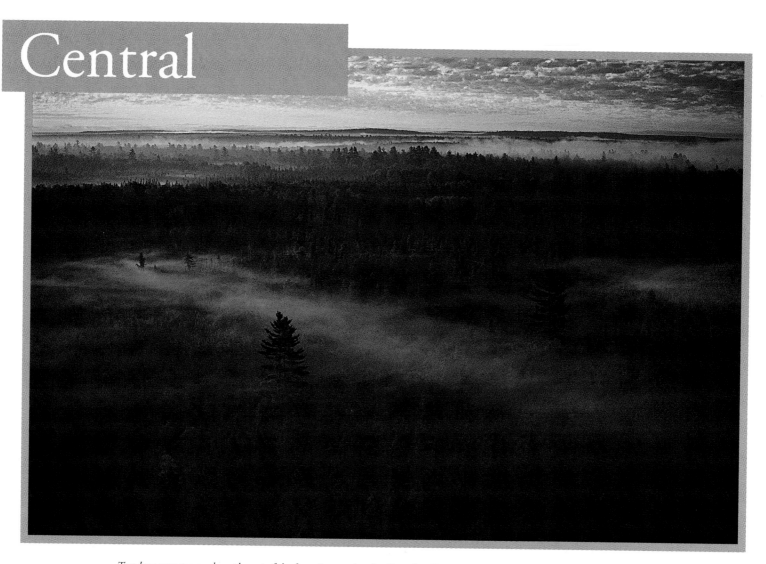

Two lone trees tower above the rest of the forest in morning fog, Boundary Waters Canoe Area Wilderness near Ely, Minnesota.
Wesley Fortney

Morning mist invades the endless forests of the
Boundary Waters Canoe Area Wilderness.
Bill Fortney

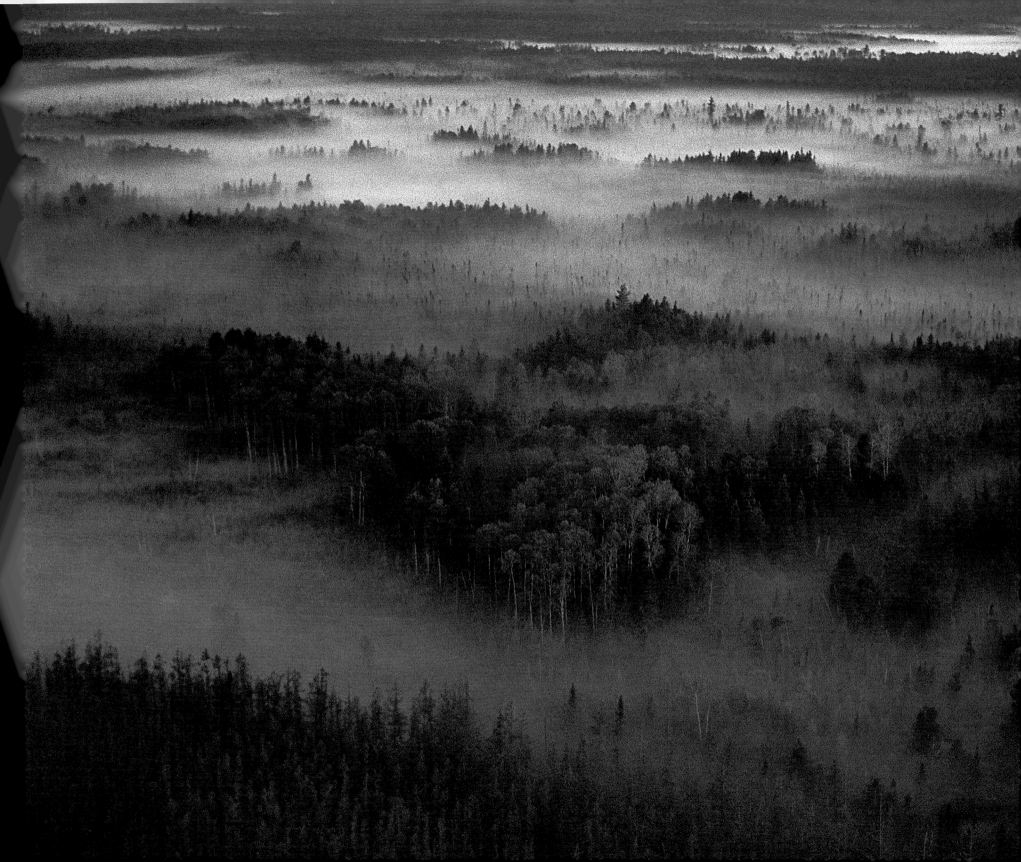

Row upon row of sunflowers, just east of the Wall Airport.
Bill Fortney

Tree-lined farm pond at daybreak, near Wall.
Bill Fortney

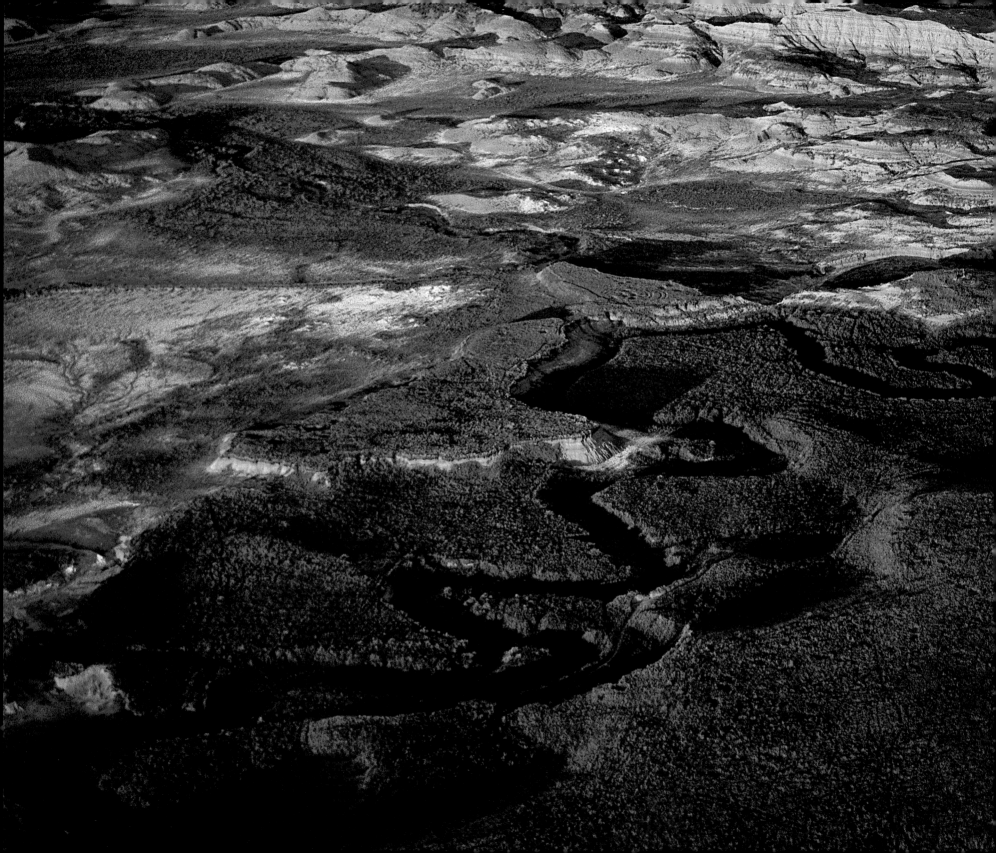

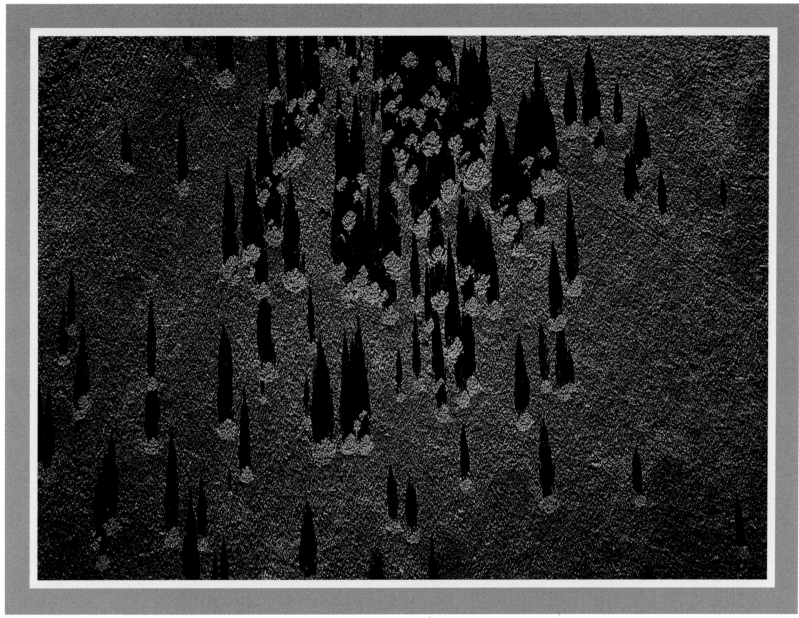

Tree shadows, Custer State Park, South Dakota.
Bill Fortney

Tabletops of fertile soil amid the vast Badlands.
Bill Fortney

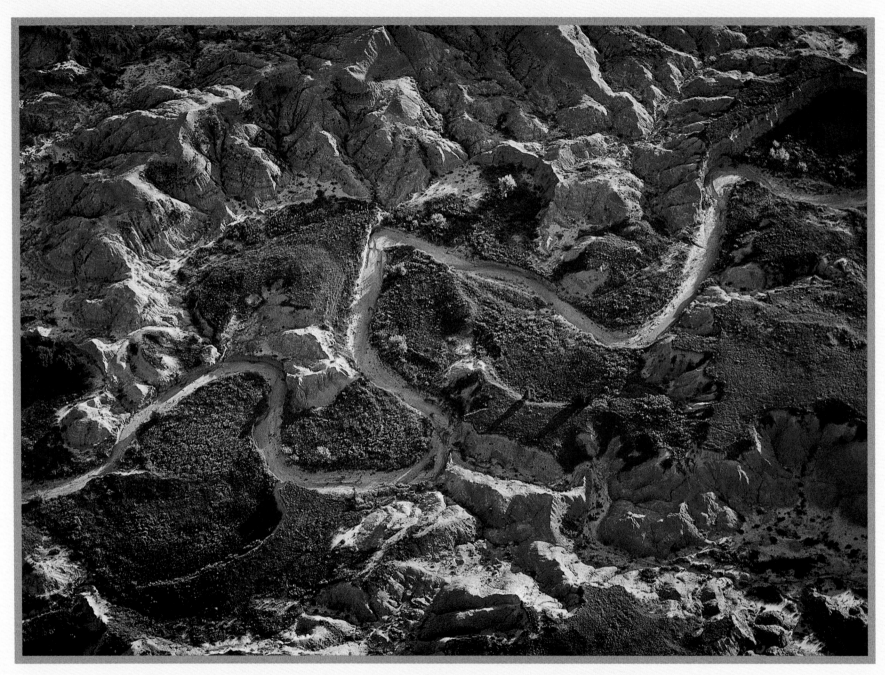

A dry river bed in the Badlands is a good reminder of how precious water is in this region.
Bill Fortney

PILOT'S LOG

Date: October 6
Location: Badlands National Park, South Dakota
Flight time: 7:45 a.m. MDT
Visibility: Clear
Conditions: Slight haze, 5 knot wind
Base of operation: Wall Municipal Airport
Field elevation: 2,810 feet MSL
Altitude: 2,810 to 4,500 feet MSL

All that remains of a small hill after millions of years of sediment layering and erosion, the Badlands.
Wesley Fortney

About 75 million years ago,
the earth was significantly warmer than it is today.

Much of the region we call the Great Plains was under a shallow salt sea. As the water receded a grayish-black sediment, called Pierre shale, covered the land. Over the centuries the rain washed away the sediment and carved the earth into spectacular ridges, peaks, and deep valleys. The result is the Badlands; few places on earth are more austere.

Dave Hahn, an experienced pilot and mayor of Wall, South Dakota, took us up in his Cessna 172. The combination of the Great Plains and the Badlands made for a great opportunity to investigate lines and forms below. We found the stark contrast between thin layers of fertile soil for farming and grazing, and the deep-cut canyons of the Badlands to be a photographer's paradise. ✍

93

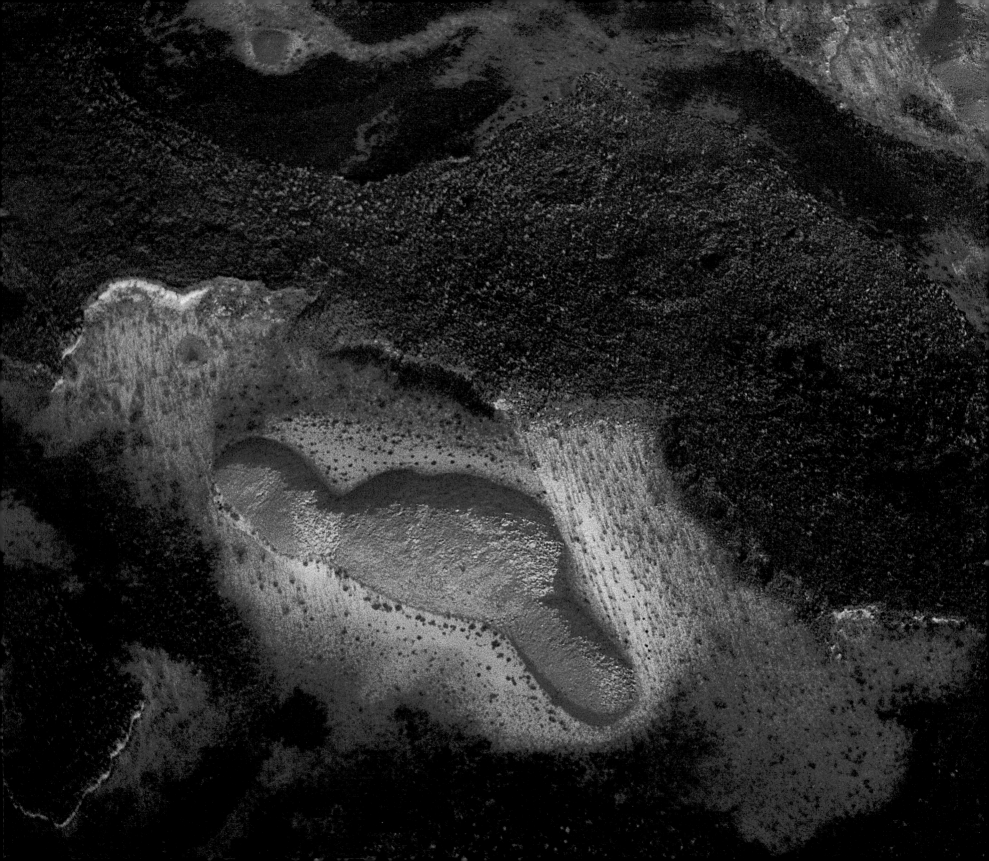

Early-morning light upon the Badlands.
Wesley Fortney

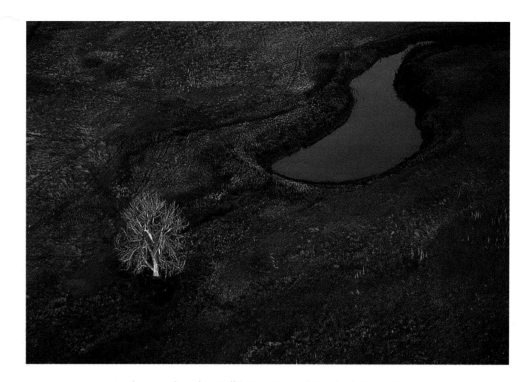

Single tree and pond in Buffalo Gap National Grasslands, South Dakota.
Bill Fortney

"When we walk to the edge of all the light we have, and we take a step into the darkness of the unknown, we must believe one of two things will happen. There will be something solid for us to stand on, or we will be taught how to fly."

Patrick Overton, *Edges*

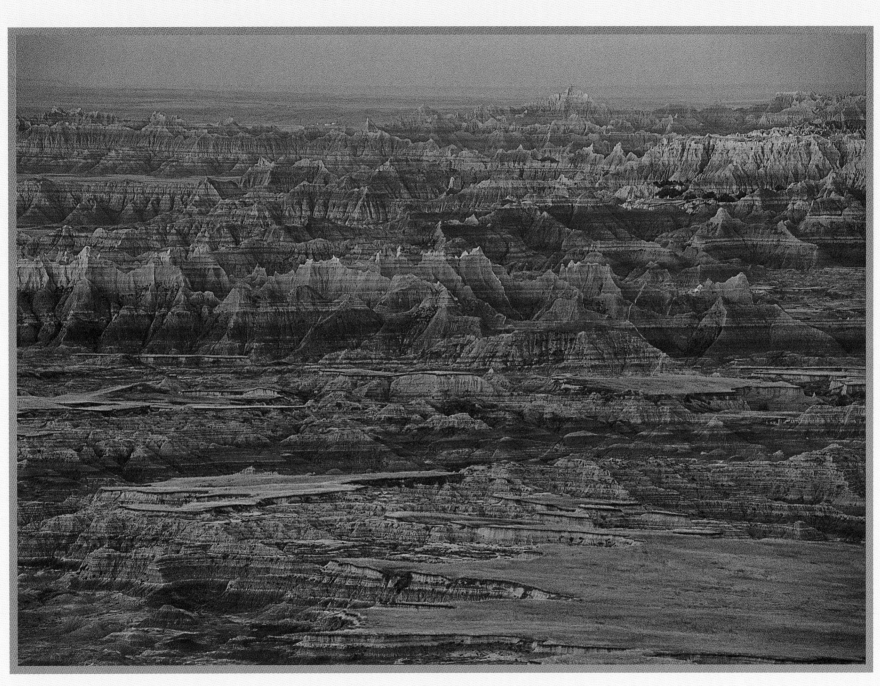

Badlands National Park scenic vista at sunrise.
Bill Fortney

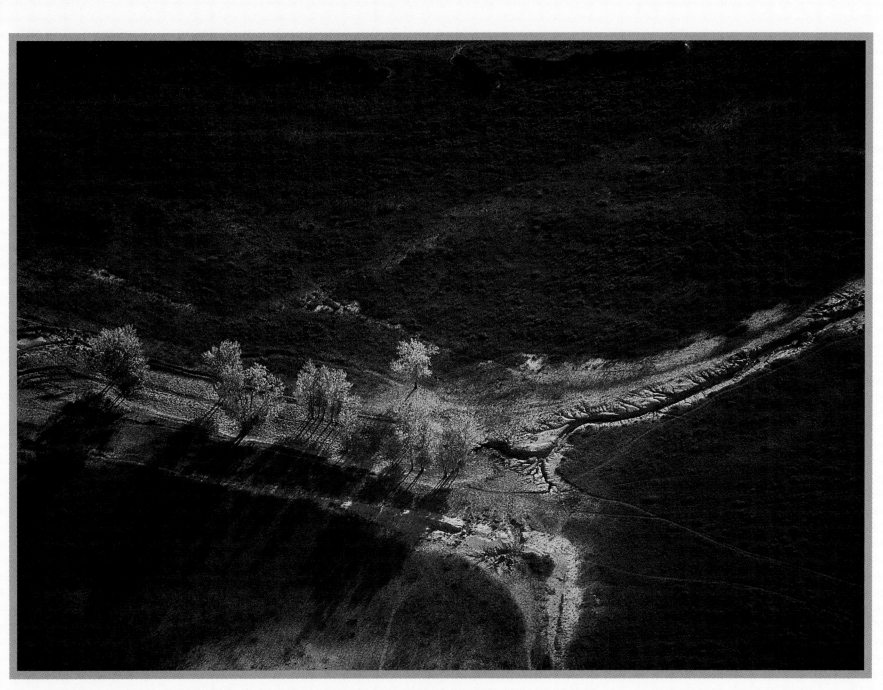

Life and water are closely intertwined in the arid Badlands, as evidenced by these trees thriving near a stream bed.
Bill Fortney

Date: October 4
Location: Great Sand Dunes National Monument, Colorado
Flight time: 5:15 p.m. MDT
Visibility: Clear
Conditions: 5 knot wind
Base of operation: Bergman Field, San Luis Valley Regional Airport
Field elevation: 7,535 feet MSL
Altitude: 7,536 to 9,000 feet MSL

Right in the middle of the United States lies a full-fledged desert. Spectacular dunes rise over 700 feet into the air, backed by the rugged Sangre de Cristo Mountains. The field elevation for the airport was over 7,500 feet, so we opted for an experienced local pilot to do the flying. Ferdinand deSouza did a great job keeping us right over the spectacular lines and forms of the dunes.

This is a perfect spot for late-afternoon light and shadows!

The Great Sand Dunes were formed by winds blowing toward the northeast across the San Luis Valley. Sands carried by the winds were deposited at the foot of the high Sangre de Cristo Mountains. Today, the winds still blow, from gentle breezes to over 65 knots, constantly shifting and re-shaping the dunes. The sand remains dry on the surface but the layer underneath is moist from annual rain and snow. This moisture encourages the growth of some plants, mostly blowout grass, Indian ricegrass, scurfpea and, in late summer, bright-yellow prairie sunflowers, which amazingly pop up right in the middle of the vast dunes. The only permanent animal residents are kangaroo rats and four kinds of insects. Though the environment is harsh it holds a beauty all its own.

Sand dunes seemingly in waves, at
Great Sand Dunes National Monument.
Bill Fortney

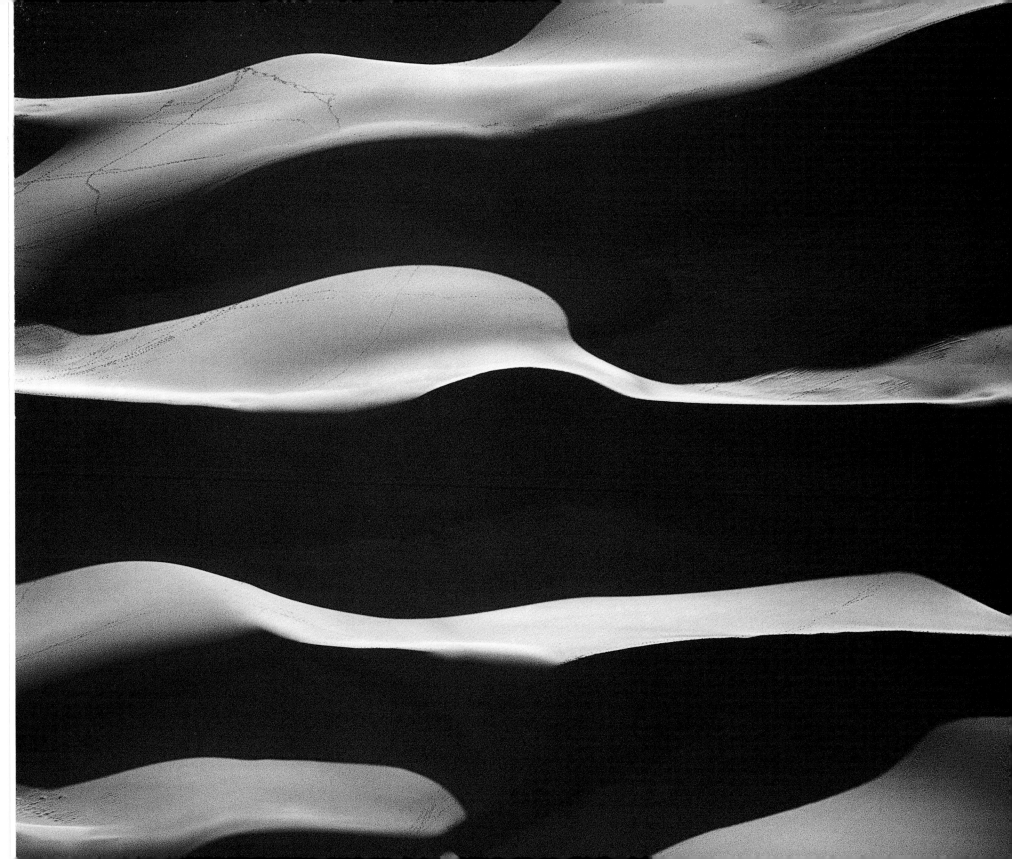

PILOT'S LOG

Date: March 2
Location: Grand Teton National Park, Wyoming
Flight time: 7:15 a.m. MST
Visibility: Clouds
Conditions: Light wind, 21°F
Base of operation: Jackson Airport
Field elevation: 6,445 feet MSL
Altitude: 6,445 to 12,500 feet MSL

It was cold, as in COLD! The temperature fell to 11°F the night before, but our cabin at Cowboy Village in Jackson was warm as toast. Early in the morning Wesley and I drove out to the airport and went up with local pilot Travis Howard. After taking off in the Cessna 172, we climbed out into some thick, overhanging cloud layers. At around 12,500 feet we punched through the top and there they were: the glorious peaks of the Grand Tetons—The Grand Teton, Teewinot Mountain, and Mount Owen—all set in a layer of cottony clouds.

What a sight! It made me think of the many mornings I've stood on the ground at Schwabacher's Landing looking up at the peaks masked by clouds. So this is what it looks like from above....

No matter how many times I see the Tetons they still hold the feeling
of peace and magnificence that I felt the very first time I ever saw them.

After a few minutes weaving in and out of the peaks we descended to the deck and flew along the Snake River. ➰

Peaks of the Grand Tetons jutting above the 12,000-foot cloud layer
in the early morning near Jackson, Wyoming.
Bill Fortney

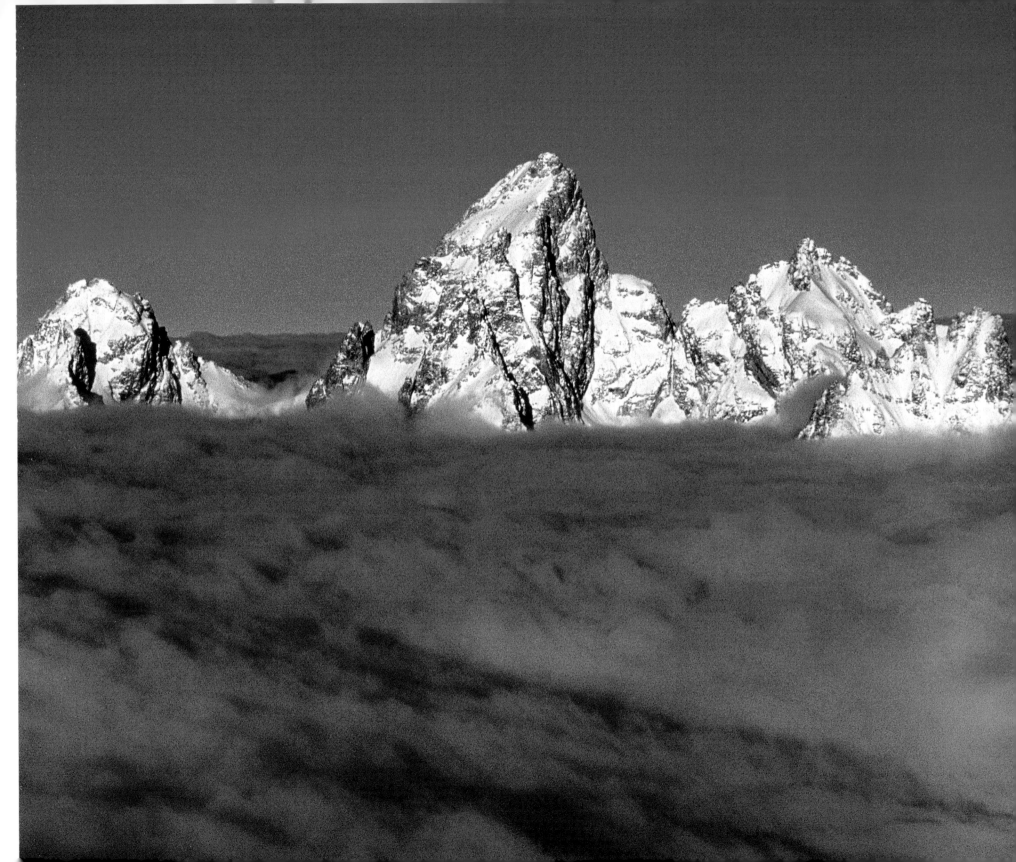

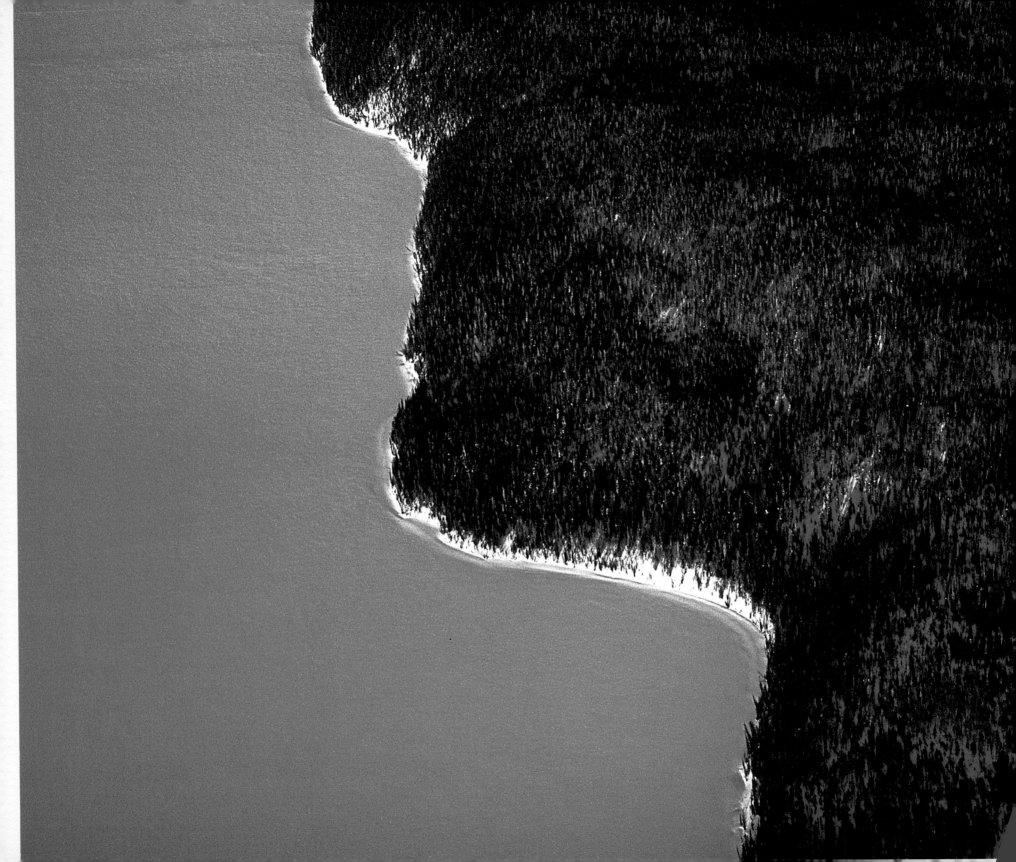

Single tree with long afternoon shadow in Yellowstone National Park.
Bill Fortney

The shoreline of Jackson Lake, Grand Teton National Park.
Bill Fortney

PILOT'S LOG

Date: March 2
Location: Yellowstone National Park, Wyoming
Flight time: 4:45 p.m. MST
Visibility: Clear
Conditions: Light wind, 38°F, windchill −24°F
Base of operation: Jackson Airport
Field elevation: 6,445 feet MSL
Altitude: 6,445 to 12,500 feet MSL

The day before our flight to Yellowstone the park celebrated its birthday—128 years as America's first and premier national park. On this afternoon the snow-covered park looked much as it must have looked when John Colter left the Lewis and Clark expedition to go to Yellowstone to trap in 1806. It is among the most diverse parks of the national park system.

Once again I realized the scenario that has replayed itself over and over—I go up with some specific images in mind, only to find something I never even envisioned. That surely was the case for this flight. The late-afternoon light made even gentle, rolling hills the owners of magnificent shadows. ✍

The burnt forests from the 1988 massive fire provided ample lines, shadows, and forms from a few hundred feet above.

Shadows cast by the burnt forest in snow, Yellowstone National Park.
Bill Fortney

110

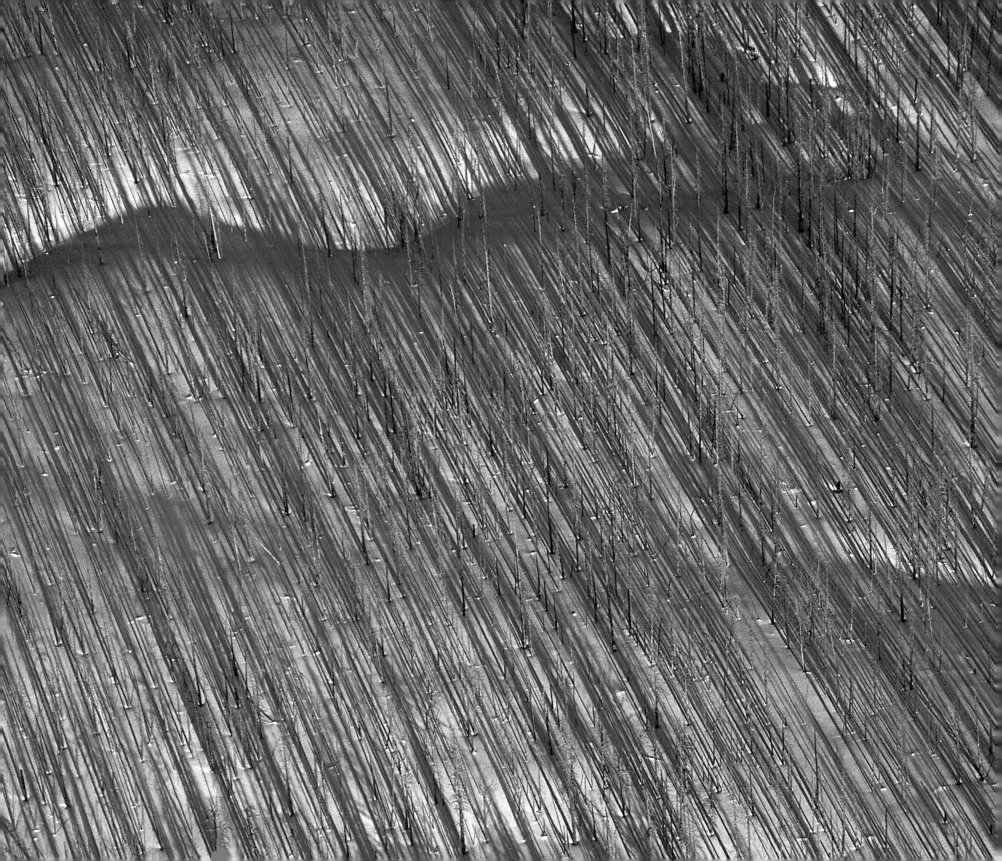

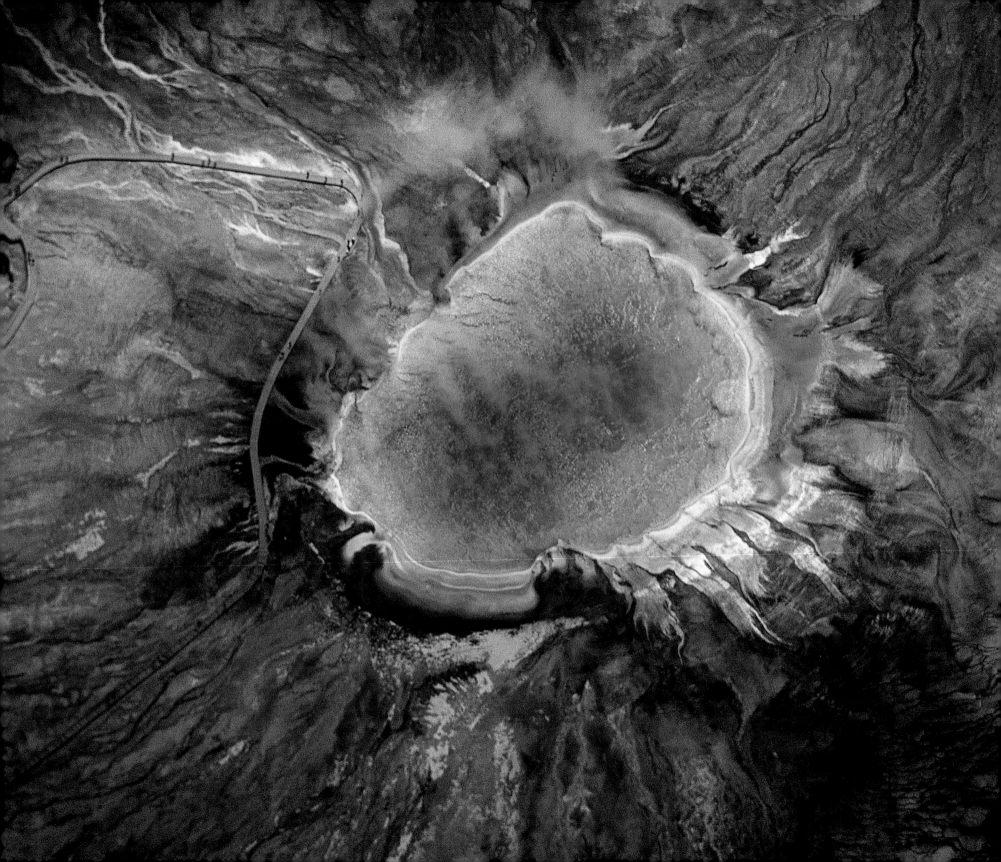

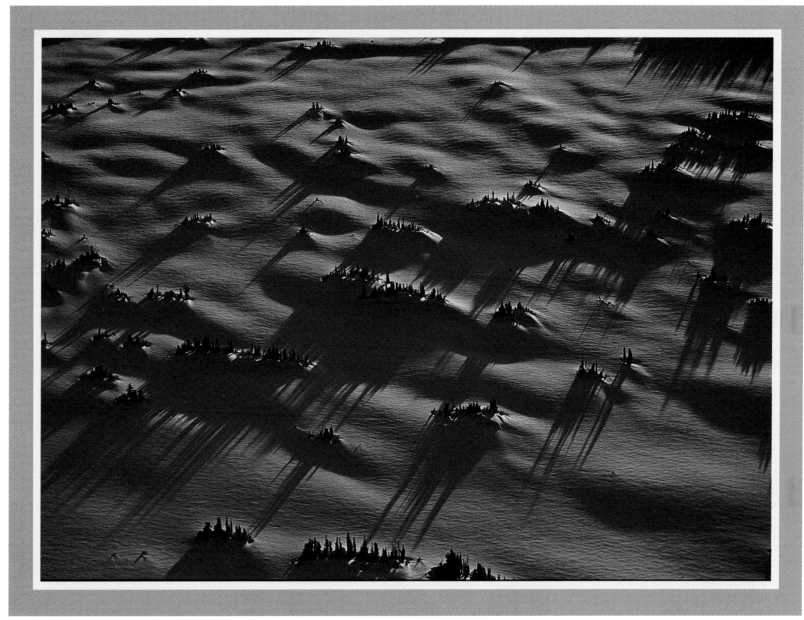

Tree-line shadows in snow fields, Yellowstone National Park.
Bill Fortney

The Grand Prismatic thermal pool in Yellowstone National Park.
Bill Fortney

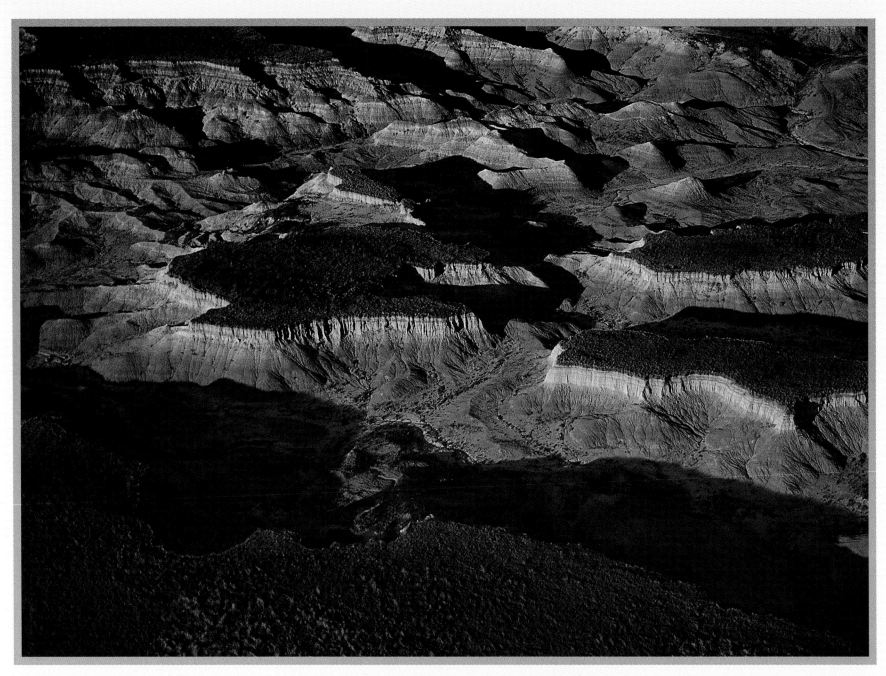

The Tabletops contain rich, fertile soil on the flat plateaus of the Badlands.
Bill Fortney

PILOT'S LOG

Date: August 6
Location: Badlands National Park, South Dakota
Flight time: 5:30 a.m. MDT
Visibility: Clear
Conditions: Calm
Base of operation: Wall Airport
Field elevation: 2,810 feet MSL
Altitude: 2,810 to 4,200 feet MSL

This flight holds a very special place in my heart. It was at this field, ten months earlier, that I first soloed an airplane. Well, it was not actually completely on purpose....

We had just taken our plane out West for our first shoot. The plane was a single-control aircraft, which means I couldn't train in it because the instructor would not have a set of controls. So my first flight would be alone. In preparation for my first "real" flight, Wesley and I agreed that I would do some taxiing and crow hops (very slight takeoffs followed by landing right back on the ground).

Unfortunately my first hop was a big one and I was really airborne. I had little choice but to keep climbing, and boy did I climb! Before I knew it, I was several hundred feet up. Now what!? Well, I had been flying Cessnas and other kinds of ultralights and I knew what to do; I just had never done it alone!

I have to admit I was feeling about fifty-percent terror and fifty-percent exhilaration.

I flew around the pattern a few times and then came in for a landing. Well actually, I made several approaches until I was ready. The landing wasn't great but did meet the definition of a good landing: You can still use the plane again!

So here we were, back at the same scene. This time I had a lot of hours under my belt and I couldn't wait to fly over the Badlands. It was one of my best flights and well worth the ten-month wait! ✍

Date: June 20–21
Location: Craters of the Moon National Monument, Idaho
Flight time: 8:00 p.m. to 5:50 a.m. MDT
Visibility: Clear
Conditions: Moderate, gusty winds up to 16 knots
Base of operation: Carey Airport
Field elevation: 4,783 feet MSL
Altitude: 4,783 to 7,780 feet MSL

This region of Idaho is truly beautiful for a number of reasons.

The low land is farm country, but with great patterns and color; the surrounding mountains are delightfully textured mounds. The area around Craters of the Moon National Monument and Wilderness Area is one of the most unique set of volcanic formations in America.

The more than 53,000 square miles also offer visitors an opportunity to see spring wildflowers, experience the solitude of a high desert wilderness, and observe wildlife capable of surviving in this harsh environment.

We flew both evening and morning, and truly enjoyed our visit, with a lot of support from local pilots. ✍

Life finds a way to grow on lava beds in
Craters of the Moon National Monument, Idaho.
Bill Fortney

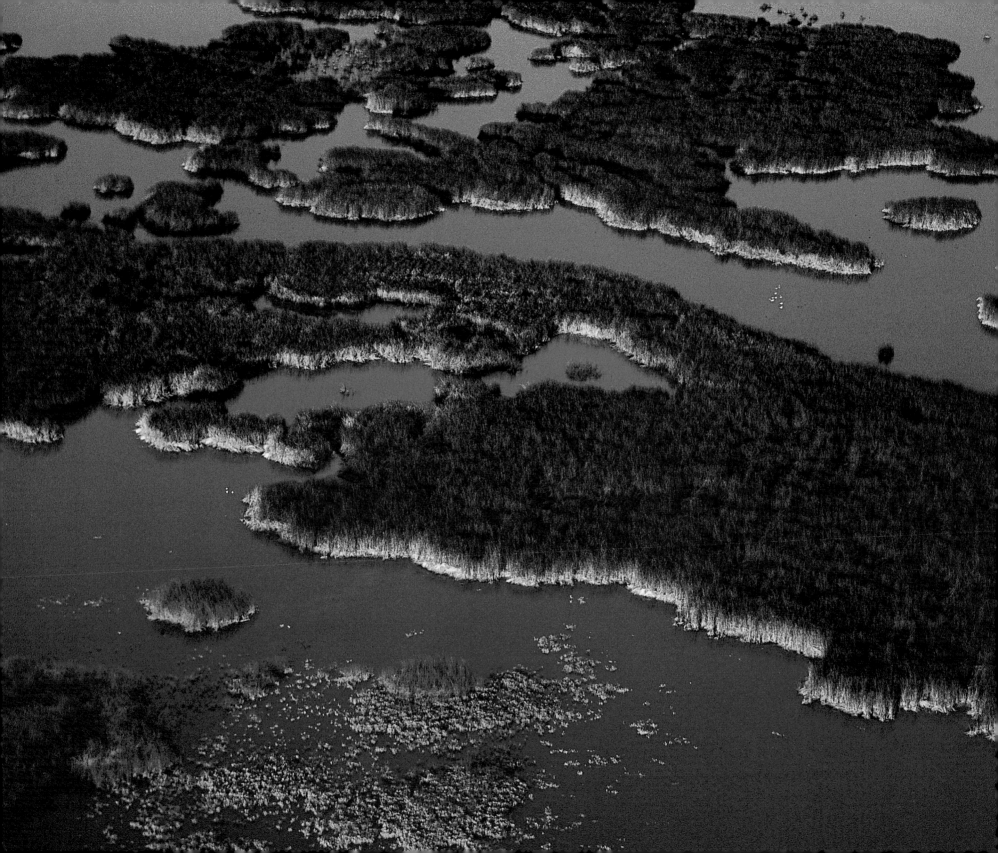

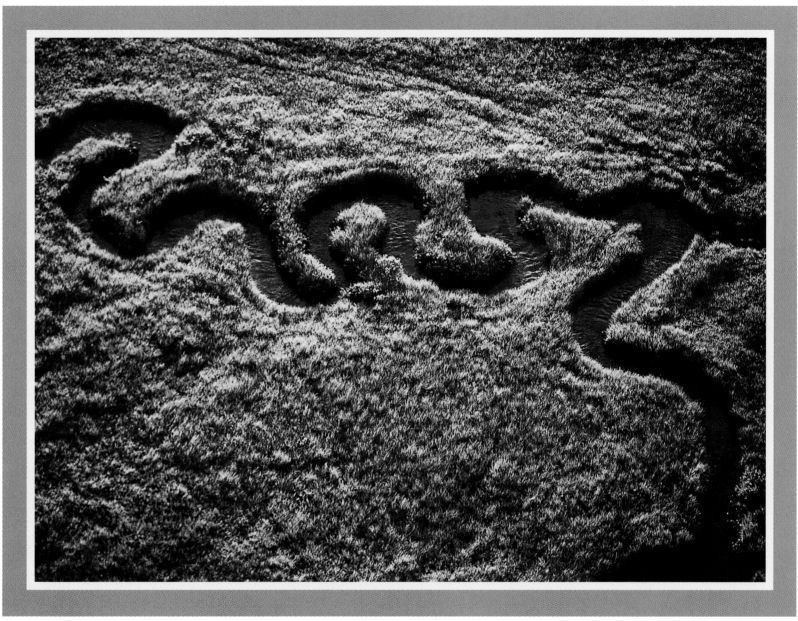

Winding stream on the lush valley floor of the Sawtooth Region near Stanley, Idaho.
Bill Fortney

Sawgrass and pools in Carey Wildlife Refuge, Carey, Idaho.
Bill Fortney

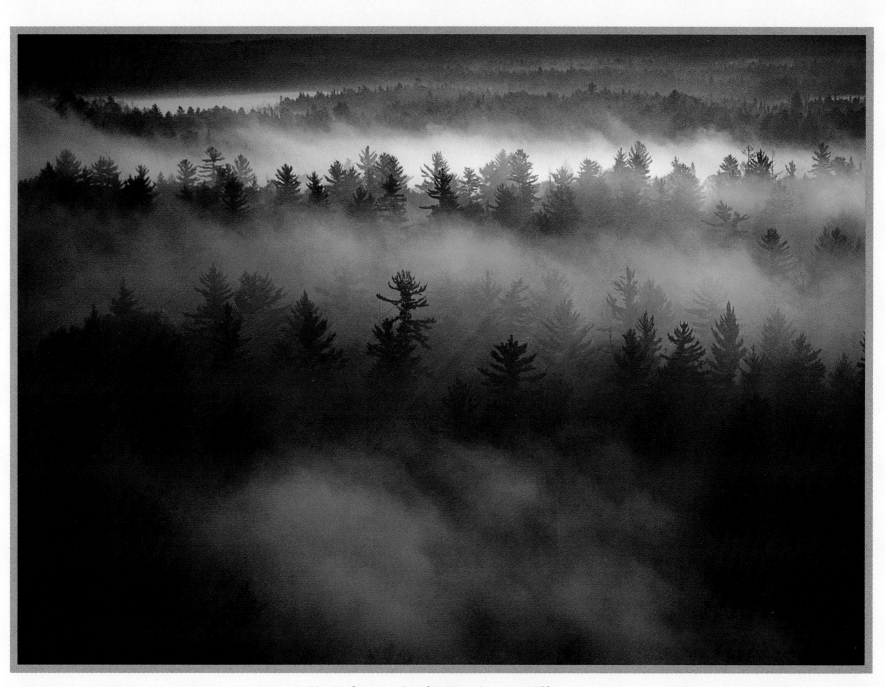

Morning fog in trees, Boundary Waters Canoe Area Wilderness.
Wesley Fortney

With over 1,500 miles of canoe routes, nearly 2,200 designated campsites, and more than 1,000 lakes and streams awaiting, the area draws thousands of visitors each year. ➤

since the glaciers melted.

The BWCAW was established in 1978, as part of the Superior National Forest. It has changed little

deserves to be in such a wonderful place!

beauty, I couldn't help but both be very envious of Jim and, at the same time, very happy knowing that he

northwoods. On the fog-enshrouded morning that Wesley and I got our introduction to its seductive

Jim sure knows how to pick great places to live; his legendary home sits right in the beautiful

would go on to be my partner and friend in seeing that this book was published.

immediately bond with, a gentle man of enormous talent. Jim had introduced me to Barbara Harold, who

how much I appreciated my friend Jim Brandenburg. He is one of those fellow photographers you

As Wesley and I drove up to the Boundary Waters Canoe Area Wilderness I couldn't help but think of

First light on treetops in the northwoods of Minnesota.

Bill Forney

Altitude: 1,445 to 2,500 feet MSL
Field elevation: 1,445 feet MSL
Base of operation: Ely Airport
Conditions: Calm
Visibility: Clear, light ground fog
Flight time: 5:50 a.m. CDT
Location: Boundary Waters Canoe Area Wilderness, Minnesota
Date: August 4

PILOT'S LOG

First warm light in fog of BWCAW.
Bill Fortney

*Morning sky and clouds reflecting in a lake
in the BWCAW, Minnesota.*
Bill Fortney

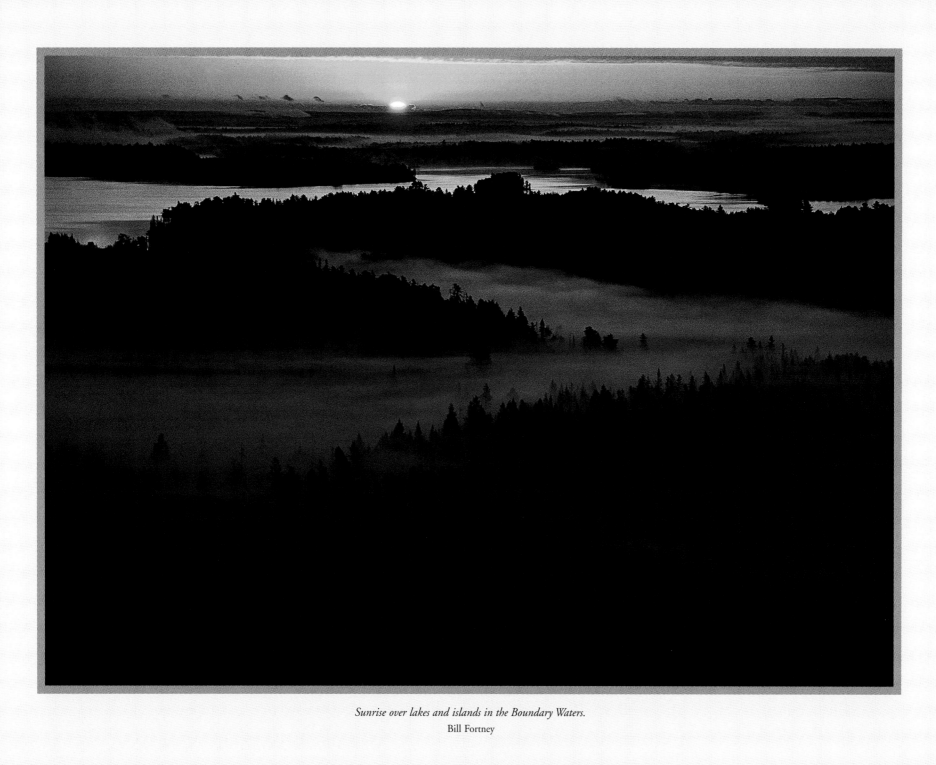

Sunrise over lakes and islands in the Boundary Waters.
Bill Fortney

124

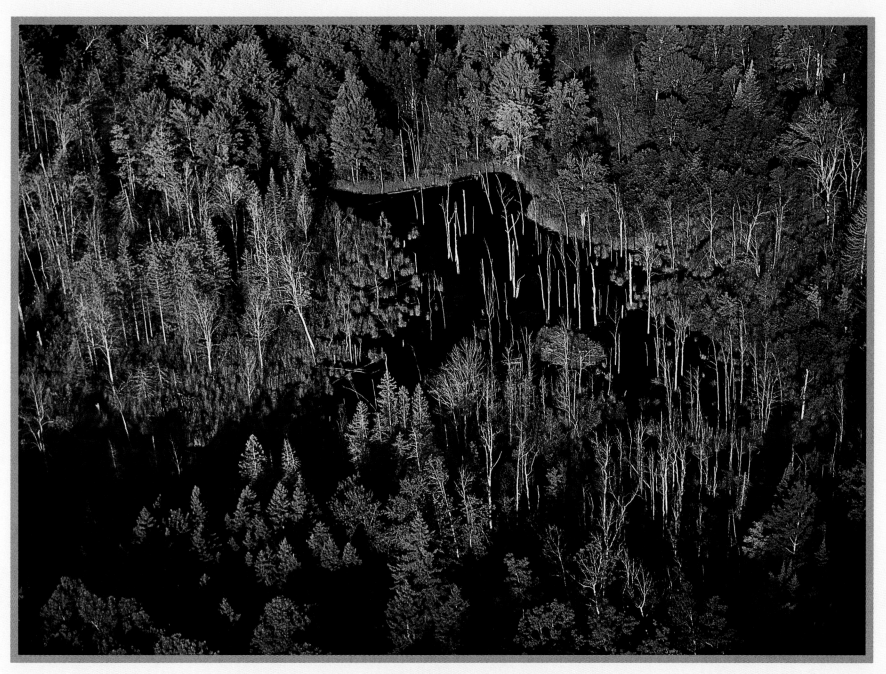

Pond in the northern woods near Minocqua, Wisconsin.
Bill Fortney

PILOT'S LOG

Date: August 9
Location: Long Lake, Wisconsin
Flight time: 6:00 a.m. to 7:00 p.m. CDT
Visibility: Morning fog
Conditions: Calm winds
Base of operation: Doug Karis' private airstrip
Field elevation: 1,700 feet MSL
Altitude: 1,700 to 3,000 feet MSL

When I think of Long Lake I think of my father, William Pelle Fortney, who first told me tall tales about fishing for muskies on the lake with his father, my grandfather, Braudes Brock Fortney. My grandfather died before I was born, but I spent many a great day fishing with my father and I knew how special this lake was to him. When I was planning the book, Long Lake just never came to my mind; after all, this was a natural-history book and Long Lake was in the "fishing" compartment of my brain. One night during a phone conversation with my brother, Homer, I told him our next trip was to Minnesota, Michigan, and Wisconsin. Homer (being a much more serious fisherman than I) asked if I planned to fly over Long Lake. All I could blurt out was, "I am now!" And we both had a good laugh!

Now when I think of Long Lake I'll also think of two great friends we made there—Doug Karis, a farmer who let us use his great airfield, and Rob Fletcher, who made us feel at home at his lodge and restaurant along the shore.

Wesley got the best flight up to the lake and had a lot of fun seeing and photographing the lake of his grandfather and great-grandfather. I had a great adventure taking off in fog. I couldn't see the lake at all so I headed back to the airport. Thanks to my GPS I flew right to it. Unfortunately, it was fogged in. I flew around some more but the fog wasn't lifting.

Finally I found a lonely and straight county road about a mile from the airport and landed safely.

I pulled the plane into a woman's yard and asked permission to leave it there until the fog lifted. She was very surprised to see me, but agreed, with a chuckle, and I hitched a ride with a farmer back to the airport.

You should have seen Wesley's face when I showed up without the plane! ン

Fog over the farmlands near Long Lake, Wisconsin.
Bill Fortney

126

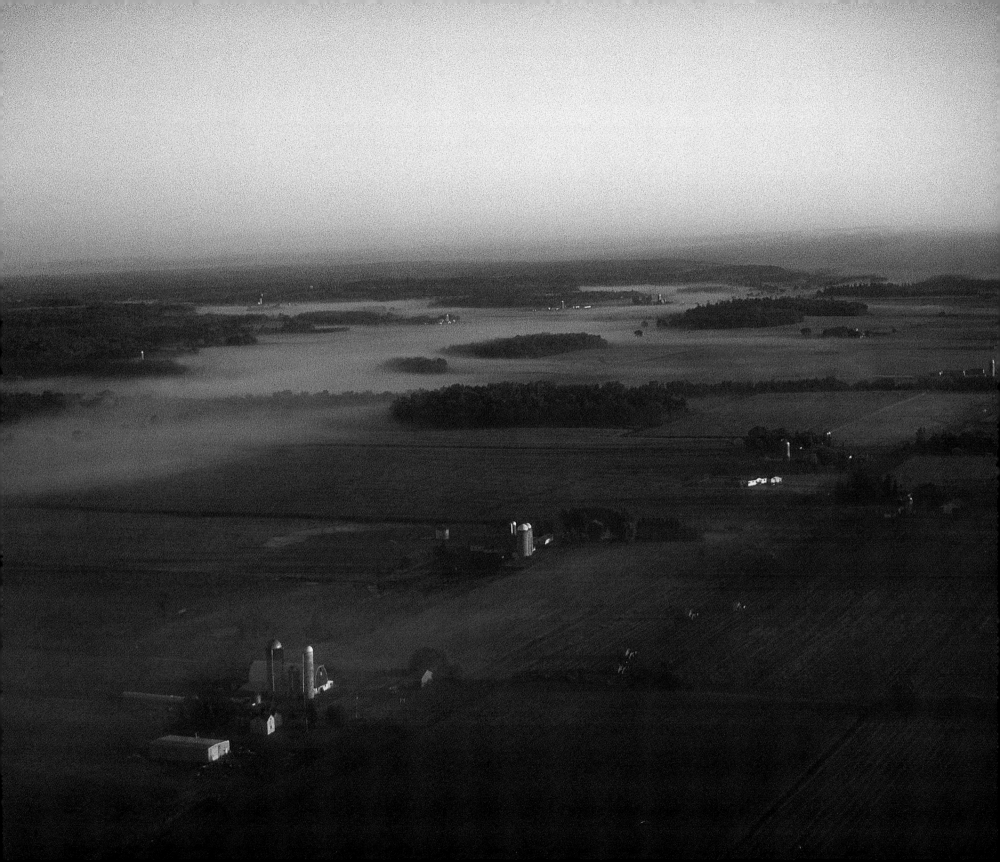

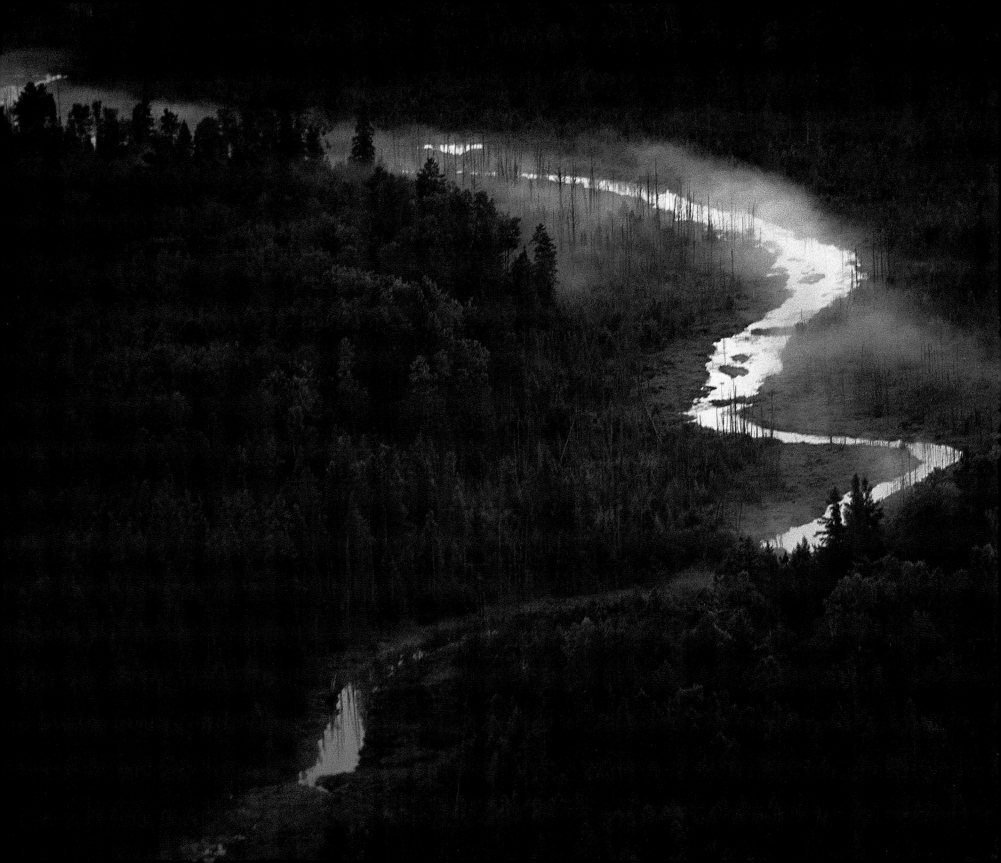

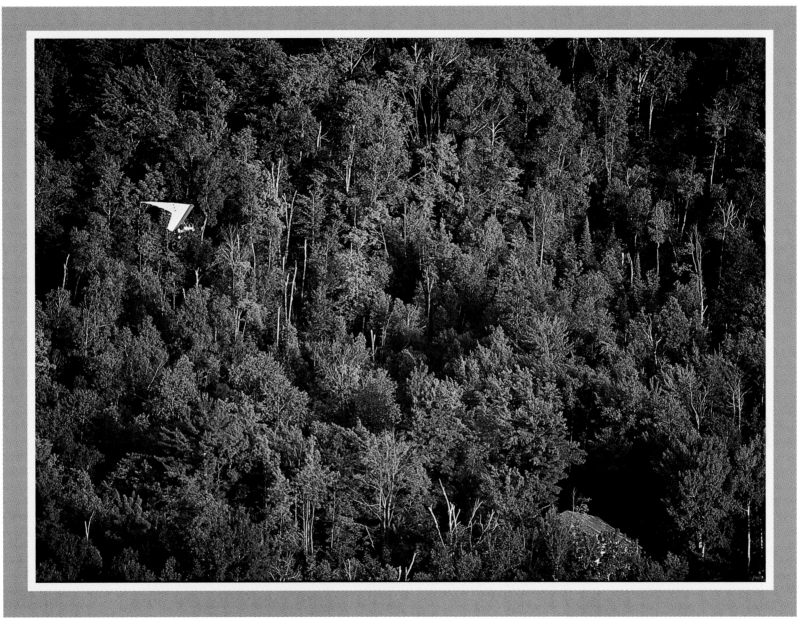

Wesley flies over the northwoods along the shore of Lake Superior.
Bill Fortney

Mishonagon River in early morning fog,
near Minocqua, Wisconsin.
Bill Fortney

PILOT'S LOG

Date: July 31
Location: Pictured Rocks National Lakeshore, Michigan
Flight time: 7:30 p.m. CDT
Visibility: Scattered clouds
Conditions: Light northwest winds
Base of operation: Hanley Field, Alger County Airport
Field elevation: 984 feet MSL
Altitude: 984 feet to 3,000 MSL

One of the most satisfying things about this project has been how the unexpected continues to happen. I've kept hoping to work in a trip to St. John in the Bahamas so I could get some of that crystal-clear aqua water and lush, green foliage. Well, I never dreamed I would find it along the coast of Lake Superior, but we did.

Wesley and I split up in a rare two-airplane assault on our subject. Wesley took our plane, the trusty Air Creation Fun Racer, and I hired the services of crack pilot Mark Geitka, who runs Skylane Pictured Rocks Air Tours, and his Cessna 172. Mark has over 3,000 hours flying this region, so I was in great hands.

We wanted to do some air-to-air shots of our plane over a striking subject—and this certainly qualified. Between us we were able to fly and shoot for over two and a half hours!

The Pictured Rocks

For over forty miles these majestic sandstone cliffs grace the shore of the world's largest inland lake.

National Lakeshore was established in 1966 to preserve the shoreline, cliffs, beaches, and dunes. The name "pictured rocks" comes from the streaks of mineral stain left behind as water trickles down the face of the sculptured cliffs. ✠

Clear water of Pictured Rocks National Lakeshore, Lake Superior.
Bill Fortney

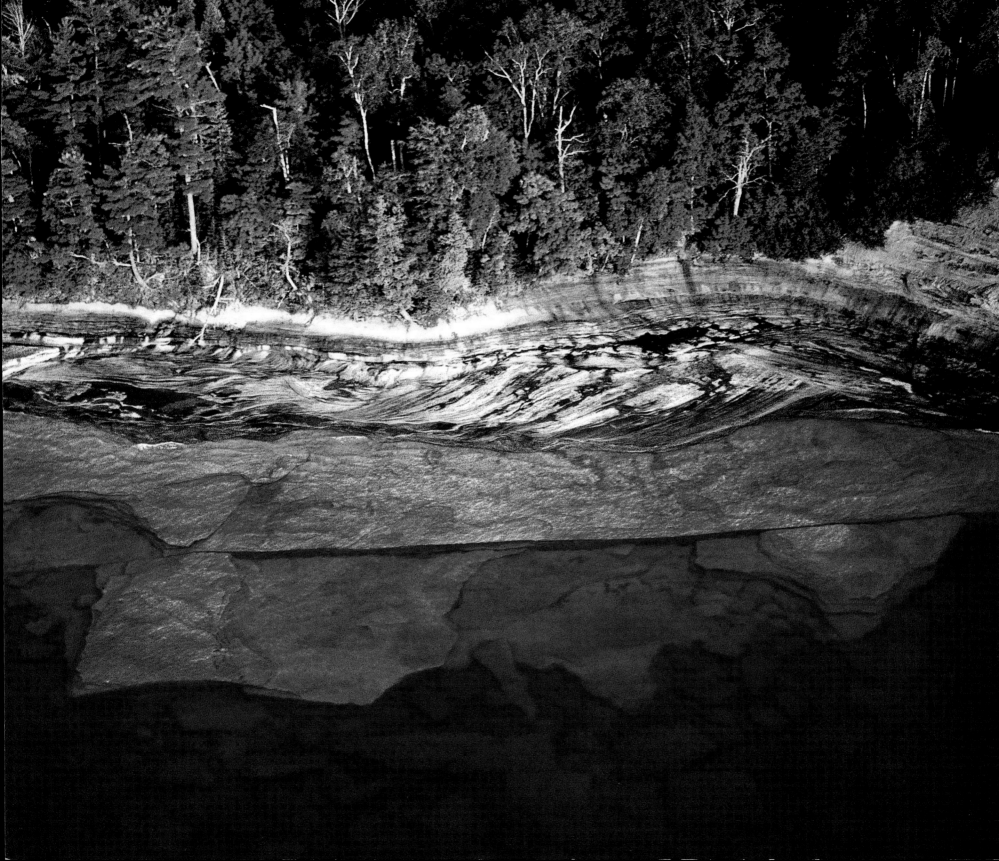

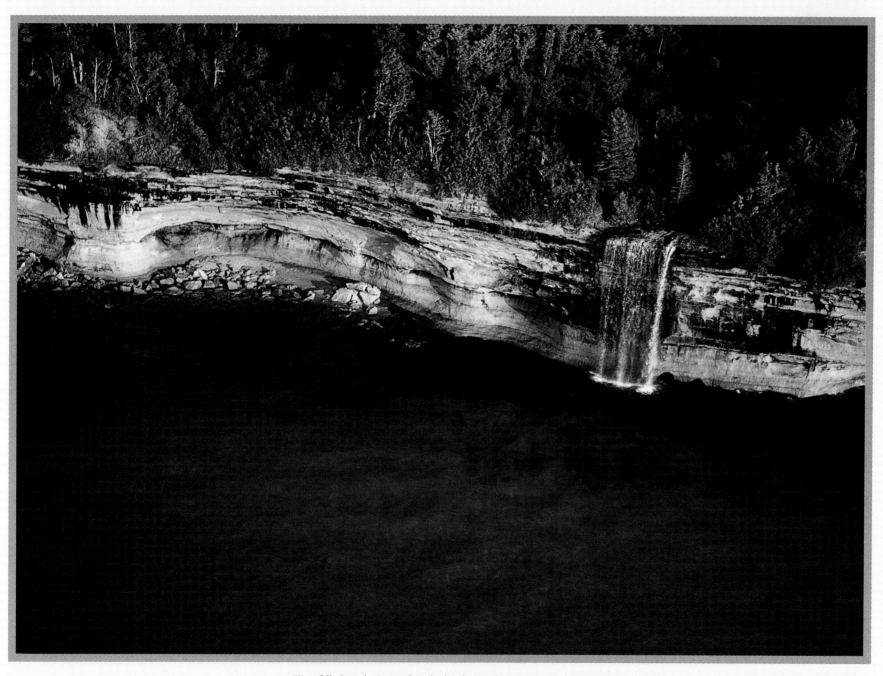

Waterfall along the Pictured Rocks shoreline, Lake Superior, Michigan.
Bill Fortney

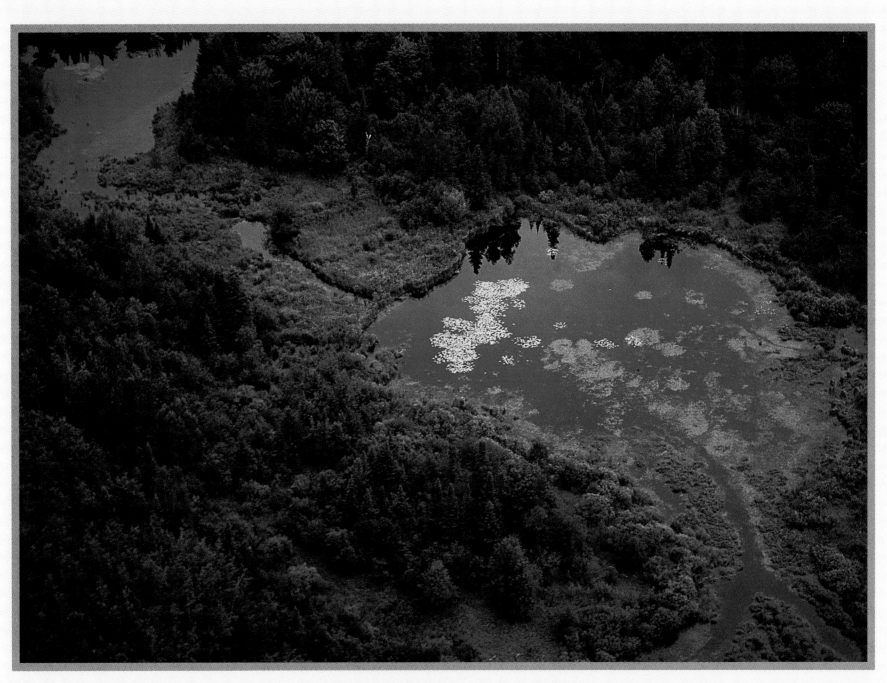

Forest pond in northern woods near the Apostle Islands.
Bill Fortney

133

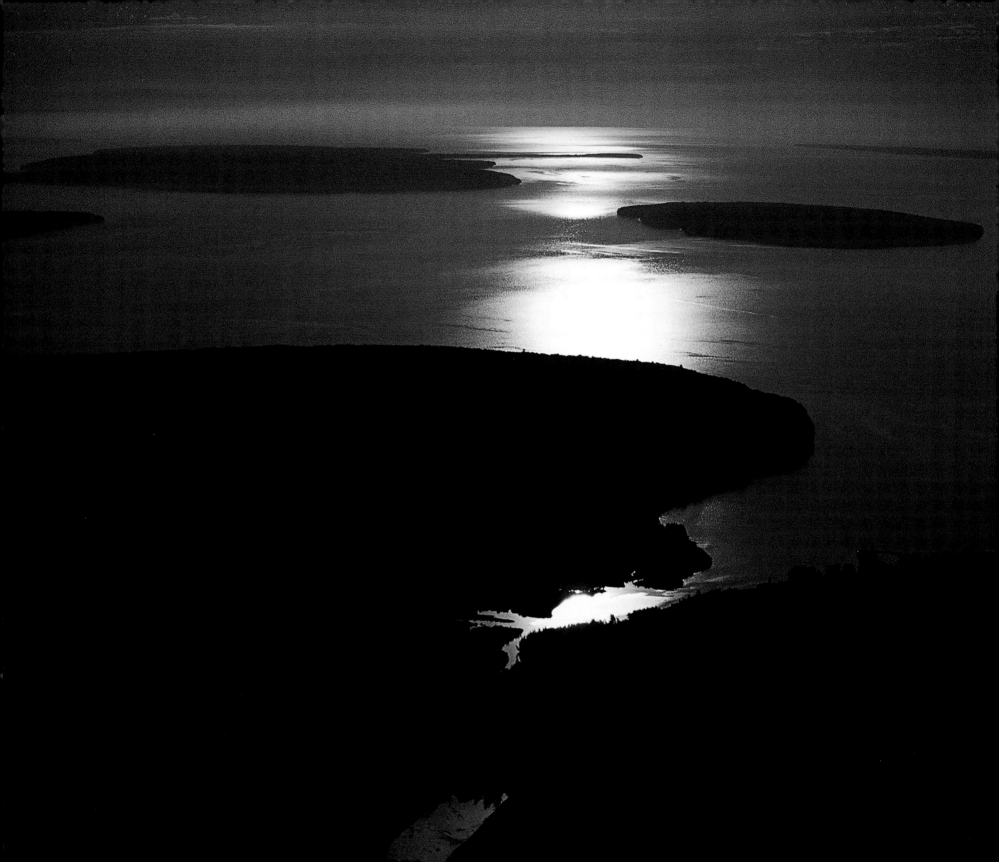

A secluded beach, with visitors this day, on Lake Superior.
Wesley Fortney

*"*Fear of danger *is ten thousand times*
more terrifying than danger itself."

Daniel Defoe, *Robinson Crusoe*

The Apostle Islands, Lake Superior, late evening.
Wesley Fortney

The East

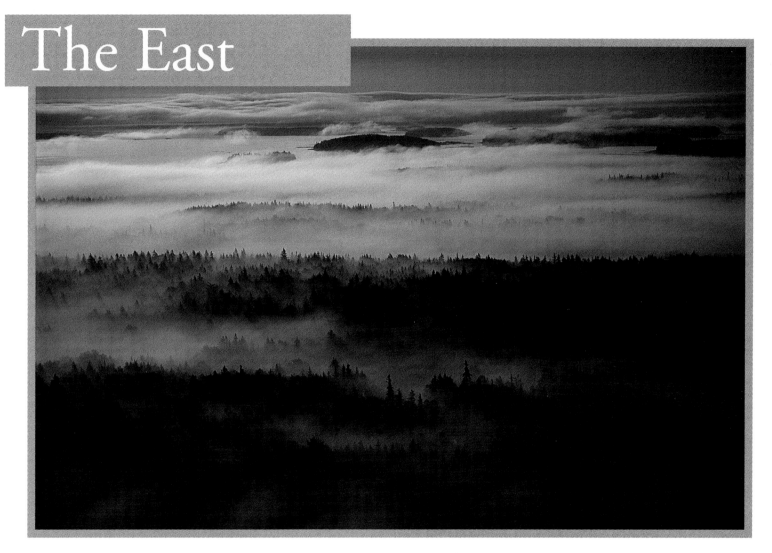

Forests and Stonington Bay near Deer Isle, Maine.
Bill Fortney

Fall color in the Maine woods, near Stonington.
Wesley Fortney

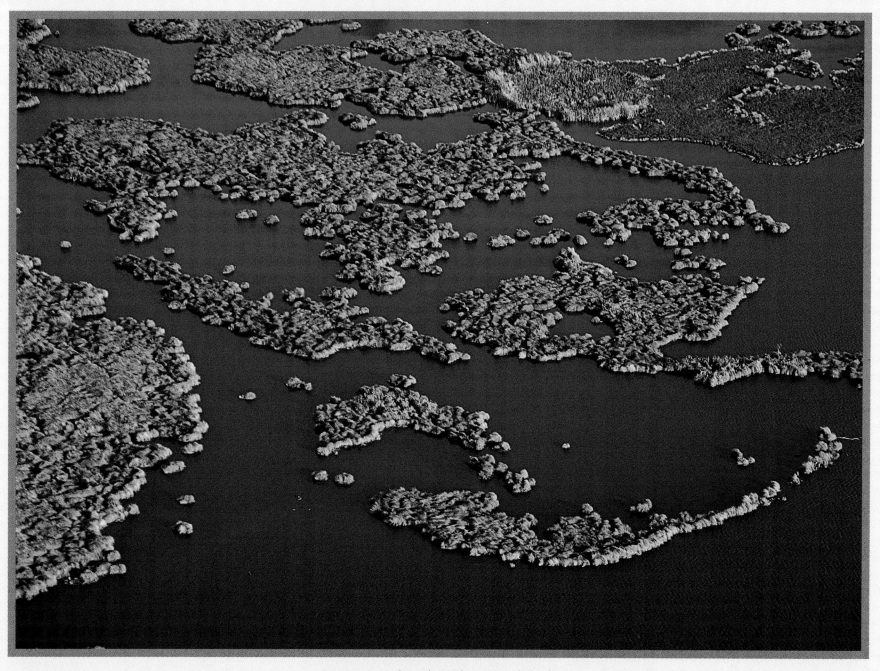

Louisiana coast salt marshes, with sawgrass at high tide.
Bill Fortney

PILOT'S LOG

Date: January 2
Location: Shell Keys National Wildlife Refuge, Louisiana
Flight time: 4:30 p.m. CST
Visibility: Clear
Conditions: Light wind
Base of operation: Lafayette Airport
Field elevation: 42 feet MSL
Altitude: 42 to 1,500 feet MSL

Before you reach the ocean, you reach the great salt marshes of our eastern and southern coasts. Millions of acres are occupied by these transitional land forms that separate the ocean's waves from the still, freshwater inland. Once considered an unattractive wasteland, this is such an important habitat that over the last decade the marshes and estuaries have been heavily protected by federal and state legislation.

No other habitat on Earth, with the exception of tropical rainforests, is as prolific as the marsh. It is the birthplace of much of our sea and coastal fish and bird life.

Each time the tides come in, the marsh grass and mud flats are flooded with nutritious sea creatures. When the tide recedes, shorebirds, raccoons, and others come to forage on the mud flats.

As important as the salt marsh is to sea and coastal life, it is also a spectacular sight from the air. In the early and late parts of the day, as the sun's rays skim across the water and grasses, the patterns come alive with glistening highlights. In the winter months the cordgrass becomes a golden hue of tan and the water varies from dark, muddy browns to strips of deep blue. From time to time, as we fly, we are investigated by one of the salt marsh's most common residents, an estimated eight hundred thousand ducks!

Date: December 18
Location: Cumberland Island National Seashore, Georgia
Flight time: 5:00 p.m. EST
Visibility: Clear
Conditions: Light wind, 60°F
Base of operation: St. Simons/Brunswick Airport
Field elevation: 20 feet MSL
Altitude: 20 to 2,500 feet MSL

What a pleasure to escape the cold winds of Kentucky just before Christmas for a few days around beautiful St. Simons Island, Georgia. The salt marshes and tidal plains of the Georgia coast provide a great place to enjoy the warm temperatures.

Flying out of the airport, it is only a short hop to Cumberland Island and to explore the south Georgia coast.

The Barrier Islands have helped to establish this very valuable resource to the eastern fisheries population—the great and thin salt marshes of the lower East Coast.

This series of marshes shelters the coast from harsh storms that frequently come in from the sea. They also have provided a great sanctuary for wading birds. Thousands of pairs of egrets, herons, and ibis have established rookeries along this and the South Carolina coasts.

Mud flats along the Georgia coast of Cumberland Island at low tide.
Bill Fortney

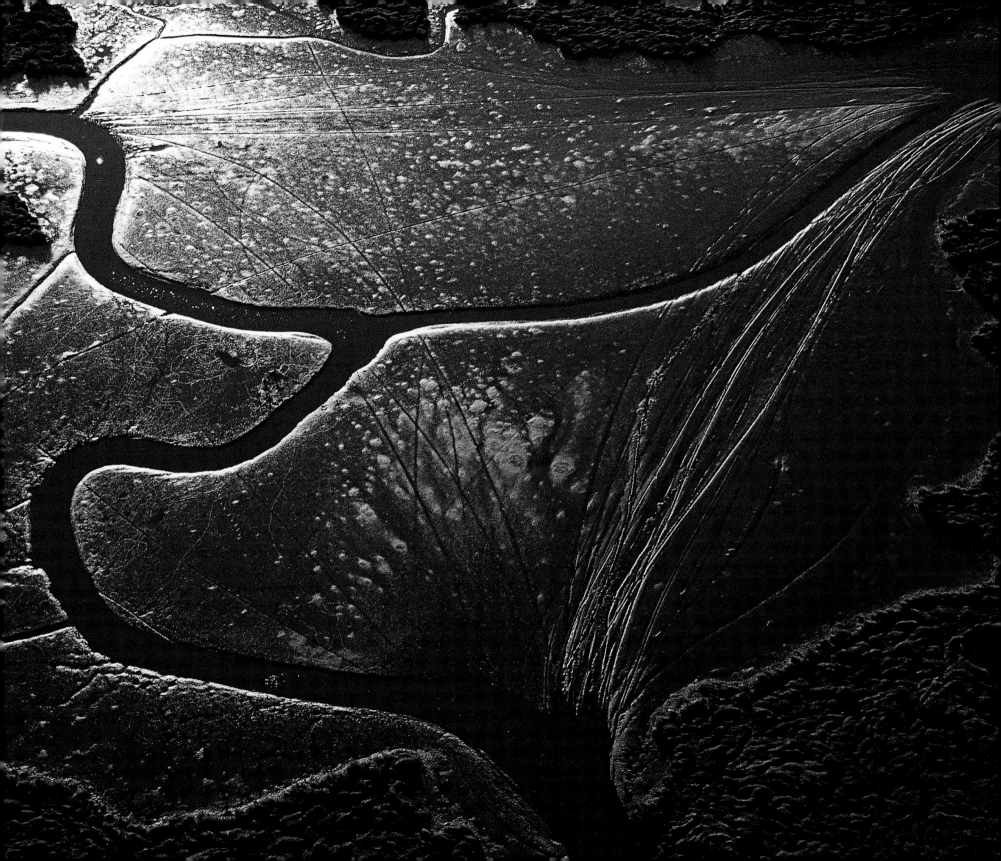

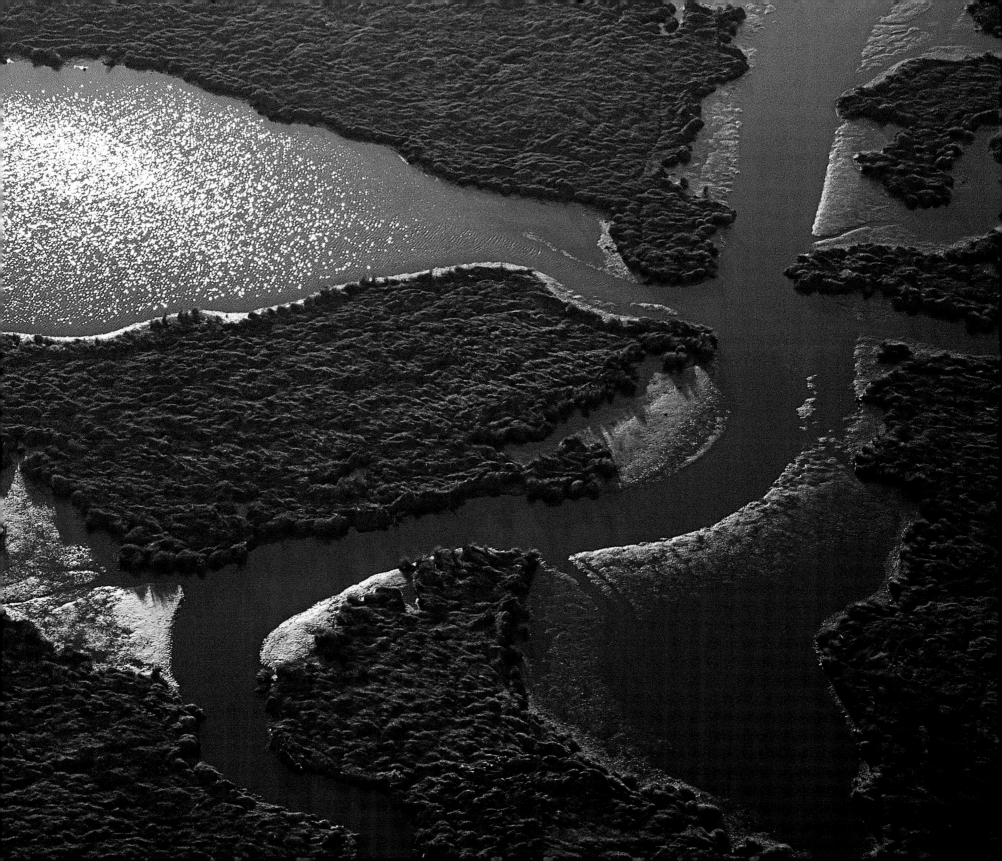

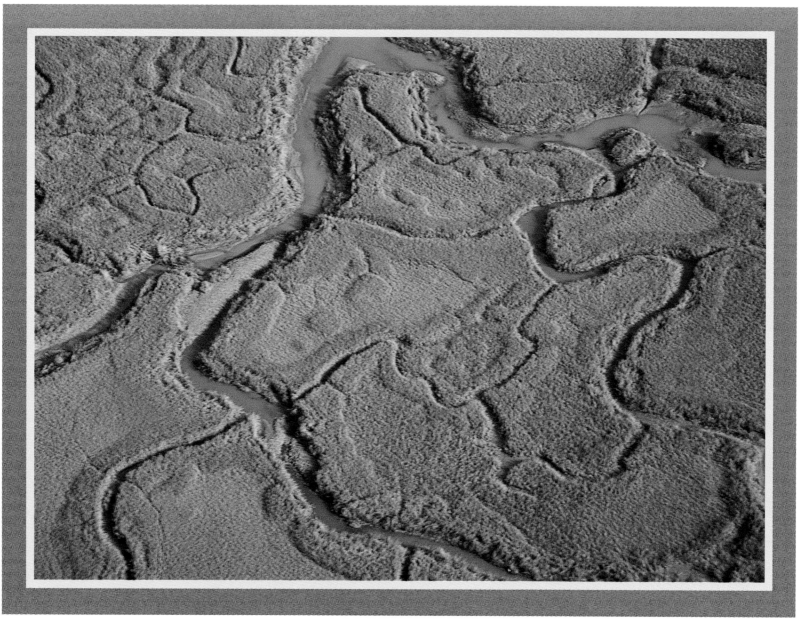

Salt marshes along the Georgia coast.
Bill Fortney

Georgia mud flats and sawgrass bathed in evening light.
Bill Fortney

143

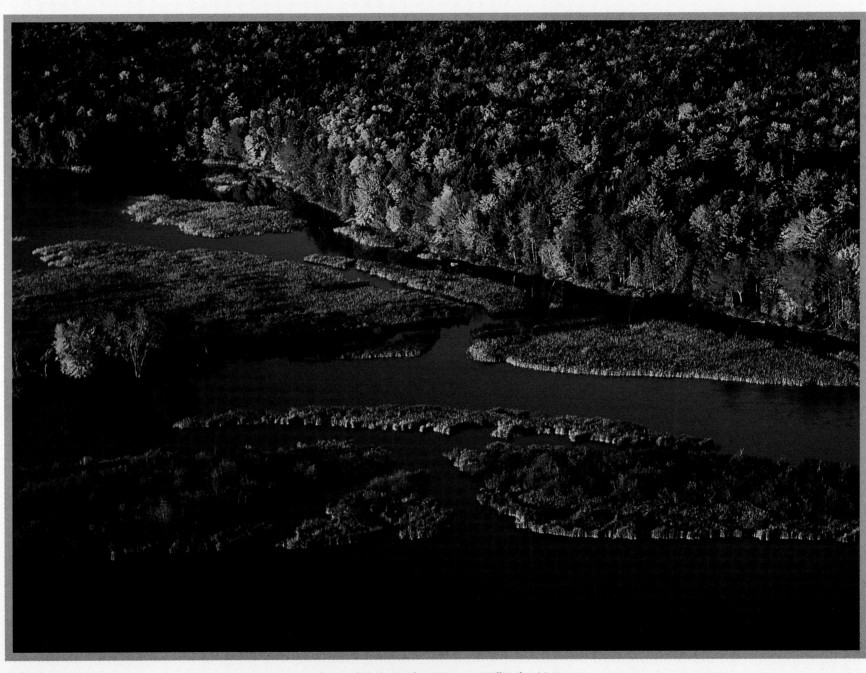

Fall color along the Penobscot River near Millinocket, Maine.
Bill Fortney

PILOT'S LOG

Date: October 4
Location: Baxter State Park, Maine
Flight time: 6:30 a.m. EDT
Visibility: Clear
Conditions: Light winds
Base of operation: Millinocket Municipal Airport
Field elevation: 409 feet MSL
Altitude: 409 to 1,500 feet MSL

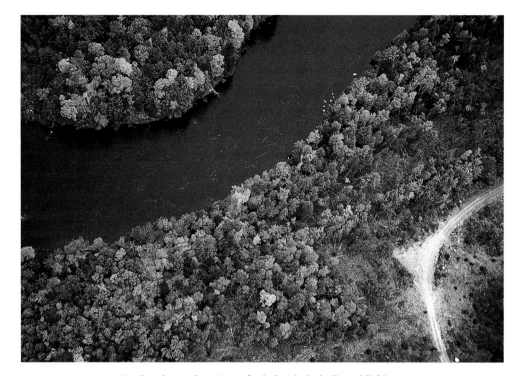

Bend in the Penobscot River, flanked with the brilliant fall foliage.
Wesley Fortney

Wesley and I arrived in Millinocket feeling a little desperate. We had spent several days in the region and did not have any great fall color. Callier Weeks, the airport manager, and Jeff Campbell, a great local ultralight pilot, took us under their wings and helped us with the use of a hangar space overnight and lots of encouragement.

The forecast was for more rain and winds within a day. We knew that this morning might be our only chance to fly. The color along the Penobscot River was spectacular and we could only hope for good flying conditions. As God often did, he blessed us with a perfect morning! It was cold but not unbearable, and very calm and clear.

Baxter State Park, a wilderness area of over 200,000 acres, was a gift to the state of Maine by former Governor Percival P. Baxter. The rugged park is a paradise for the naturalist, mountain climber, hiker, and photographer.

It has been said that you haven't seen fall color until you see it in Baxter State Park.

Well, from our experience, I would say Amen! 🪶

145

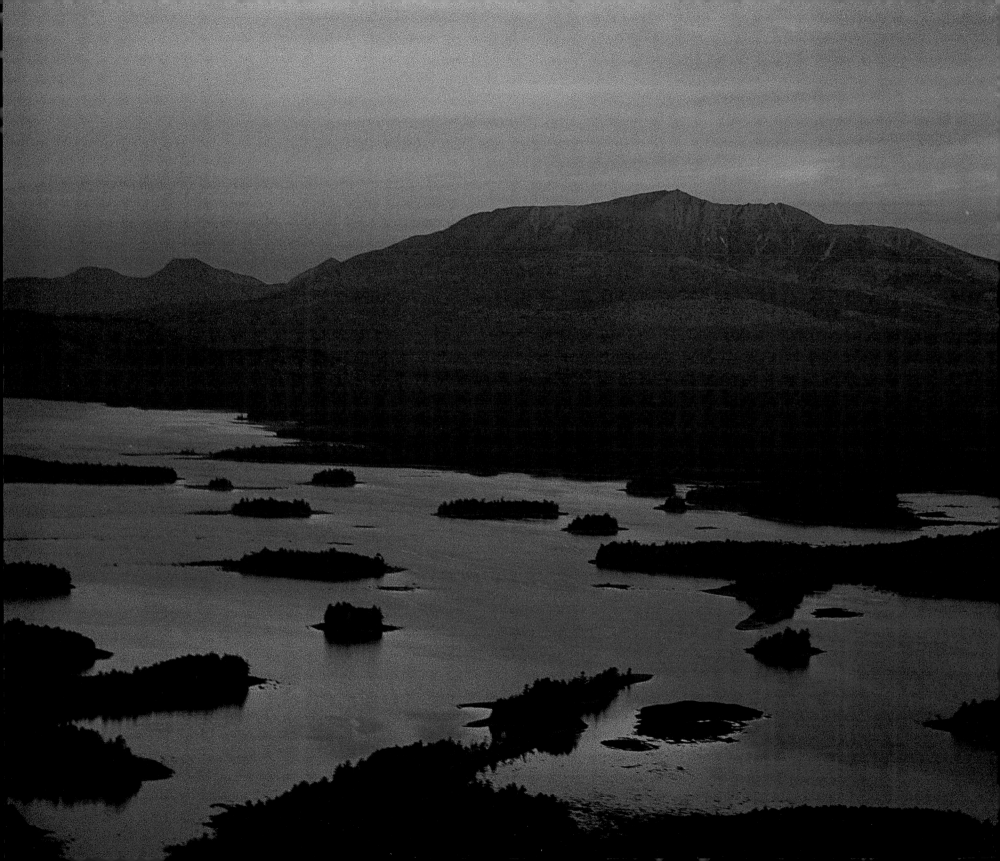

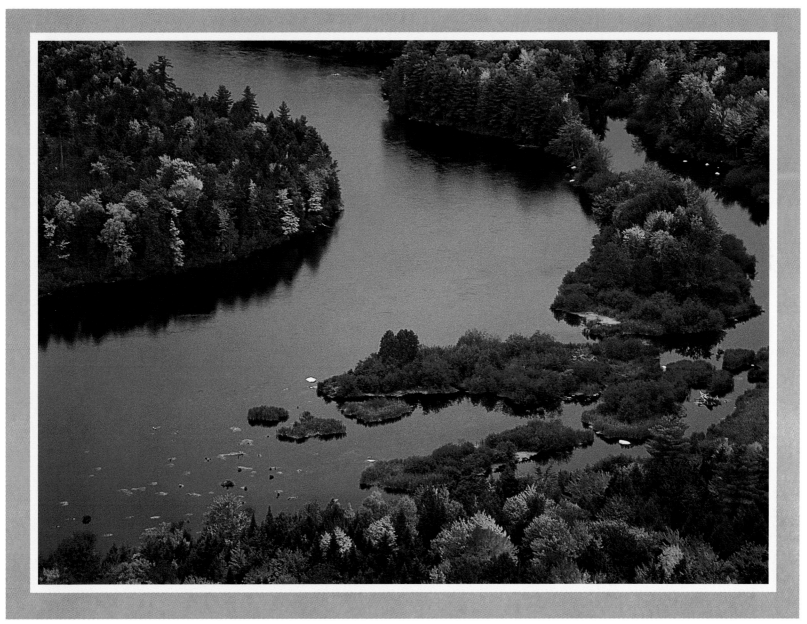

Fall color along the Penobscot River, Maine.
Wesley Fortney

Mount Katahdin and nearby lakes at sunrise, Baxter State Park, Maine.
Wesley Fortney

147

PILOT'S LOG

Date: November 29
Location: Bombay Hook Wildlife Refuge, Delaware
Flight time: 7:20 a.m. EST
Visibility: Clear
Conditions: Moderate, gusty winds up to 8 knots
Base of operation: Chandele Estates near Dover
Field elevation: 22 feet MSL
Altitude: 22 to 1,000 feet MSL

The film *Fly Away Home* with its splendid aerial film work was the inspiration to attempt this project. After fourteen months of driving and flying we were at one of our last two flights for the book, Bombay Hook Wildlife Refuge near Dover, Delaware. This happens to be one of the shooting locations for the film!

In November and December of each year hundreds of thousands of snow geese migrate down the East Coast of the United States. Many winter in these marshes near Delaware Bay, while others continue south.

From the moment I saw the film I dreamed of flying with and photographing the geese.

This morning that dream came true. It was pretty cold but I never seemed to notice while, from a thousand feet, I looked down on thousands of geese flying over the beautiful canals of the refuge. When we first flew into the area the geese were 500 feet above us. They soon went lower and we were able to keep a very safe distance from them and photograph from above.

What a thrill! 〕⌒

Snow geese over the Bombay Hook Wildlife Refuge, near Dover, Delaware.
Bill Fortney

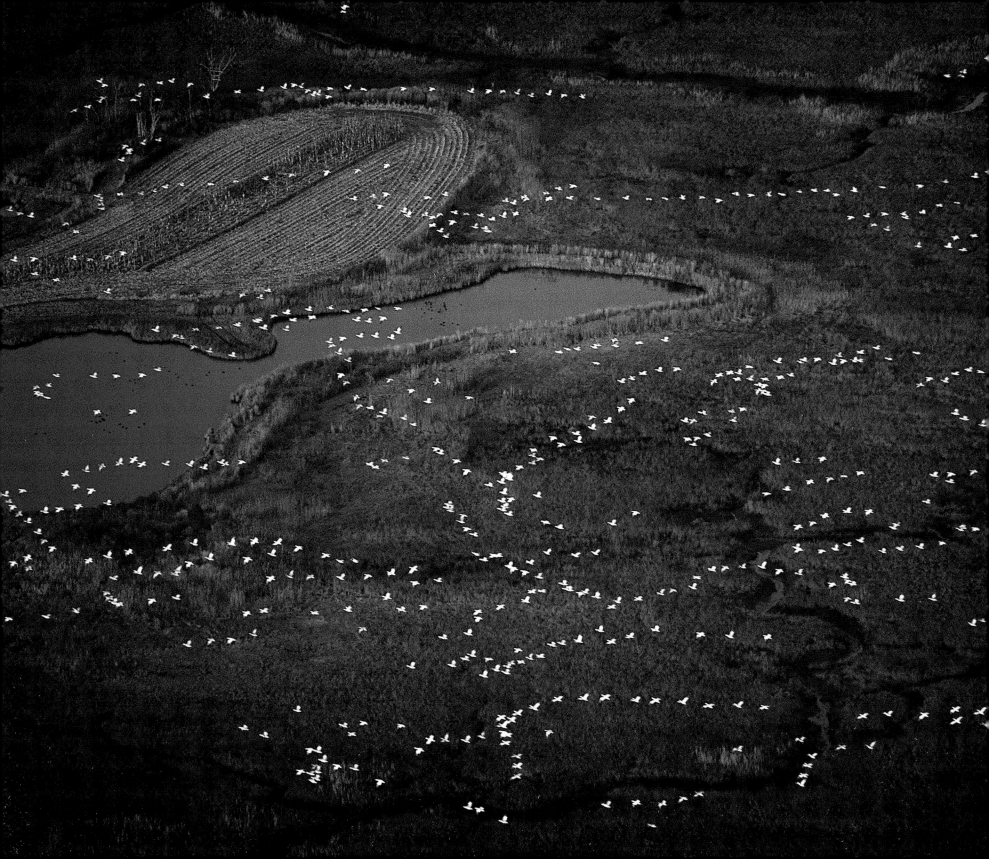

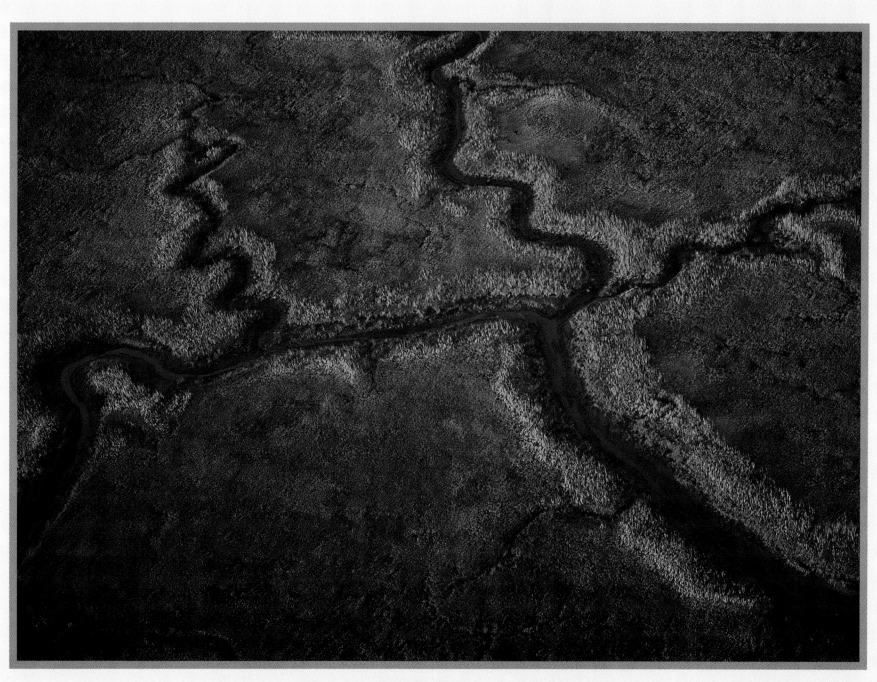

Marsh patterns, Bombay Hook Wildlife Refuge, near Dover, Delaware.
Bill Fortney

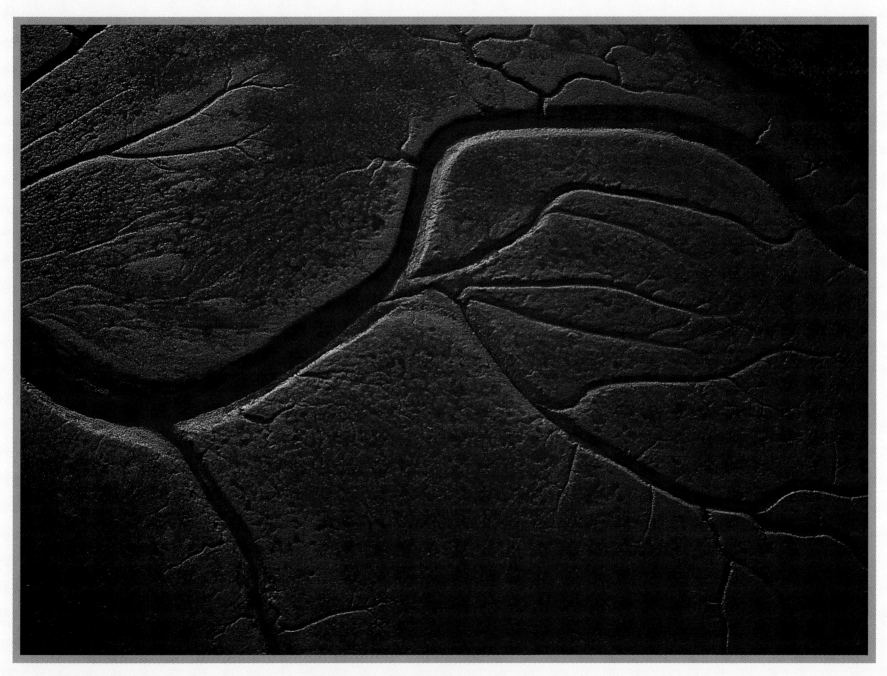

Mud patterns at low tide on the Atlantic coast near Dover, Delaware.
Bill Fortney

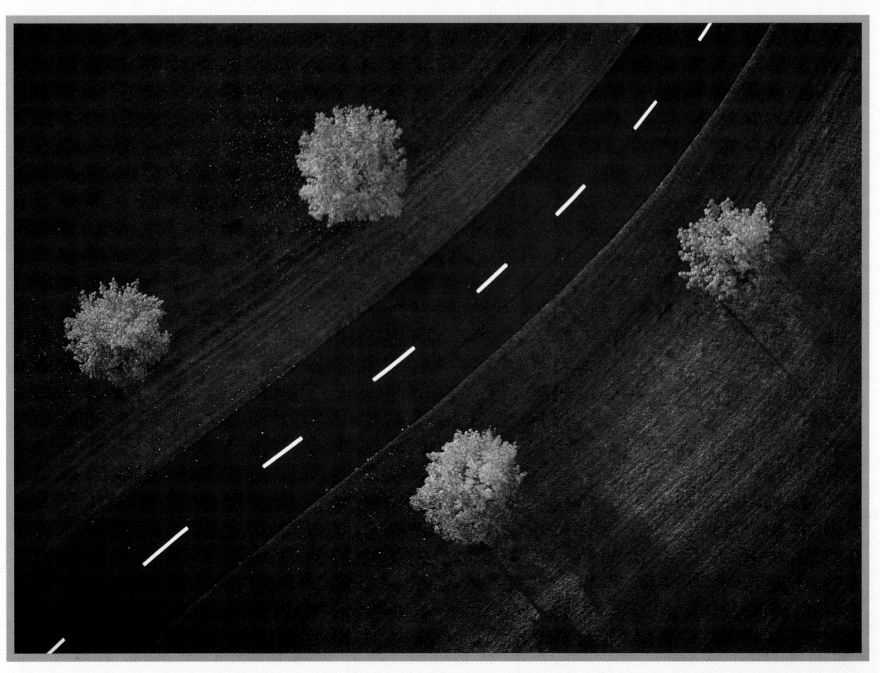

A freshly paved road and fall trees combine into an unusual symmetry near Kutztown, Pennsylvania.
Bill Fortney

Date: October 15
Location: Kutztown, Pennsylvania
Flight time: 6:45 a.m. EDT
Visibility: Broken clouds
Conditions: 12 knot winds aloft
Base of operation: Kutztown Airport
Field elevation: 512 feet MSL
Altitude: 512 to 1,200 feet MSL

Of all the airports we flew from, this one will forever stick in my memory. When we first pulled in we could see the runway stretching out into the distance, looking like a roller coaster track! It had a couple of hills in it and the beautiful, smooth asphalt strip just stretched out and over them. Since our plane usually only takes about 150 to 200 feet to get airborne we had no problems, but it sure was fun watching the Cessnas hop over the hills.

The very late fall foliage combined with the ready-for-harvesting fields gave us lots of chances for great photographs.

Once you're in the air, the Pennsylvania Dutch farm country is a great place to fly. It was Sunday morning and we saw Mennonites in their buggies going to church among the soft contours of the expansive farm country.

We met an ultralight instructor named Art Tarola and had a lot of fun frolicking in the sky with him over what has to be one of the spots in America you can truly call God's Country.

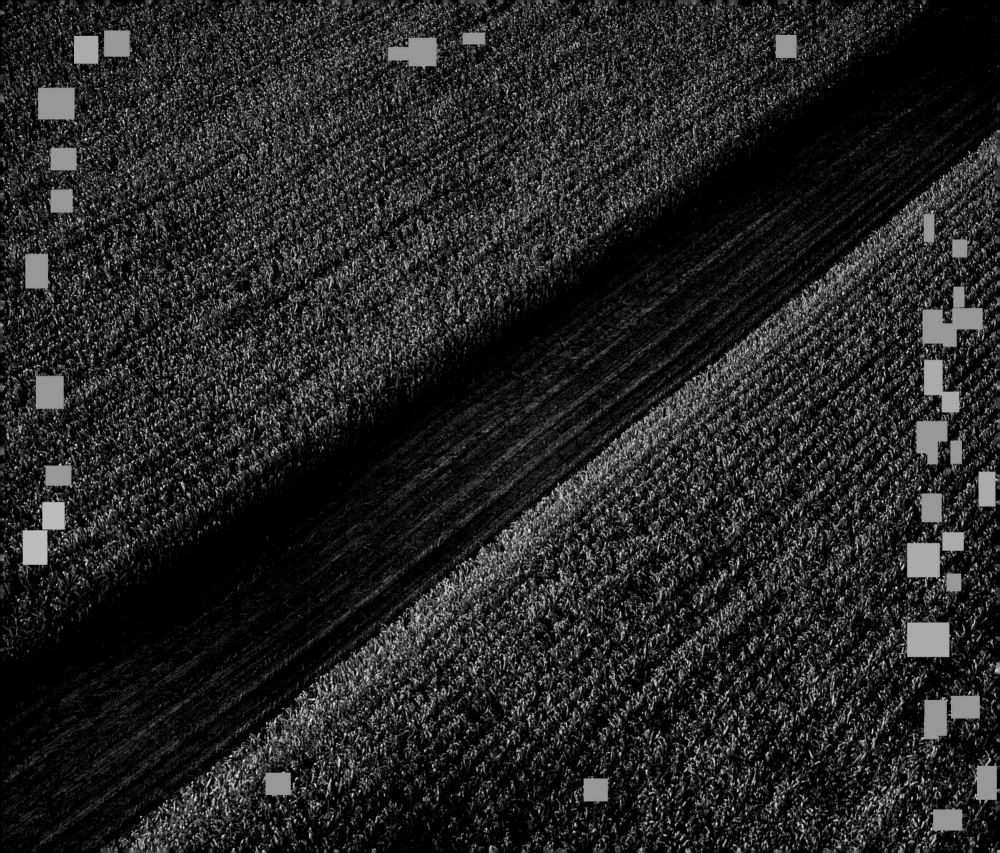

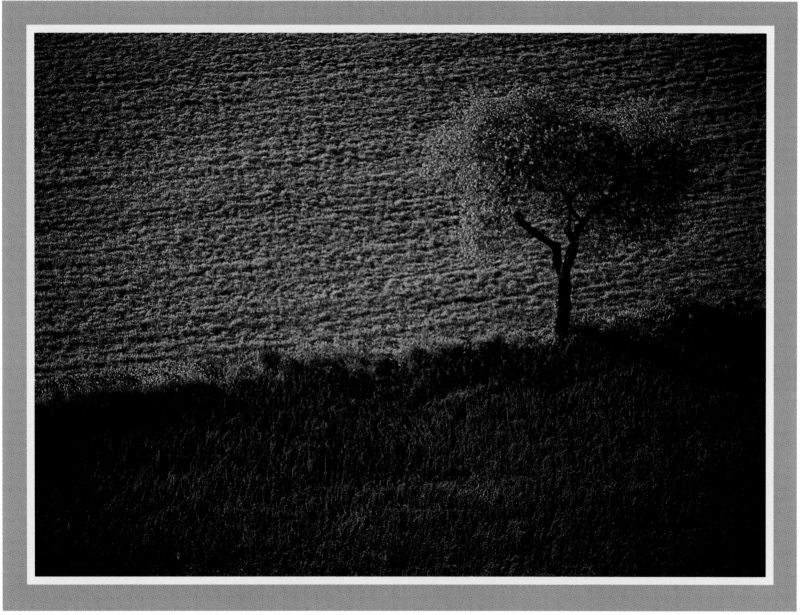

This single tree seems to stand guard over the crop line near Kutztown, Pennsylvania.
Bill Fortney

Fall grain crops in rows create interesting patterns in the Pennsylvania Dutch farmlands.
Bill Fortney

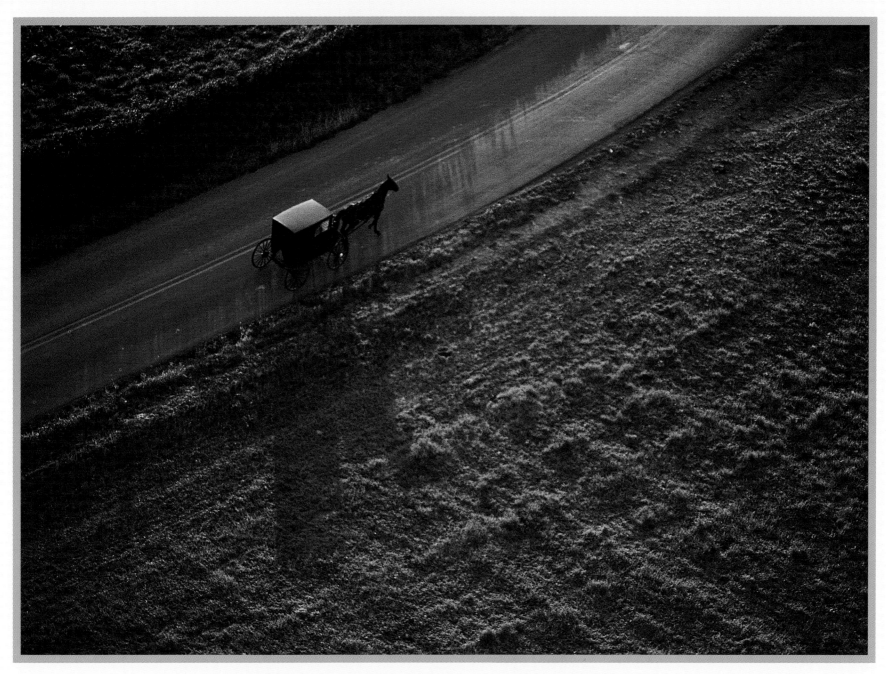

A Mennonite farmer going to church on a Sunday morning in the Pennsylvania Dutch country.
Bill Fortney

Intricate crop patterns near Kutztown, Pennsylvania.
Wesley Fortney

"To love what you do and feel

that it matters—how could anything be more fun?"

Katharine Graham

Varied crops and their differing harvesting times create unique farm patterns in Pennsylvania.
Bill Fortney

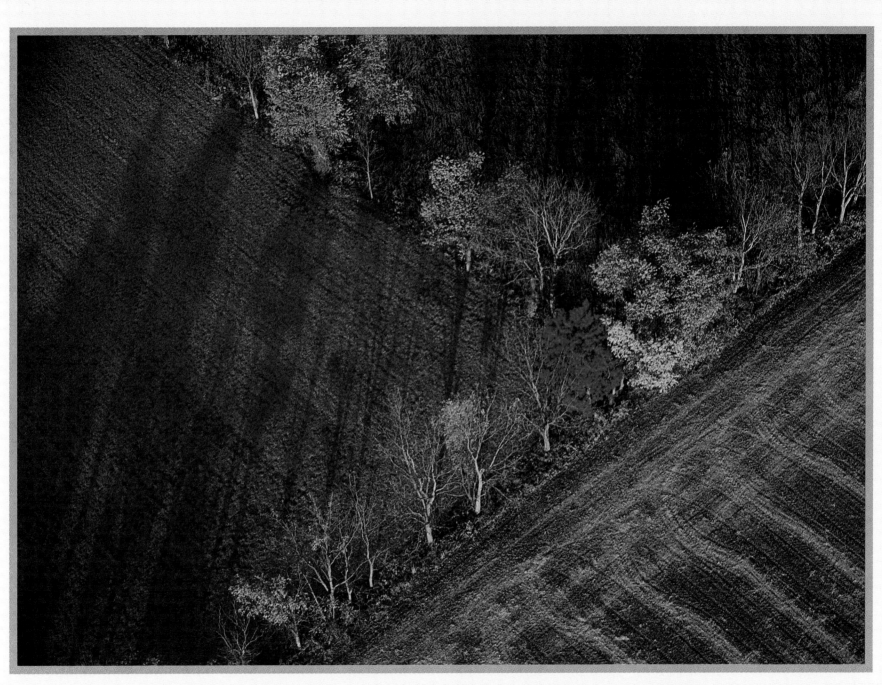

Nature can surely get your attention with a dot of bright red among these Pennsylvania farm patterns and other fall foliage.
Bill Fortney

159

PILOT'S LOG

Date: October 15
Location: Shenandoah National Park, Washington, D.C.
Flight time: 6:00 p.m. EDT
Visibility: Broken clouds, smog
Conditions: Calm
Base of operation: Luray Caverns Airport
Field elevation: 902 feet MSL
Altitude: 902 to 4,200 feet MSL

Arriving no more than an hour before sunset, we were frantic but managed to put the trike together. There was only time for one flight and Wesley took the opportunity.

The smog was very heavy from the Washington, D.C., area so there was only one direction to shoot—west, at the setting sun over the western ridge of the Shenandoah Valley, with some reflection in the Shenandoah River below.

He had to climb up to over 4,000 feet MSL to get the shot he wanted. Flying at high altitudes in an ultralight can be surreal and scary—and Wesley said this flight was both! ✍

First light in mist, Shenandoah National Park, Pennsylvania.
Wesley Fortney

160

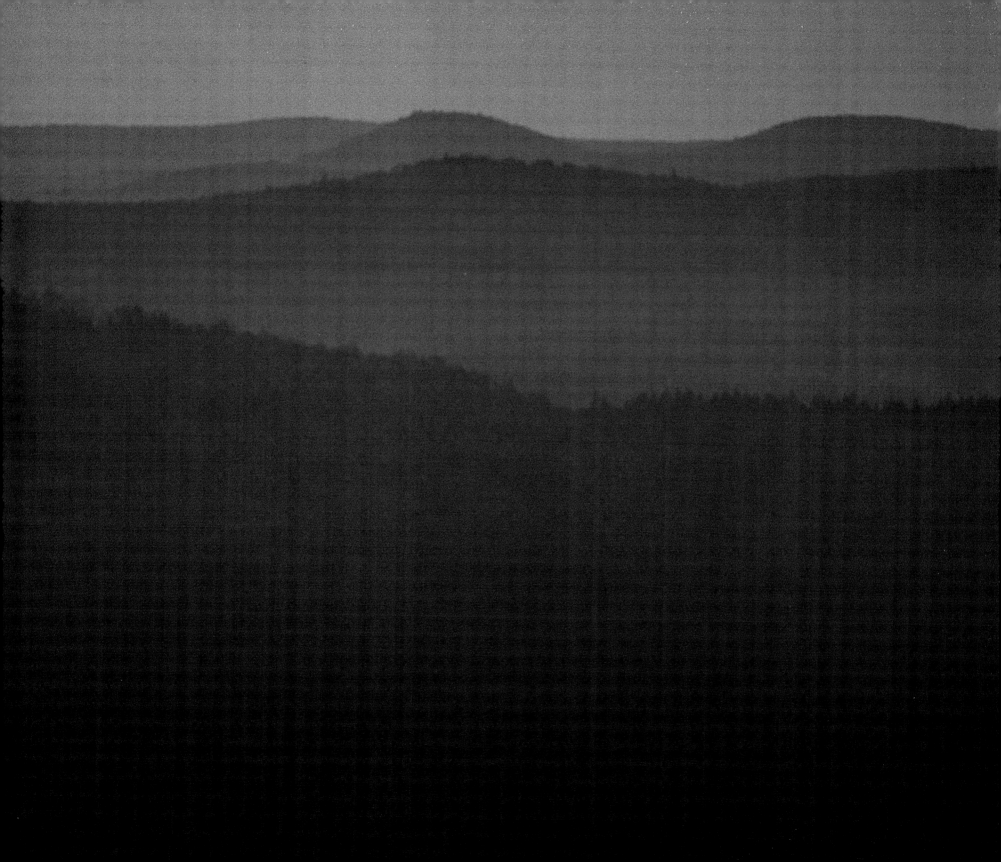

Late afternoon, Shenandoah National Park.
Wesley Fortney

Sunset over mountains in Shenandoah National Park.
Wesley Fortney

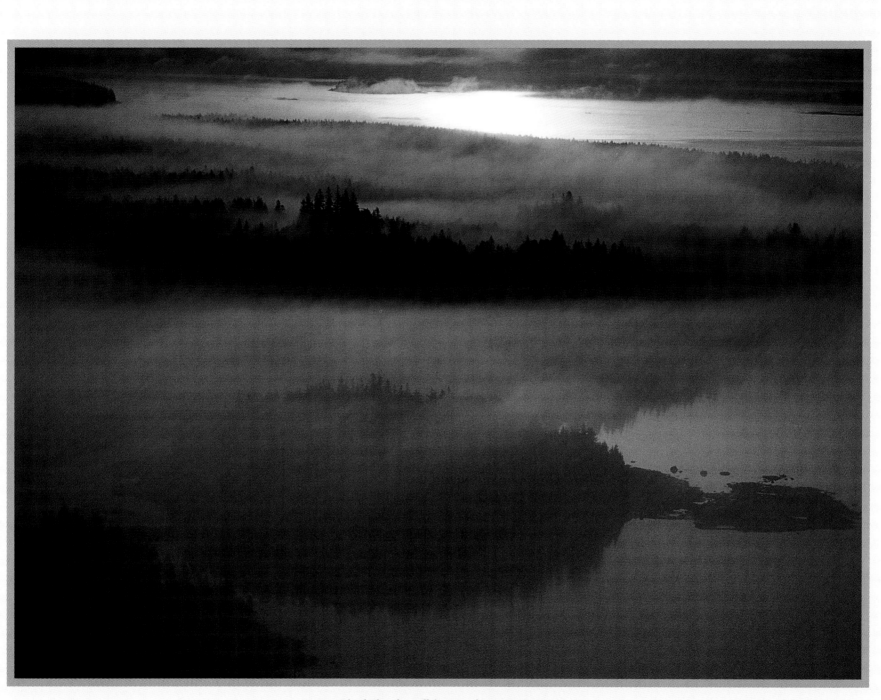

Deer Island Thorofare, off the coast of Stonington, Maine.
Wesley Fortney

PILOT'S LOG

Date: October 3
Location: Stonington, Maine
Flight time: 6:30 a.m. EDT
Visibility: Heavy ground fog, moderate clouds
Conditions: Calm
Base of operation: Stonington Municipal Airport
Field elevation: 30 feet MSL
Altitude: 30 to 1,300 feet MSL

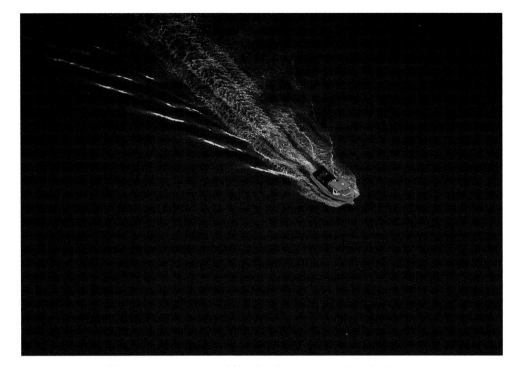

The morning commute—a fishing boat heads out to sea from Stonington.
Bill Fortney

Deer Island and Stonington are "downeast" Maine at its best. The island is reachable by auto over a high, narrow suspension bridge. Clustered in the area are quiet communities where fishing is still the mainstay of the economy. In fact, fishing boats still out-number yachts and sailboats!

The spruce-crowned pink granite ledges, dense woods and open fields, vistas of islands and sparkling water provided more than a few unparalleled photographic opportunities.

Imagine taking off and flying over a peaceful paradise—one of the most picturesque sea coast villages anywhere! That's just what we did this morning.

The low-lying ground fog was a major plus to the views that abound along this lovely coast. The Stonington Airport was a great field, and the surrounding area yielded more pictures than we ever imagined possible. Wesley and I were each able to get in almost an hour of flying during this stop in Stonington.

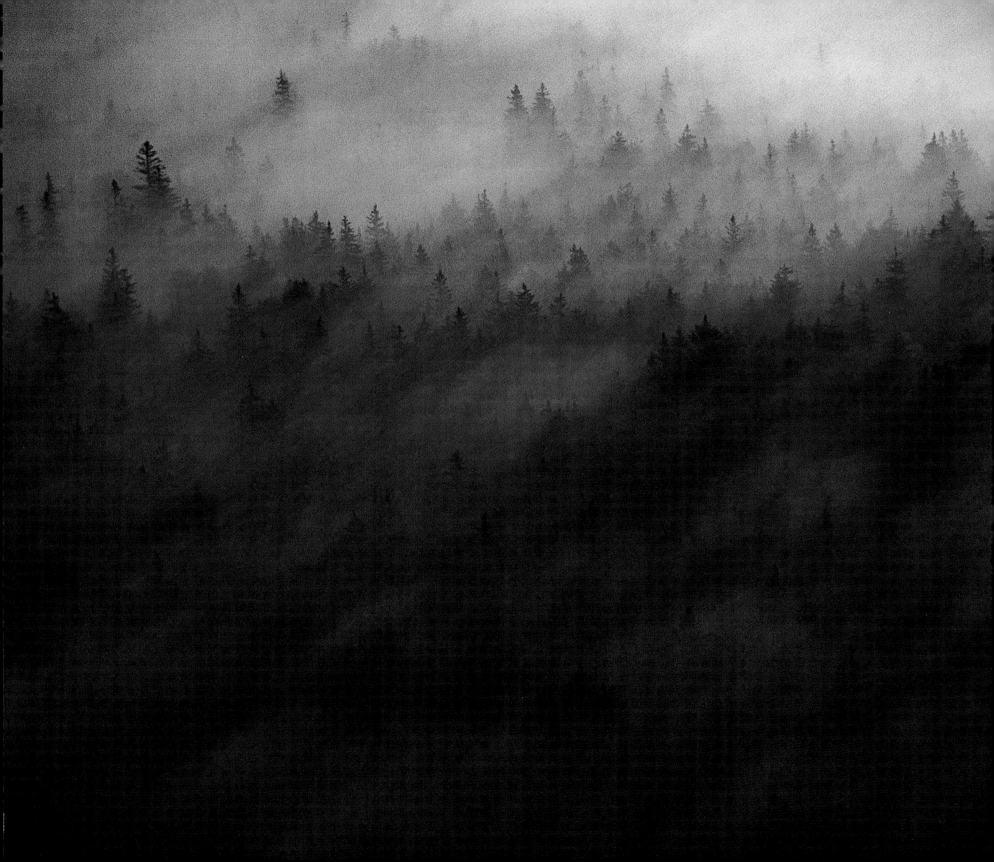

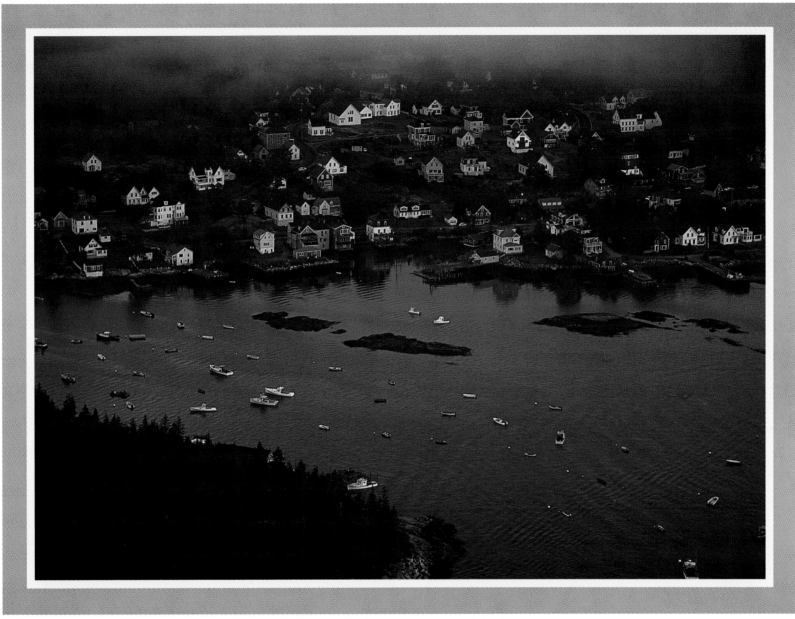

Quiet and lovely Stonington Harbor at daybreak.
Bill Fortney

Deer Island forest takes on a mystical aura when enveloped by ground fog.
Bill Fortney

Marsh and fall color in the Maine forest, near Stonington.
Wesley Fortney

"If I am very, very careful,
nothing good or bad
will ever happen to me . . ."

Anonymous

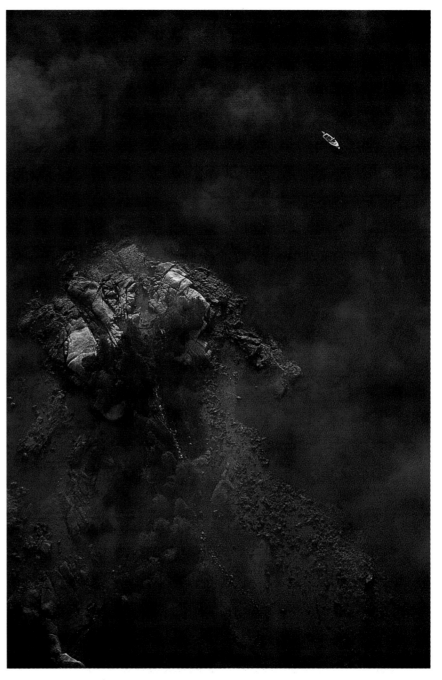

This single boat is careful to stay out of danger in the rocky coastal area near Stonington.
Wesley Fortney

169

Date: October 8
Location: White Mountains, New Hampshire
Flight time: 5:00 p.m. EDT
Visibility: Partly cloudy
Conditions: Moderate, gusty winds up to 10 knots
Base of operation: Gorham Airport
Field elevation: 835 feet MSL
Altitude: 835 to 1,900 feet MSL

After being grounded for a few days I was both eager to fly and nervous that we were running out of time to get representative photographs of this beautiful area. It is also known as the Presidential Range because the major summits are all named for former presidents.

*These mountains also produce their own weather,
which made for a rainy and blustery visit.*

However, the weather broke just long enough for us to fly and photograph the late-afternoon light streaming across one of the foothills leading up to Mount Madison.

We had the company of friend and colleague Ian Dicker at the time of this flight. Ian, who is based in the Boston area, has designed and maintained our website throughout this grand adventure. For him to be able to share the action was very satisfying—for both of us!

White Mountains of New Hampshire in late afternoon.
Wesley Fortney

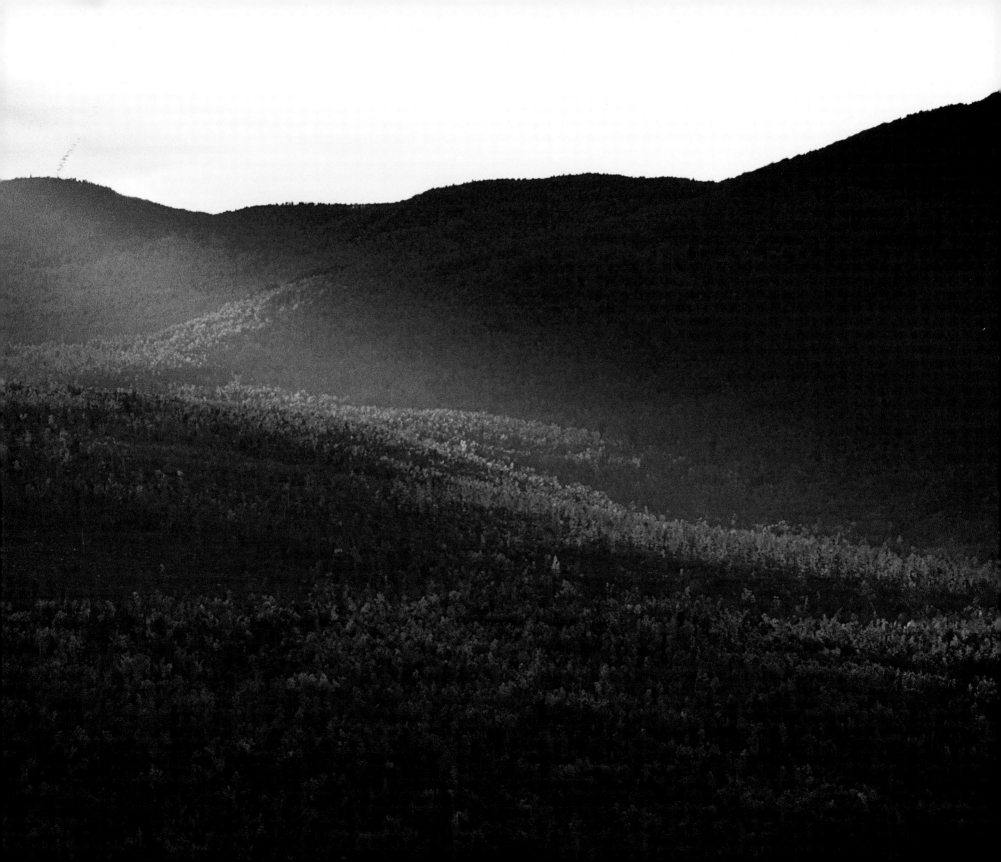

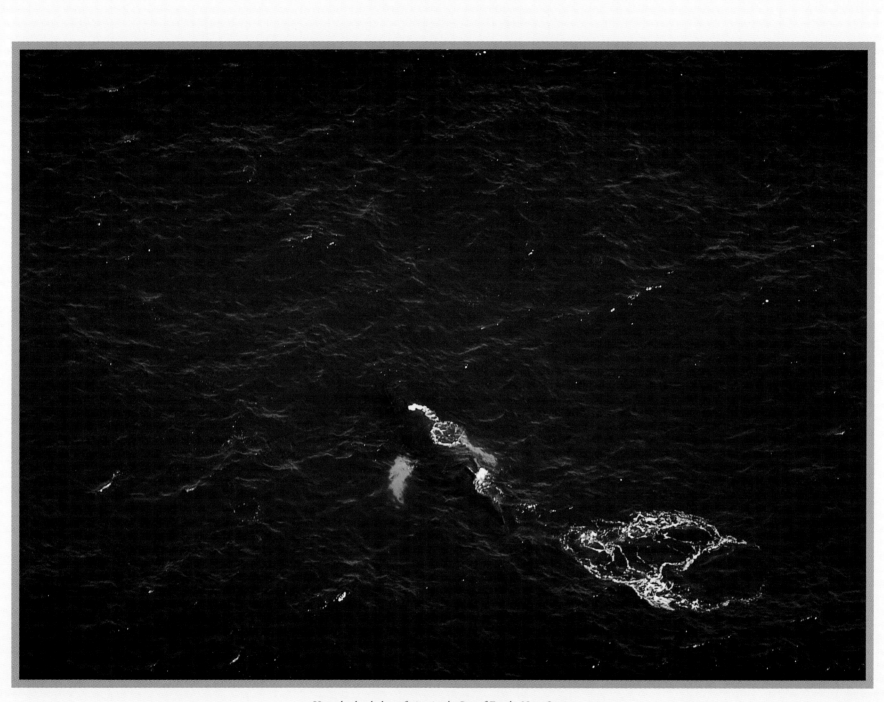

Humpback whale surfacing in the Bay of Fundy, Nova Scotia.
Bill Fortney

PILOT'S LOG

Date: September 30

Location: Bay of Fundy, Nova Scotia

Flight time: 9:00 a.m. Maritime

Visibility: Clear

Conditions: Moderate, gusty winds up to 19 knots

Base of operation: Digby Airport

Field elevation: 499 feet MSL

Altitude: 499 to 3,500 feet MSL

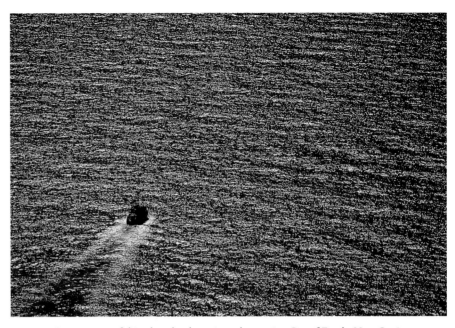

Going to sea, a fishing boat heads out in early morning, Bay of Fundy, Nova Scotia.
Bill Fortney

This morning, we rented a Cessna and hired a pilot to do something rather spectacular—take us whale watching! Since the beginning of the project I had had this vision of flying over humpback whales. It turns out that the best place to find whales at this time of the year is in the Bay of Fundy about twenty miles from shore. It would be too long a flight for our ultralight over such cold water!

We flew for nearly two hours with no sign of a whale, so we decided to head in and regroup.

Then, right below us, we saw a mother and her calf.

We made several tight turns and I burned film like crazy. This was one of the most wonderful moments of the project—what magnificent animals and what a great thrill to watch them glide through the water! ⟩

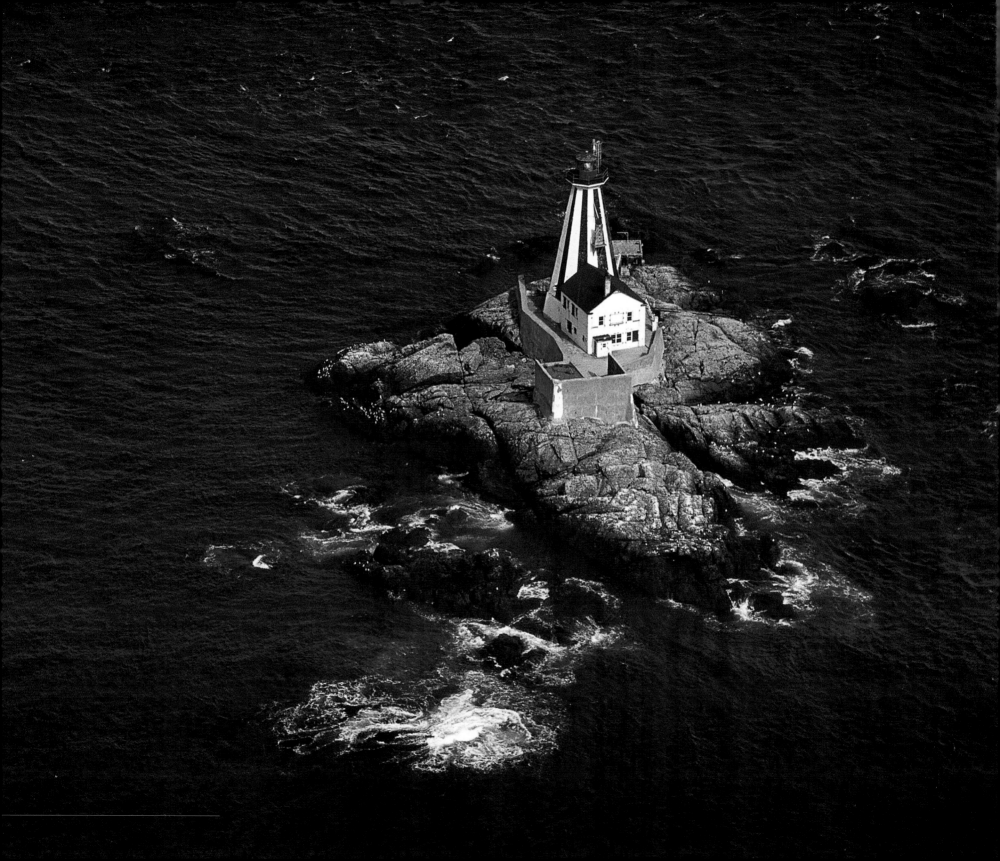

Clear water in the bay of a coastal community, Bay of Fundy, Nova Scotia.
Bill Fortney

Lighthouse on the coast of New Brunswick.
Bill Fortney

PILOT'S LOG

Date: December 13
Location: Everglades National Park, Florida
Flight time: 5:00 p.m. EST
Visibility: Clear with broken clouds to the east
Conditions: 5 knot wind
Base of operation: Everglades City Airport
Field elevation: 5 feet MSL
Altitude: 5 to 1,500 feet MSL

Well, this is it—the last flight for the book! With the deadline past, we left yesterday to drive the 978 miles to the Everglades. We checked into a motel and headed straight to Everglades City Airport, a little 2,400-foot strip right on the Gulf Coast. I wanted to fly our plane for the last "mission," but I decided against it due to the lack of nearby safe landing spots. So in keeping with our sworn policy of safety first, I opted to hire an excellent local pilot to fly me to our shoot destinations. It turned out to be a great flight with John Apte in his Cessna 170.

The Everglades get their nickname "the river of grass" from the thousands of square miles of sawgrass dotted with hammocks of hardwoods and small islands. The wildlife is spectacular with regular sightings of alligators, deer, and a wonderful array of birds. The ponds, sloughs, and drainage courses create wonderful lines and patterns. In the winter the water levels drop and the animals move into higher areas while staying near life-giving water.

This was a wonderful flight and one that I will think back on
for a lifetime as I remember this most incredible adventure.

Winding River, Everglades National Park, near Everglades City, Florida.
Bill Fortney

176

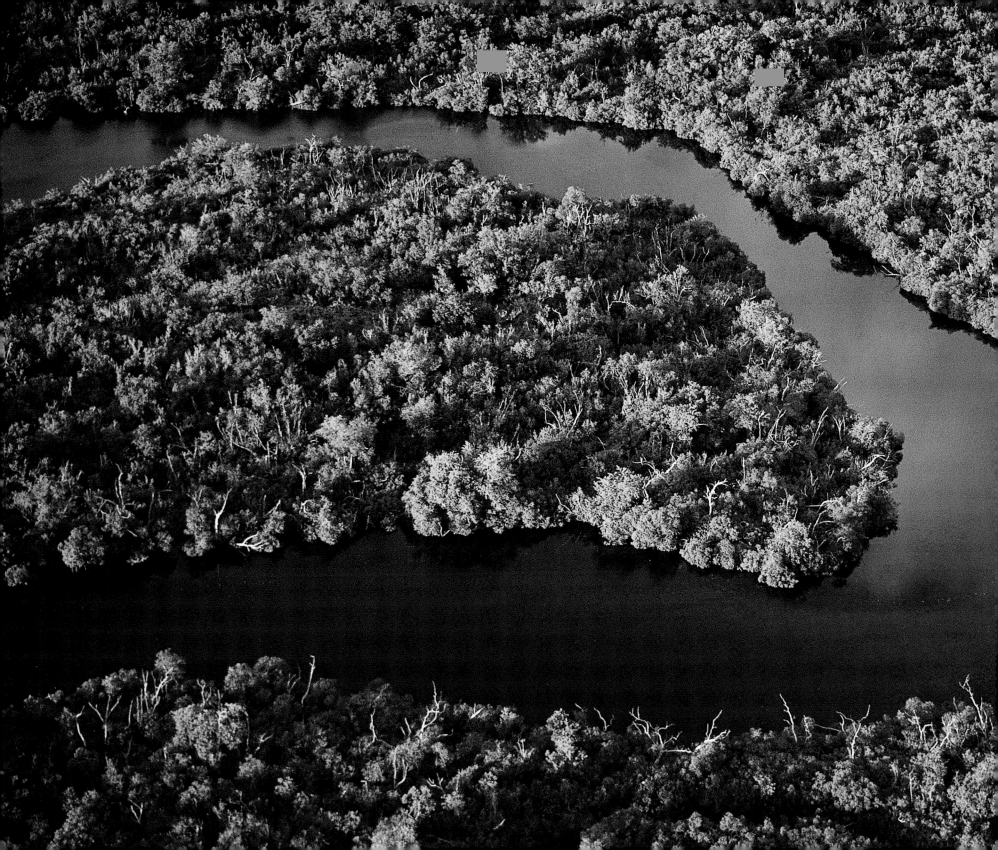

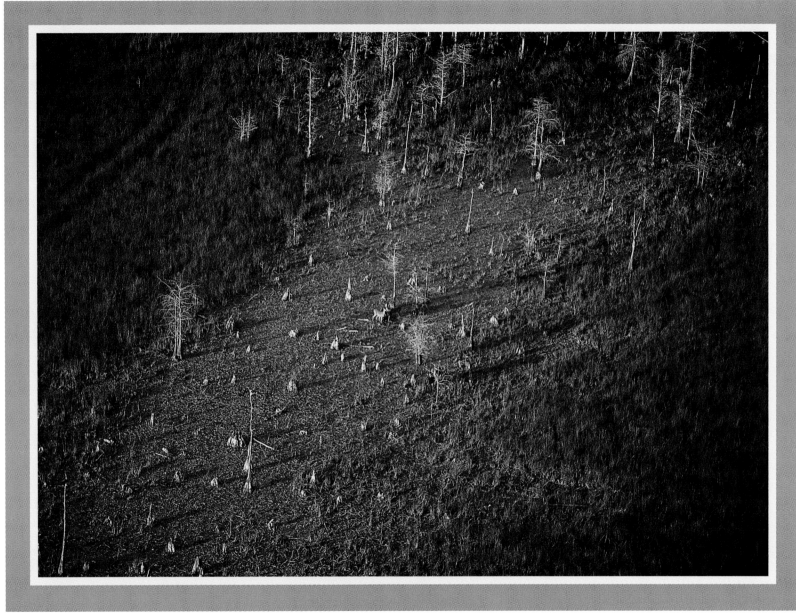

Deer in the Pinelands, Everglades National Park, Florida.
Bill Fortney

Afternoon light and gathering storm over the Everglades.
Bill Fortney

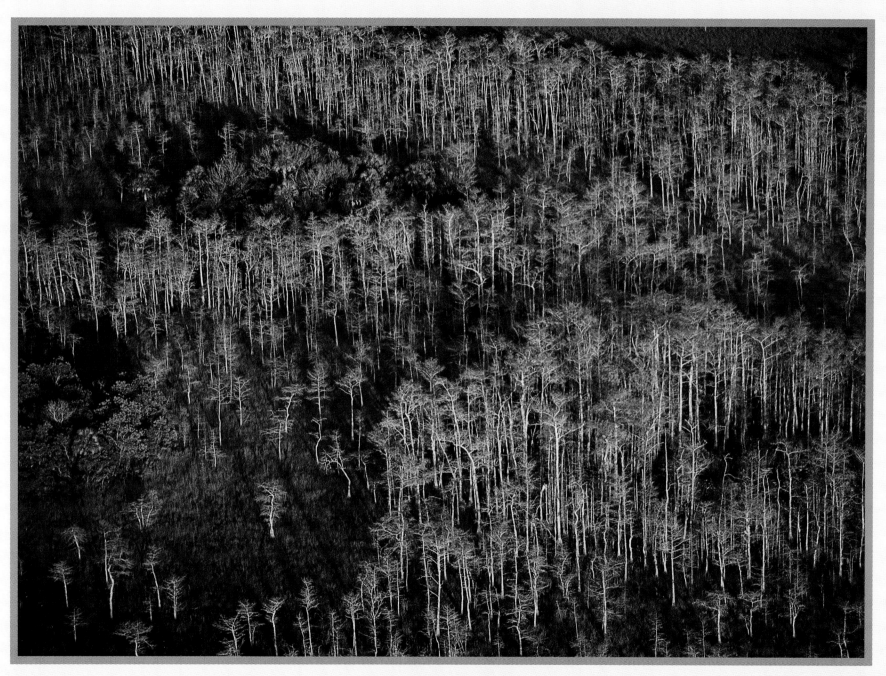

Pinelands forest in the Everglades.
Bill Fortney

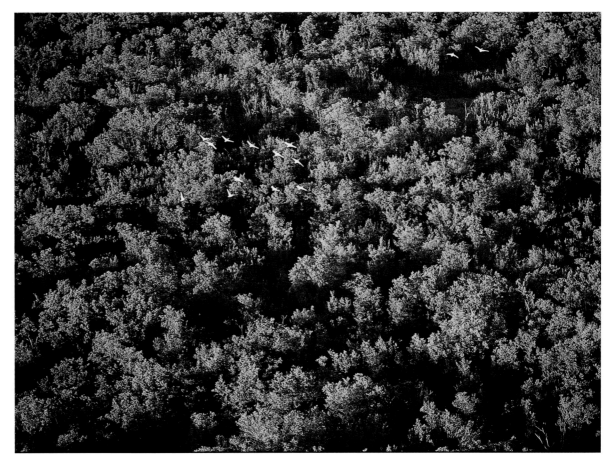

Storks in flight over the thick swamp forests of the Everglades.
Bill Fortney

"For once you have tasted flight,

You will walk this earth with your eyes turned skyward. For there you have been,

And there you long to return."

Leonardo da Vinci

Author's Postscript

Summer wheat and canola in farm patterns in the Palouse Region near Colfax, Washington.
Bill Fortney

December 4

The last package will be sent to the publisher today, after I write these final thoughts. As I come to the end of this experience it is nearly impossible to think of a way to bring it to some sense of closure. The flying has been one of the greatest experiences of my life, and I found our country to be beautiful beyond imagination. I can only hope that the images in our book will bear witness to that. The travel was both wonderful and character testing all at once. Over these months, Wesley and I have both grown as photographers, pilots, and friends.

I was recently asked what I thought was the biggest accomplishment of our project. The list of things we overcame to get this book finished was substantial to be sure. For me it would have to be that I simply never gave up. In the early part of the project lots of roadblocks seemed to be preventing us from seeing our dream come true. The plane crash was my biggest test. As much as I wanted to do this book, a part of me wanted to simply quit. Now over fourteen months, 73,000 miles of driving and countless hours of flying later, I'm so glad I didn't! Among Wesley's biggest contributions may be that he kept encouraging me and never let me throw in the towel. For that I will always be grateful.

We would wish for everyone, that at least once in your lifetime, you experience such a grand adventure and then cherish its memory forever!

Bill Fortney

Escalante Grand Staircase canyon in late light.
Bill Fortney

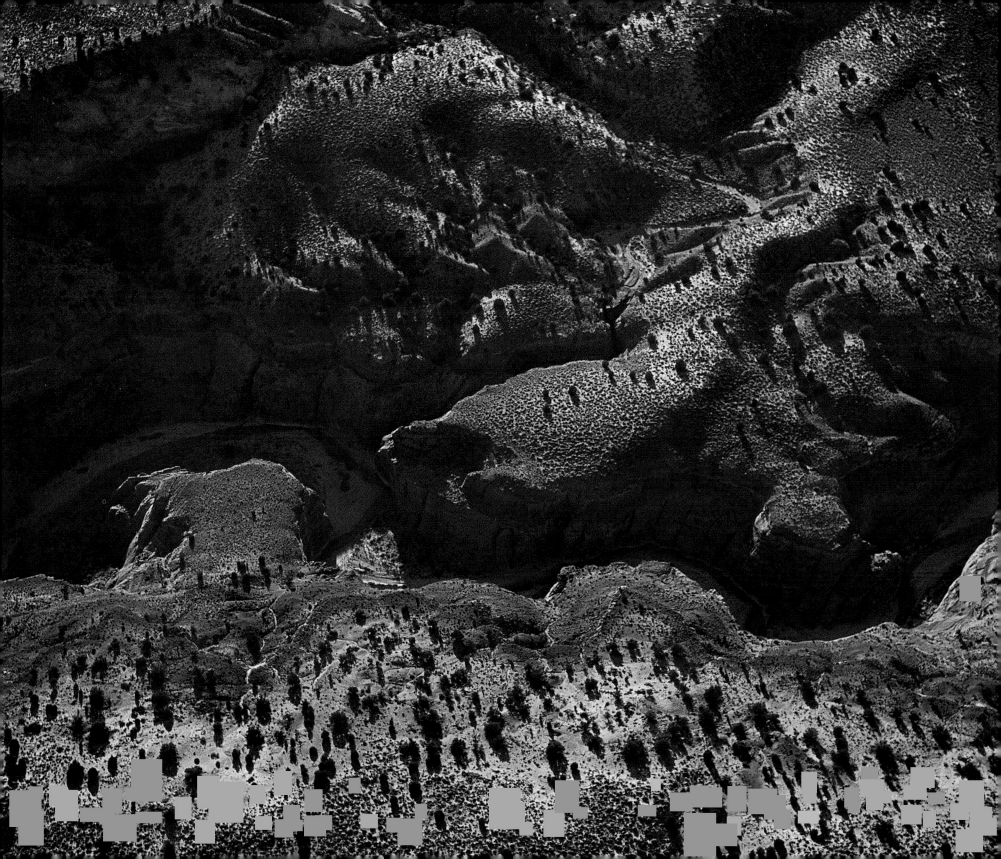

Pilot Notes

When Wesley and I began this project, we were serious nature photographers, and it was our love of nature that made us want to capture photographs from a totally new perspective—from the air. We would take stills for a book and shoot video for a television special. To accomplish our goals, we knew we would have to produce really great images and video, both technically and aesthetically.

We knew that our past experience on the ground would help us deliver the technical quality. And we felt confident that the aesthetic value of the pictures posed no problem, because during almost every trip up in the air we saw fantastic things that would make really good photographs. So we came up with a list of things we thought would be great to photograph from an ultralight. On a few test flights, however, we discovered that some subjects turned out to be rather dull from the air. Fortunately, for every site that didn't make the grade, we saw ten new things we never expected! So we knew we would have a wealth of photographic opportunities during the project—but how would we capture them?

Planes

Of course, flying the plane always has to be the first order of business. We chose the French-made Air Creation Fun Racer 447 trike because it is very stable in calm winds and allows you, at a safe altitude, to take your hands off the control bar to compose the frame and make a few photographs. Our Fun Racer was prepared for the project by Greg Silva of Kemmeries Ultralight Flight Center in Peoria, Arizona. It worked perfectly for the entire project!

This trike is a Part 103 ultralight, powered by a 40 horsepower Rotax 447 engine. The wing is the well-tested and proven Fun 14 meter single-surface wing. This ultralight climbs very well at over 1,100 feet per minute and has a nice, slow ground speed of around 35 to 40 mph, and a top speed of 58 mph. For landing, the Fun Racer stalls at around 23 mph, which is very slow!

We also flew a Pegasus Quantum and a Kolb Firestar II early on. At locations where we felt the ultralight might be too risky to fly, we hired pilots and generally flew in Cessna 152s, 172s, and 182s. On one occasion we used a helicopter. Approximately seventy percent of the images in the book were shot from our ultralight.

Instruments

Our Fun Racer was equipped with a serious array of instruments for an ultralight, including an air-speed indicator, altimeter, engine temperature gauges, a variometer (a highly acccurate electric vertical speed indicator), a magnetic heading indicator, tach and hour meter, flight timer, and a Garmin Model 295 GPS.

The GPS was of particular importance as we often flew from airports where we were not familiar with the area. It was very easy to get busy flying and shooting and not remember the direction back to the airport. We of course studied sectional maps, but it was comforting to be able to follow the GPS heading right back to the runway! We checked the batteries in the GPS constantly and changed them when they were even just a little weak.

The altimeter indicates altitude in MSL (mean sea level). Throughout the book, all of the altitudes and field elevations are given in MSL.

Clothing

We each had flight suits made by OZEE in England (distributed by Rollison Airplane Company). These suits are made from hurricane cloth, which is the English version of Gore-Tex. One suit was lighter, for summer flying, and the other was well insulated for flying in cold weather. I really tested that one on a 45-minute flight at 8,500 feet in 20 degree temperatures—it worked!

We used a Comtronics Model 500 helmet with its full communications package.

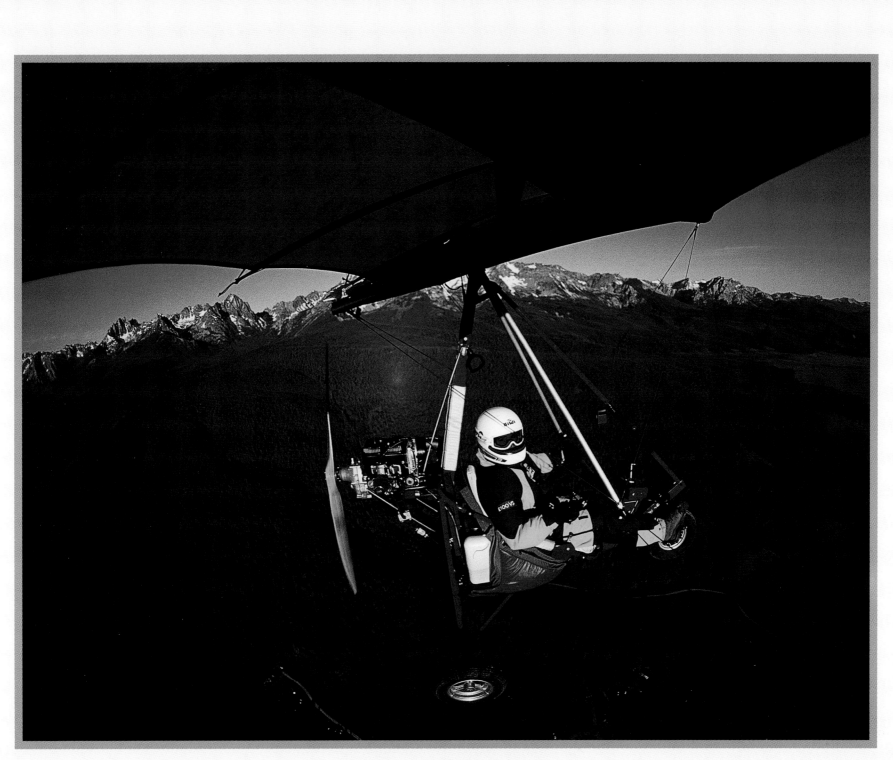

Wesley flying in the Sawtooth Region of Idaho.
Wesley Fortney

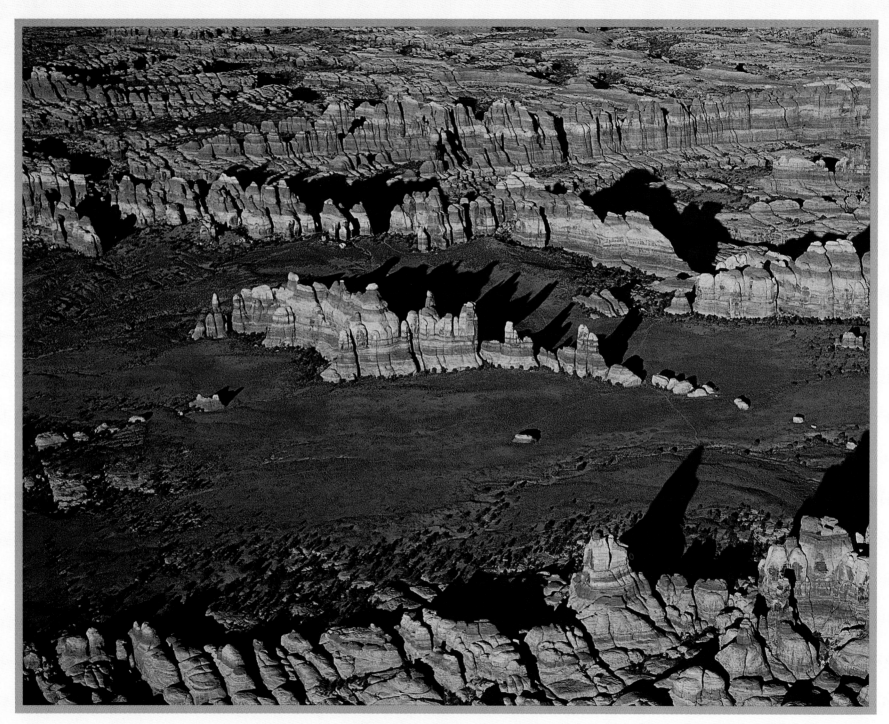

The Needles area of Canyonlands National Park.
Bill Fortney

Airports

Wesley and I flew mostly out of small county airports located close to the shooting destinations. Most runways were paved, but some were grass strips. We also flew from a couple of towered airports. But the added stress of communicating with the tower and needing to look for all the heavy metal in the airport operating area made us really love the little, out-of-the-way strips. The resident pilots were great and the local airport folks—we fondly came to refer to them as airport geezers—almost always went out of their way to help us.

Still Cameras

No matter which of us was shooting from the trike, we each would find a good subject and then circle it to determine the best angle to the sun for shooting. As we did this reconnaissance, we were also carefully watching for other traffic and for any obstructions—like hills, power lines, or radio towers—that would cause major problems.

Once we determined that the sky was clear, we approached the subject from the best angle. If the trike was cruising smoothly, we would let go of the control bar and fire off a few frames.

During flight, we simply kept our camera in our Lowepro S&F Toploader 75AW camera bag, which was attached to the side of the trike. This is a great bag made of tough Cordura nylon, and its zippers can be opened with one hand—a good thing, since the other hand is usually pretty busy! This bag holds a 35mm camera body and up to an 80–200mm zoom lens. The 80–200 zoom was the longest lens we used during our project because of its weight, size, and nearly perfect coverage from our usual altitudes.

The camera itself was also attached to the trike frame by a plastic-covered stainless-steel wire, serving as a safety cable. In the event it should drop, the camera couldn't go far and—most importantly—couldn't go through the prop. Anything going through the prop would definitely ruin our day!

For our regular inflight shots we used an F100 camera with either 28–70mm or 50–135mm Nikon zoom lens. These seemed to work very well at the altitudes we flew, usually between 500 and 3,000 feet AGL (above ground level). When we got over a subject we wanted to photograph we usually had the camera cradled in our lap, ready to start shooting.

Video Cameras

For all of our video work, we used two Sony camcorders. And from time to time we wanted to shoot video looking at the front of the plane in flight, with the ability to see the pilot, trike, and landscape below. We placed one camcorder on the wingtip and a second one on a boom holding it out in front of the trike. John Kemmeries of Kemmeries Ultralight Flight Center made us the boom from an old center-wing batten. It worked great.

The video cameras were attached to the trike by Bogen SuperClamps (Whittenburg Photographic Supply), using the RAM System of articulated arms from Leza-Lockwood Aviation Supply. We used the following pieces: RAM-108B (strap clamp base), Ram-B-202A (Ram Base with 1-inch ball), two RAM 201s (double socket arms) and a RAM-B-230 (double ball connector). We would use the same mounting hardware to shoot still photographs with our Nikon F100 camera, with either an 18mm or 16mm fish-eye lens.

With this setup you can attach just about any still or video camera of suitable size and weight. We found the added cameras made very little difference in the stability of the plane. Some drag pulled us ever-so-slightly toward the camera location, but certainly not enough to make the attached cameras a safety hazard.

Shooting from an ultralight was a great experience. And we would recommend it to anyone. Just fly safe!

Photographer Notes

Making photographs and video from a moving aircraft was a new challenge in my career. I put to good use all my previous knowledge and experience—and learned a lot!

Cameras

All images for this book were made with Nikon cameras and lenses. The vast majority were made with Nikon F100 cameras and a smaller percentage with the Nikon F5 camera. From the ground we shot images of the plane with both 500mm f4 AFS and 400mm f3.5 IFED lenses. For the aerial images, we used 28–70mm f2.8 AFS, 80–200mm f2.8 AFS, 80–200mm f4.5, and 50–135mm f3.5 lenses. For self-portraits with cameras remotely located on the plane, we used Nikon's 14mm f2.8, 18mm f2.8, and 16mm f2.8 lenses. Remote cameras were triggered with the Nikon Modulite infrared firing device, which allows the shutter to be released without wires, using a small remote controller.

Our video equipment consisted of two Sony camcorders, a DCR-PC100 (the first megapixel single CCD camcorder) and the new 3-chip DCR-VX2000. These camcorders use the new mini-DV format, which is a giant leap forward in quality from the previous Hi-8 format. They are very small and light. The mini-DV format offers very high quality video, rivaling that of some broadcast-quality cameras, with over 500 lines of resolution. We did buy a couple of wide-angle attachments for the cameras to take in more of the wing or trike (a Sony .60 and a Kenko .42).

Exposure

Because our plane is a single-seat aircraft we had to put most of our attention to flying the plane, and that made creating photographs very challenging! For the sake of safety we trusted the automatic exposure features of both our still and video cameras. The Nikon F100 and F5 have a wonderful exposure system called Matrix Metering, in which the camera assesses multiple spots in the frame for brightness, contrast, and color and then sets the camera for what it considers optimum exposure for that situation. We found this system to work perfectly about ninety percent of the time. For that other ten percent of the time when we thought the Matrix Metering might not be giving us correct information we did a spot reading to verify it.

We also took advantage of the F100's and F5's ability to bracket exposures and set the camera to give us one-third stops over and under exposures of each shot. With a motor drive that can shoot from 4½ to 7 frames per second, the camera allowed us to have three different exposures of essentially the same frame.

The video cameras have a wonderful auto-exposure system that worked nearly perfectly. This was a good thing, since we could not reach out and adjust them once they were attached to the wing or front boom.

Here is a little tip we learned for focusing the camera. When photographing from the air, you can set your lens at infinity. In fact, if you ever had to focus, it would mean you were a lot closer to the ground than you should be!

Film

All images were shot on Kodak Ektachrome 100VS 35mm slide film, which was chosen for its color vibrancy and push ability. All film was pushed one stop to an ISO of 200 and push-processed by A & I Color Lab in Hollywood, California. All video was shot on Sony Premium Grade DV tape.

Steadying Devices

While nearly all of the still photographs were made by hand-holding the camera, we also used Kenyon Laboratories' GyroStabilizer. It's kind of like having a tripod without legs. A gyro stabilizer has two small gyros that spin in different directions at a very high rate of speed, creating a centrifugal force that keeps the camera steady, thus allowing much sharper pictures. We wouldn't have wanted to do this project

without this nifty device!

The video camcorders had a built-in feature called Super Steady Shot. This allowed us to make very sharp video without the plane's movement or vibration lessening the quality of the video.

Digital Manipulation

All but one photograph appearing in this book were reproduced without digital manipulation of any kind. That single exception is the shot of the Grand Tetons rising through the thick cloud bank (page 105). It had a contrail that has been removed. That was the only image in the project on which any kind of digital repair was used. All other images were reproduced directly from the original transparencies.

This is not meant to be a statement against digital manipulation. In fact, I am excited about the future of photography and embrace the good things this technology will bring. However, in this natural-history book the accuracy of the images was of paramount importance.

Video Editing

We discovered that it is now possible to edit your video right on your computer to produce really professional looking tapes, complete with transitions between clips, music backgrounds, and titles. We used the Apple iMac DV computer and the easy-to-use iMovie software that comes with it. It is a super system, and our video, "The Story of America From 500 Feet," looks great.

One Last Tip

We already knew that the soft, warm light of the early morning and the hours before sunset were great for photography. When the sun is at a low angle to the ground, the shadows make almost every subject more interesting. And we quickly learned that these same hours in the day are also perfect for flying. The wind tends to be calm during this time, which not only makes flying safer and more fun, but also helped us capture sharper images!

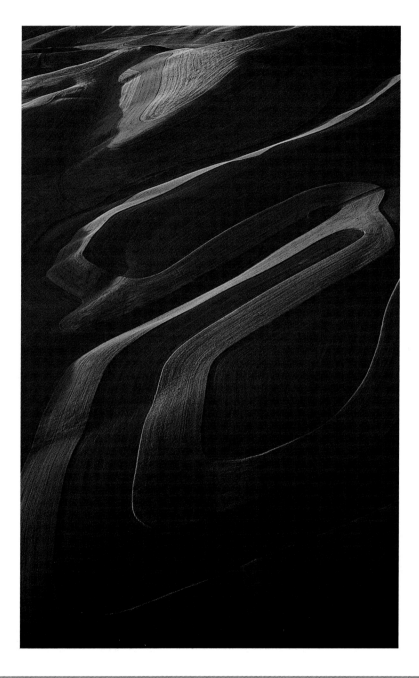

Farm patterns in the Palouse Region of Washington.
Wesley Fortney

Acknowledgments

A project of this magnitude would not have been possible without a great deal of help, counsel, and support. Our most sincere appreciation goes to Dan Steinhardt, Marc Boris, Scott DiSaboto, and Todd & Laura Blumsack of Kodak. We extend our great appreciation to Richard LoPinto, Jerry Grossman, Diane Bachman, Anna Marie Baker, Sharon Lebowitz, Bill Pekala of Nikon, Linda Vuolo of Sony Electronics, John Kemmeries of Kemmeries Ultralight Flight Center and Air Creation U.S.A., and Brian Blackwood & Bruce Chestnut of The New Kolb Aircraft Company. And to Ron Denman of Kenyon Laboratories, the great folks of Grand Rapids Technologies, and David Alexander & Magdi Szaktilla of A & I Color Lab—the only people we would let touch our film!

For all their labors we wish to express appreciation to Travis Brown, Randy Tabor, Todd Fields, and Kris Jerome of Kolb. For the best training you could hope for in a Microlight Trike: John Beeman, Jeff Reynolds. Many thanks to Gary Lapierre and Rob Rollison for more training and advice. Deep appreciation is due to Greg Silva for his hours of hard work at Kemmeries to get our Air Creation trike ready for the project. And to Air Creation of France, thanks for making the best trike on earth—our Fun Racer 447.

Thanks to all our pilot friends, who have inspired and encouraged us along the way: Jerry Boian, Dick Cramer, Charlotte Haney, Burlin Caulder, Jim Wurth, Tug Kangus, Cris Widener, John Darby, Lenny Morrison, Paul Swantstrom, Bob Cossette, Dan English, Martin Angelle, Dave Hempy, Todd Bunn, Bill Massey, George Almond, Ron Phoebus, Otis Holt, Travis Howard, Todd Bunn, Shawn Stice, B.J. Findlay, Daniel Piper, Liz & David Jones, Art Tartola, Bill Hammond, Steve Oliver, David Caldwell, Jim Trachsel, Ronnie "Papaw" Looney, Dennis Curtsinger, Pax "The Wonder Dog," Doug Karis, Rob Fletcher, Ian Shaw, Jeff Campbell, Betty Burke, Carmen Eastman, Bruce M. Olsen, Roger Kruser, Chuck Gretzke, John Apte, Dennis Birozy, Callier Weeks, Jeff Campbell, Larry Snowden, Dave Sbur, John D. Haas, Stacy Campbell, Julie Carlborn, Atlee Atkinson II, Bob Sells, and George Wilde. A very special thanks to Stan Burman for his friendship, encouragement, and logistical help.

For research we owe a great debt of gratitude to Robert Hitchman, publisher of *Photograph America Newsletter*, and to Douglas Kahan, producer of *America By Air Video Series*, two of our best sources of information while planning our shooting locations. To Hal McSwain and Lucian Bartosik, thanks for the best book on trike flying, *Trikes, The Flex-Wing Flyers*. We deeply appreciate the coverage of our project provided by Jim & Irene Byers of *Ultraflight Magazine*. A special thanks goes to Ian Dicker for friendship and managing our website. We are grateful for the invaluable support of wonderful friends like Dr. Charles Stanley, Cliff & Mary Zenor, Dr. Bill Campbell, David Middleton, John Shaw, Dr. Wayne Lynch, David Muench, Marc Muench, Larry West, Dr. Chuck Summers, Tom Rogenburg, Jack Dykinga, Bryan Peterson, Art Wolfe, Chico & Gloria Simich, Neil & Susan Silverman, N.S. Guy, Danny Lawson, Leo & Sandy Miller, artist Jeff Schaub, Don Nelson, Steve & Susan Dodson, and John Netherton.

We want to recognize Carl E. Hiebert for his inspiration. His book, *Gift of Wings*, which chronicled his paralyzing accident and his subsequent flight across Canada in an ultralight, served as an example of what is possible if you truly believe in your God and yourself. We are indebted to Dr. Charles Stanley for his wonderful Foreword, and to Ned Beatty for his clever and delightful Preface.

A very special thanks to our friend and chief encourager, Paul Huber—no project ever had a better cheerleader, laborer, and friend. We could not have stayed on this punishing fourteen-month schedule without support and love from Scott, Diane, Benjamin, Hannah, Catherine, Clint, and Cassidy.

Barbara Harold and Russ Kuepper of Creative Publishing were great friends and enablers in making this book possible.

Bill & Wesley Fortney

And, lastly, thanks to Sherelene, my wife, best friend, and love of my life, who has endured my countless follies and dreams, failures and victories; yet through it all has never left my side, or stopped believing in me. She has truly been *The Wind Beneath My Wings*.

Bill Fortney

Morning fog, Boundary Waters Canoe Area Wilderness, Minnesota.
Bill Fortney

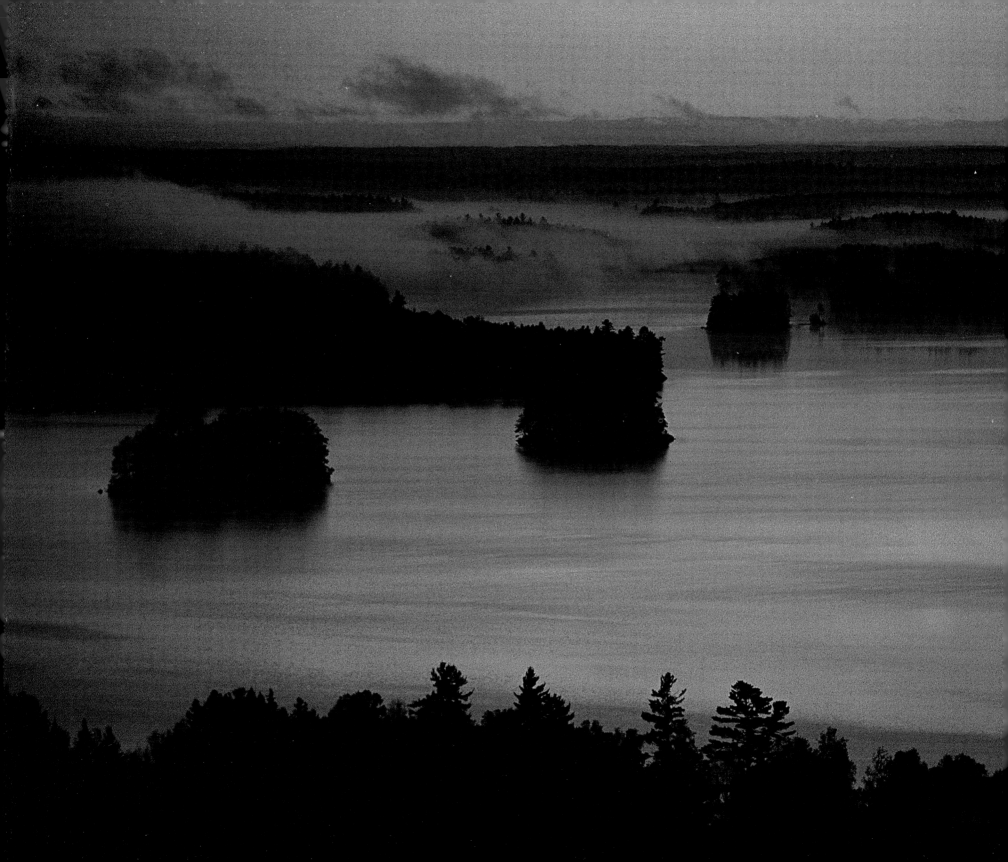

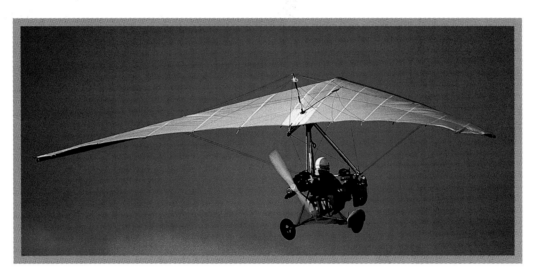

Wesley, taking off from the airport at Lake Mead, north of Las Vegas, Arizona.
Bill Fortney